IMAGES
of America

U.S. PENITENTIARY
LEAVENWORTH

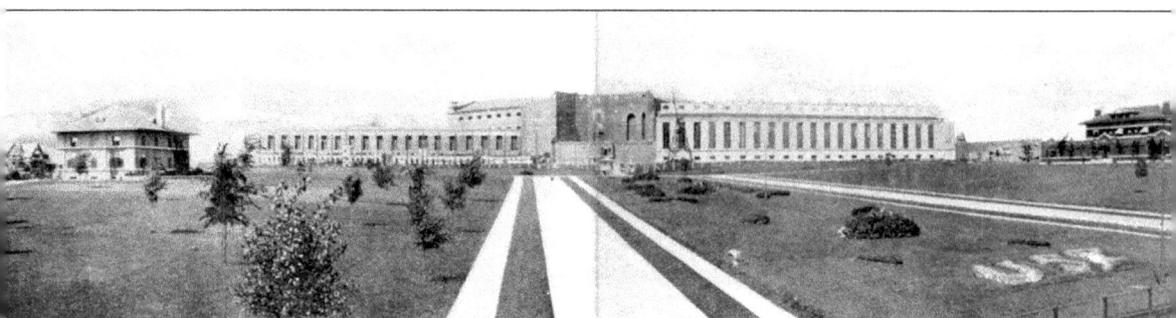

This panoramic view illustrates the U.S. Penitentiary Leavenworth around 1910. (Author's collection.)

On the cover: Building a legend, the dome construction is seen here in 1931. (Courtesy Carl Zarter.)

IMAGES
of America

U.S. Penitentiary
Leavenworth

Kenneth M. LaMaster

ARCADIA
PUBLISHING

Published by Arcadia Publishing
Charleston, South Carolina

Library of Congress Catalog Card Number: 2007931982

For all general information contact Arcadia Publishing at:
Telephone 843-853-2070
Fax 843-853-0044
E-mail sales@arcadiapublishing.com
For customer service and orders:
Toll-Free 1-888-313-2665

Visit us on the Internet at www.arcadiapublishing.com

OPINIONS EXPRESSED IN THIS MANUSCRIPT ARE THOSE OF THE AUTHOR
AND DO NOT NECESSARILY REPRESENT THE POSITION OF THE FEDERAL
BUREAU OF PRISONS OR THE U.S. DEPARTMENT OF JUSTICE.

CONTENTS

Acknowledgments 6

Introduction 7

1. The Old Military Prison 9

2. The Early Years 21

3. For Bad Men Only 31

4. Escape 45

5. Cell Houses 53

6. Inmate Hands are Not Idle Hands 63

7. Work Assignments 73

8. Scenes 83

9. Hacks 95

10. People, Places 109

ACKNOWLEDGMENTS

I would like to thank the following whose help made this project possible: Deborah Bates-Lamborn, Jim Will, and Chuck Zarter. Their talents and photographs make this a great project. Thanks also goes to the National Archives and Records Administration, particularly Tim Rives and Joseph Sanchez for their help and research materials; Abbot Owen Purcell and Fr. Michael Santa of Benedictine College; and the research library of the Command and General Staff College in Fort Leavenworth. Thank you to the following for supplying additional photographs: Kenny Meyer, Bob Logan, Jim Trum, Annabell Willcott, Les Hunnell, Sharon Williams, Dorothy Arnold, Rick Edgell, and the Alexander family. And for those who have shared more than a photograph, thank you to Mercedes Leonard-Dougherty, Agnes T. Kramer, Toni McLeod, Cheryl Mellavan, Pauline Brown, the Cogan family, the Warnke family, and the Haas family. A special thank you goes to David R. Phillips for the use of the photographs of E. E. Henry, R. S. Stevenson, Horace Stevenson, and P. L. Huckins.

INTRODUCTION

Go anywhere in the world and tell people you are from Leavenworth and you will probably hear, "When did you get out?" Known primarily as the home of a United States penitentiary, most people do not know it is much more than that. It is a town rich in history. It is home to the United States Disciplinary Barracks, Lansing Correctional Facility, and the Corrections Corporation of America, Leavenworth Detention Center, run by U.S. marshals. Leavenworth is also the original home of the buck knife, C. W. Parker Carousel and amusements, and famed frontiersman Buffalo Bill Cody. Fort Leavenworth supplied early settlers heading west and served as the starting point for exploration of the Santa Fe and Oregon Trails. It provided protection for fur traders from the incursions of Native Americans. Gen. George Armstrong Custer and his famed seventh cavalry were frequent visitors. It is home to the Command and General Staff College, the place where generals are made. And it is the final resting place and hallowed ground of American military men and women who have given their all.

Col. Henry H. Leavenworth and members of the Third U.S. Infantry ascended the Missouri River in 1827 in search of land suitable for a permanent cantonment. After much exploration of the eastern side of the river, it was determined there was no suitable land for a military post. Leavenworth located land on the western side of the river that was quite suitable, 20 miles further up the river. On September 19, 1827, official approval was granted and Cantonment Leavenworth was born. Under direction of the secretary of war, the name was changed to Fort Leavenworth in February 1832.

The city of Leavenworth was established in 1854 and 10 years later construction began on the Kansas State Penitentiary. In 1874, the U.S. Department of War established the military prison at Fort Leavenworth. In 1891, Congress approved the Three Prisons Act, which called for the construction of three prisons, one each in the East, the West, and the South. On July 1, 1895, over vigorous protest by the Department of War, Congress directed the transfer of the military prison to the Department of Justice and the U.S. Penitentiary Leavenworth was born.

Construction began on the new institution located on the southwest edge of Fort Leavenworth in March 1897. For the next 30 years, inmates worked from sun up to late afternoon seven days a week in all types of weather constructing their new home. Early guards were along side to insure an honest day's work. The rules for guards were almost as stringent as those for the inmates. Day after day, brick by brick, the institution began to take shape. Along the way, escapes, riots, and minor disturbances slowed things down, but they never stopped progress. In 1903, the first 400 inmates were moved into a temporary dormitory located inside what would become the

laundry building. The last of the inmates were moved in January 1906, and the military prison was returned to the Department of War.

As construction progressed, onlookers stood along Metropolitan Avenue and gazed. Early photographers in Leavenworth, such as E. E. Henry, the Stevensons, and P. L. Huckins, recorded daily progress with each flash of their shutters. Newspapers and magazines provided vivid details of the events as they unfolded. Souvenirs began to appear. Postcards, plates, and even sterling silver spoons were hocked in an almost circuslike fashion. All the while, the legend of Leavenworth grew.

As decade after decade passed, inmates came and went, including train robbers, businessmen, gangsters, serial killers, counterfeiters, assassins, hit men, those involved in organized crime, labor leaders, government officials, gang members, and international terrorists. The most notorious became synonymous with the legend of the institution.

As with any prison, there was tragedy. Twelve members of Leavenworth's family have made the ultimate sacrifice, seven at the hands of inmates and the other five in institution accidents. Leavenworth has lost more officers than any other institution in the history of the Federal Bureau of Prisons. The families of the fallen are always on our minds and in our hearts.

For the past 110 years, U.S. Penitentiary Leavenworth has been home to the country's most vicious of criminals. It has also been home to one of the most professional correctional forces ever assembled. Many authors have tried to explain what it is like to live and work in America's most recognizable prison, but if the written word paints a picture, then the photograph should tell a story.

One

THE OLD
MILITARY PRISON

James French had held positions as a school teacher, prosecuting attorney, Indiana state representative, state senator, and warden of the Indiana State Prison. On July 1, 1895, the old military prison at Fort Leavenworth was transferred to the Department of Justice. The first U.S. penitentiary was born with French as its first warden. (Author's collection.)

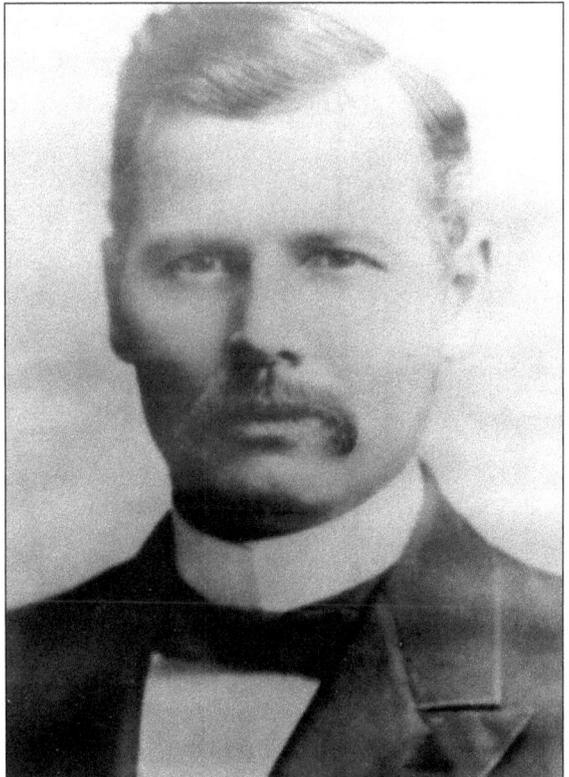

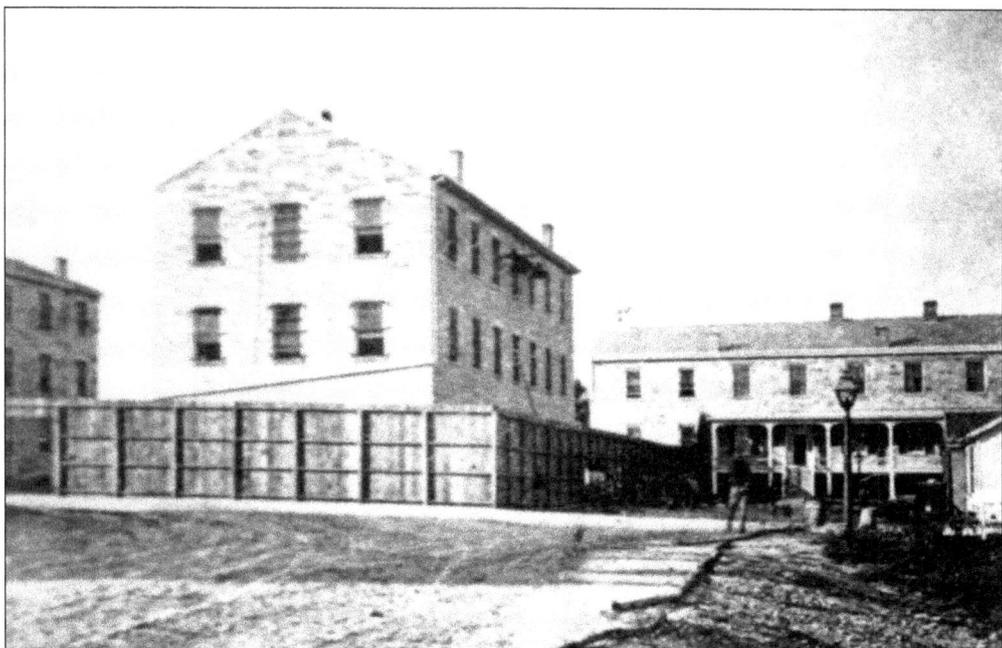

Built in 1840 as a quartermaster depot, these two buildings served as the first territorial capital of Kansas, soldiers' assembly hall, chapel, and post school. In 1867, this was the site of the court martial of Lt. Col. George A. Custer on charges of dereliction of duty. The wooden barricade, built in 1875, enclosed what became the military prison. (Courtesy Leavenworth Public Library.)

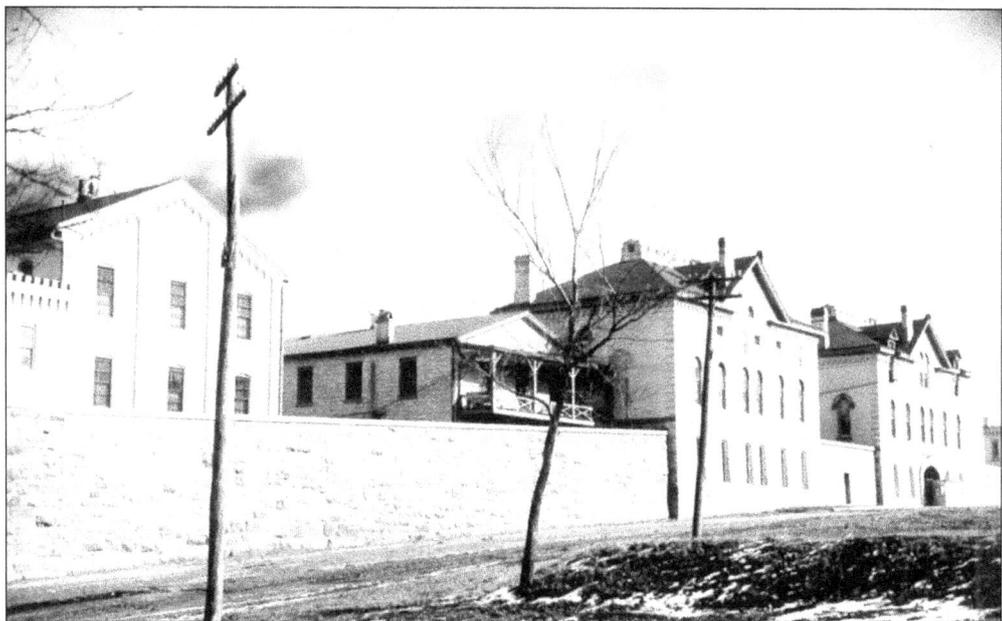

The south entrance to the prison, along with the 2,000-foot-wall, was completed in 1877. The first military prisoners arrived from the military prison located at Alcatraz Island and were housed here in 1878. Known later as the south gate, this served as the main entrance into the facility. This area housed the armory, locksmith shop, visiting room, and commandant's office. (Author's collection.)

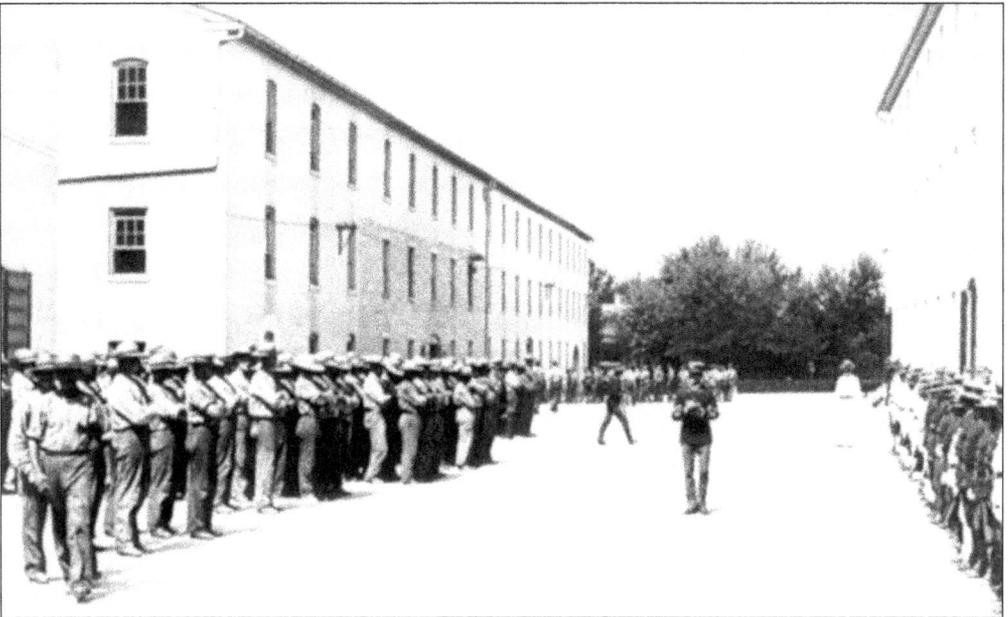

Inmates mustered outside their domiciles after each meal. They were accounted for prior to being released to their job assignments. Prior to 1875, military inmates were housed in jails and prisons all over the country. Many were subjected to less-than-humane conditions. Discipline included flogging, tattooing, and the ball and chain. Some were branded on the face with a *D* for deserter or a *T* for thief. (Author's collection.)

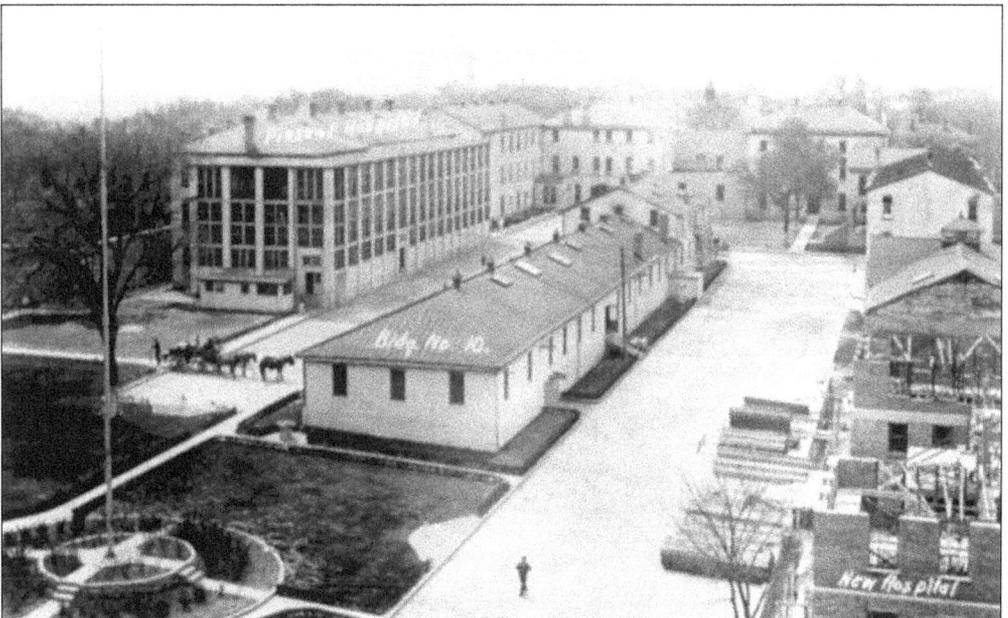

The courtyard inside the facility contained inmate domiciles, workshops, a dining facility, and a hospital. For many inmates, this facility offered clean bedding, wholesome meals, and job opportunities. Inmates stood in silence and were not permitted to salute as the flag was raised or lowered. Guards were not permitted to use violence towards inmates unless it was in self defense. (Author's collection.)

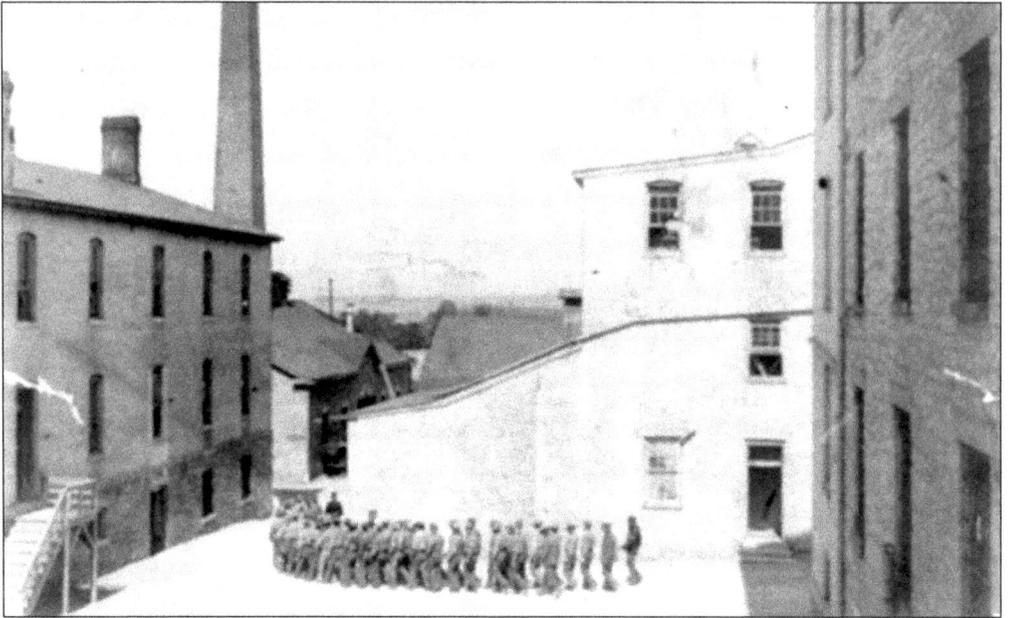

Inmates are marching in lockstep formation and escorted wherever they go. (Author's collection.)

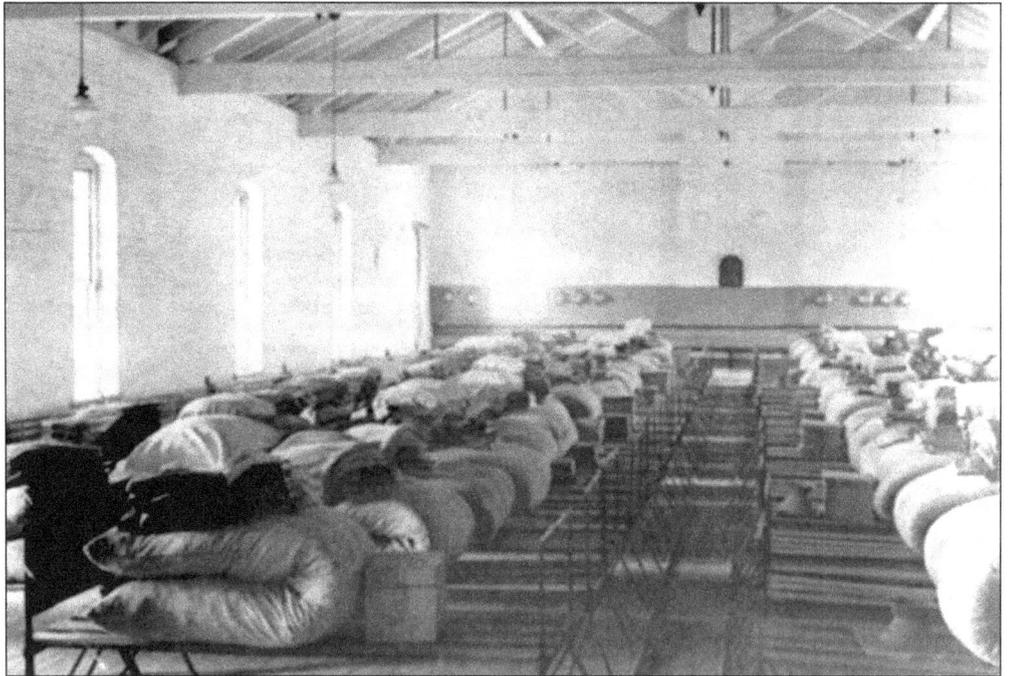

This photograph shows early inmate living quarters. (Author's collection.)

The houses of Bluntville were located due north of the facility. The grassy hillside became home to the largest structure inside the facility, the castle. Congress approved and allocated the money in 1905 and construction began on the castle in 1908. (Courtesy James Will.)

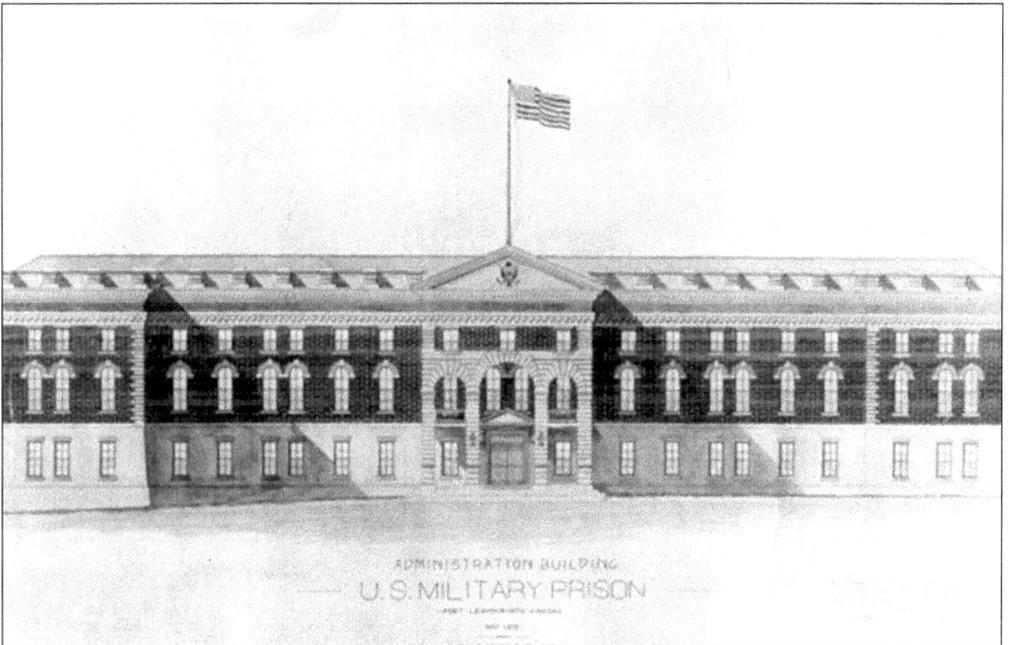

ADMINISTRATION BUILDING
U. S. MILITARY PRISON

This original architectural drawing by Frank K. Rowland, done in 1902, shows what the military had in mind for their new confinement facility. Several modifications were made and the final draft was approved in 1904. Like the justice department, inmates were used as the principle labor force, with many materials coming from the surrounding area. The cheap labor and abundant material saved the government over $400,000. (Author's collection.)

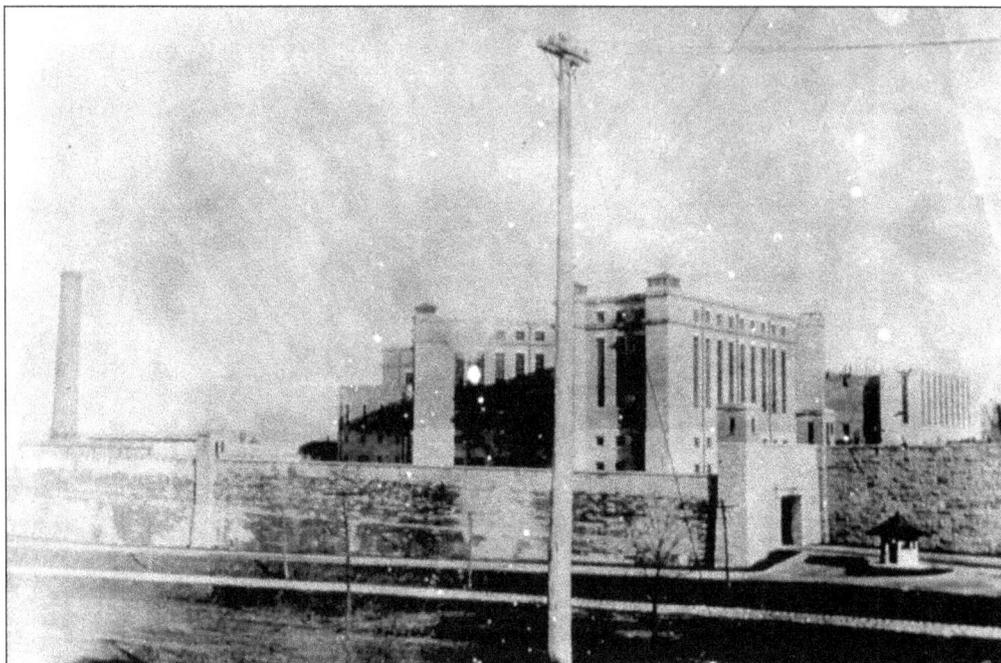

The original north wall was extended to make room for the castle. The west gate area and powerhouse were also completed. Wings three, four, six, and seven housed inmates, while wing one housed the administration building and military police investigations. Wing two was originally an office and mail room and later the staff dining room. Wing eight housed the guard commander's and duty officer's area. Wing five was the inmate dining facility. (Author's collection.)

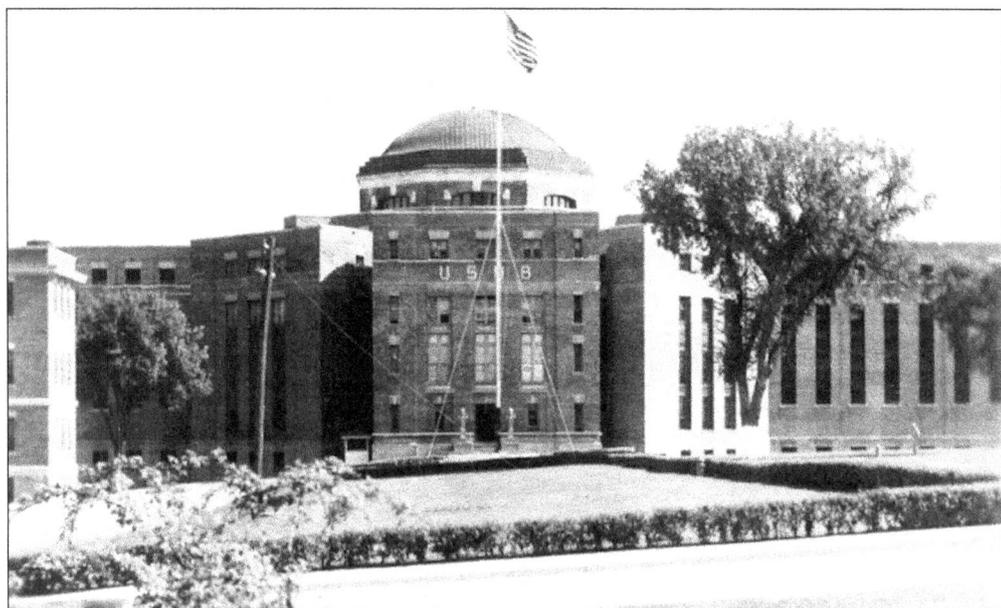

Completed in 1921, the 366,000-square-foot castle contained 1,200 cells, a dining facility, a segregation area, offices, an inmate radio station, a commissary, a gymnasium, a movie-projection booth, a mail room, a chapel, and a death chamber. (Author's collection.)

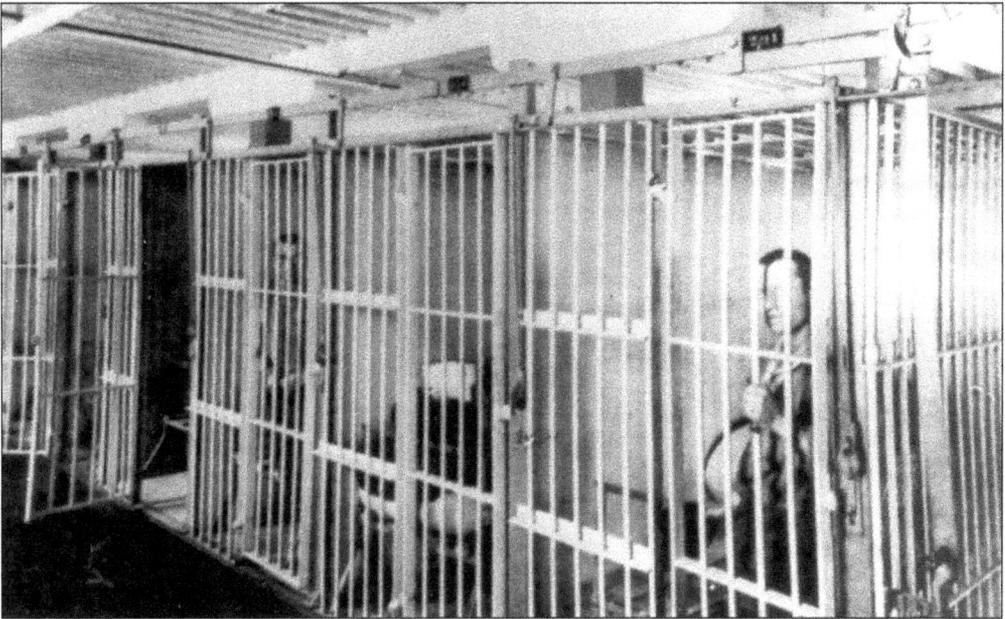

Early cells were located in the basement area of the castle. Known as base, this area housed maximum-custody prisoners, the segregation area, and the death chamber. Early punishment could include reduction in grade, loss of good time, loss of privileges, and a reduced diet. Inmates that attempted to assault staff, other inmates, or harm themselves could be shackled to the door. (Author's collection.)

Wing five was the main inmate dining facility for the institution. Inmates entered through the rotunda and filled up the area from front to back. In later years, the dining room was converted to cafeteria-style dining. Inmates entering had to take one knife, one fork, and one spoon. As they left, they had to show each utensil to a guard for accountability. (Author's collection.)

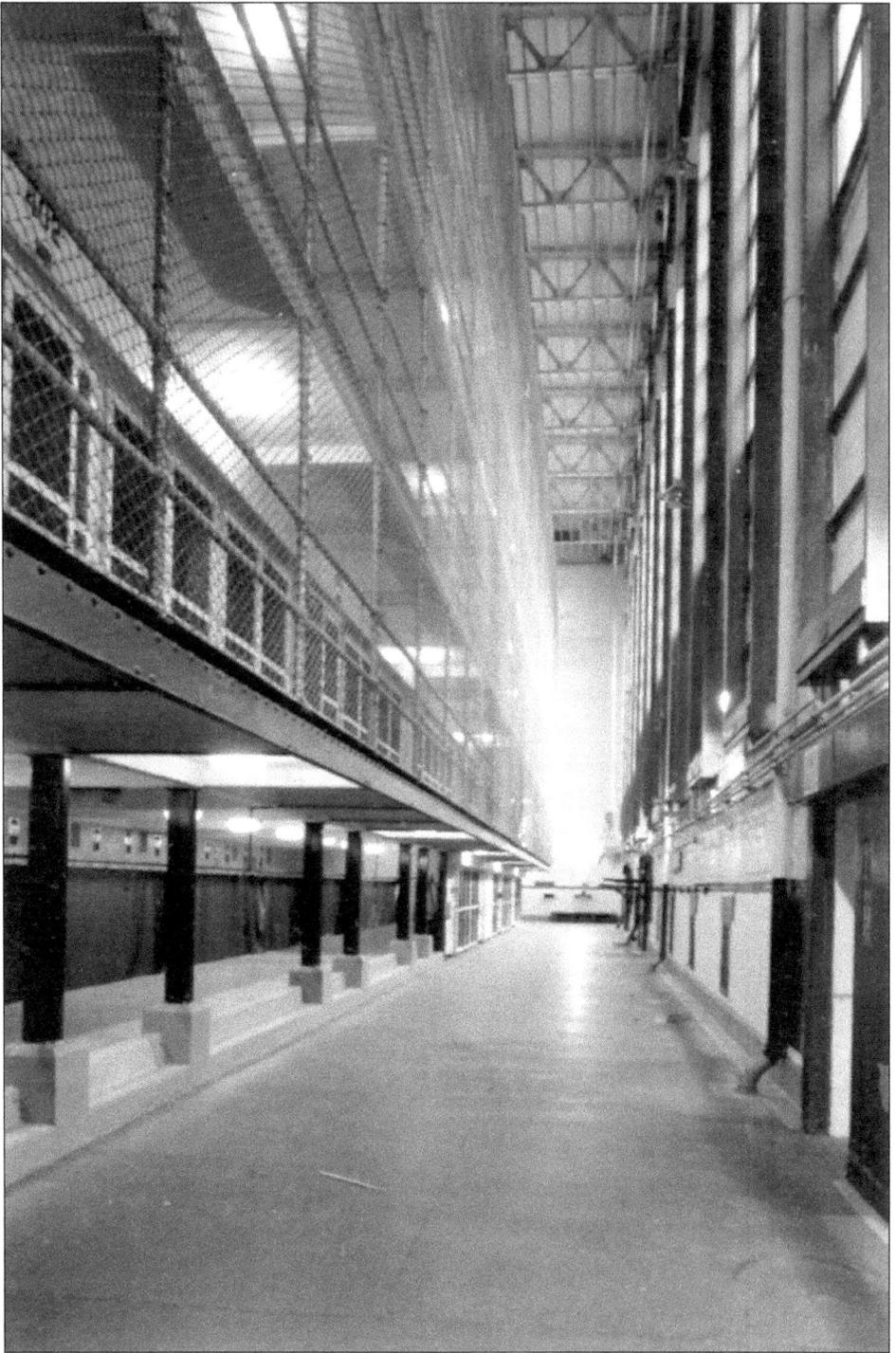

Each of the four main cell houses contained enough cells to house 400 inmates. Six floors, known as galleries, housed medium-custody prisoners. Each cell house contained a shower and offices. Each inmate was assigned a counselor and was subject to daily cell inspections. (Author's collection.)

Institution legend claims this electric chair was purchased from the California Department of Corrections where it was used once. Complete with control panel, a bank of lights indicated when there was sufficient electricity for an execution. Though never used, it became a novelty for staff to have their pictures taken in. (Author's collection.)

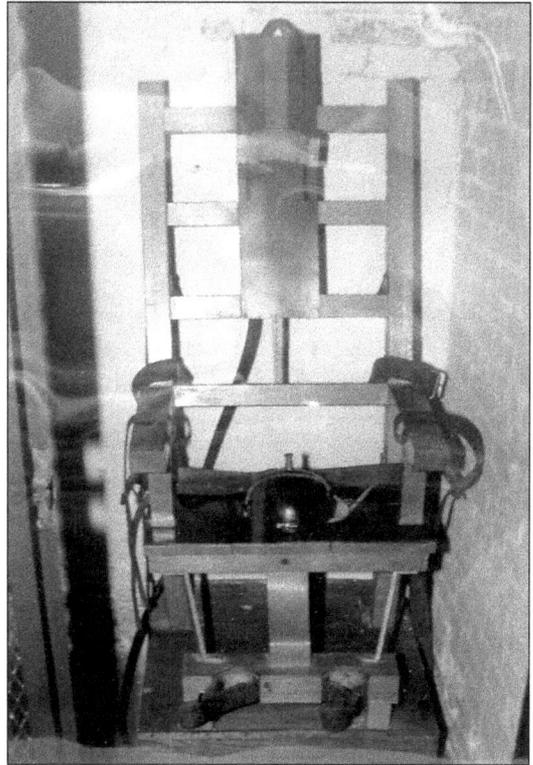

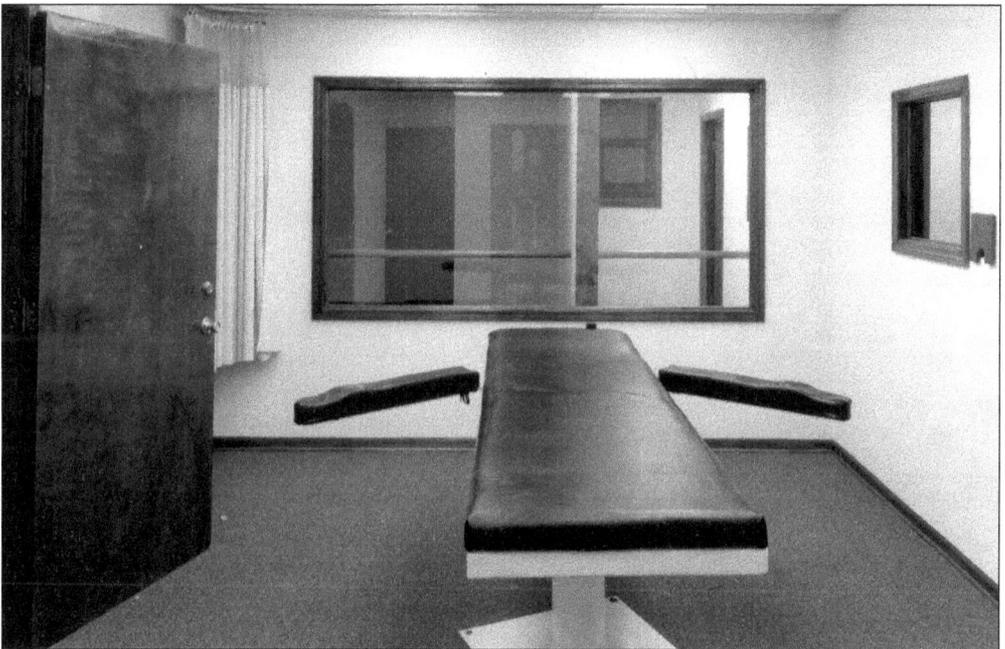

After the state of Kansas reinstated the death penalty, a lethal injection table and viewing area were constructed. A dead man's cell was constructed and covered with Plexiglas. A guard was posted outside the cell on constant vigil to ensure the inmate did not cheat the executioner. (Author's collection.)

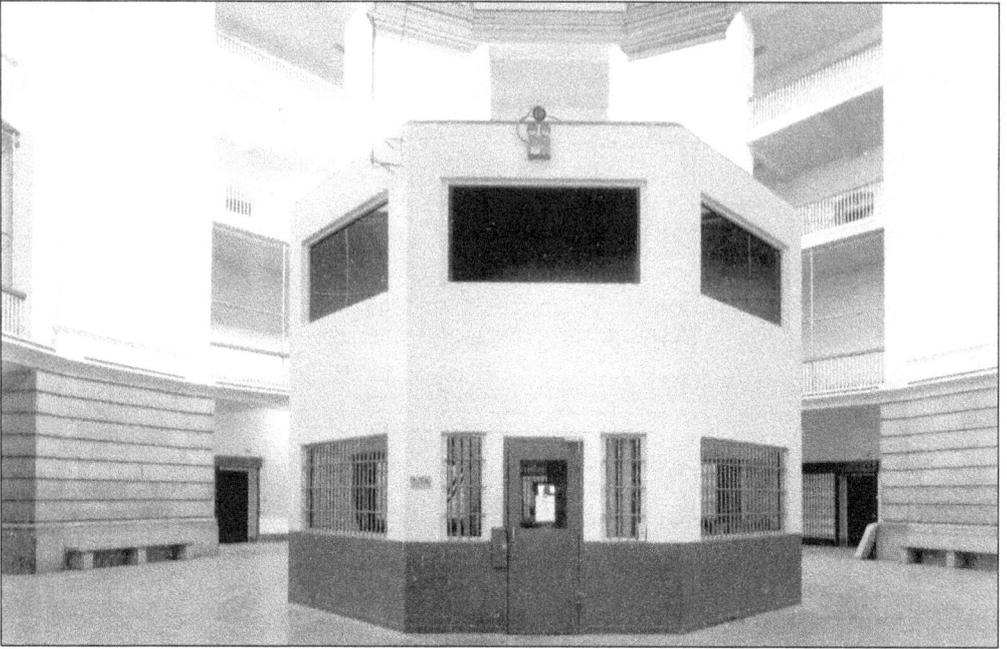

Located in the center of the rotunda was the control center. This area was responsible for issuing keys and equipment that staff needed during their shifts. Additionally this area was responsible for counts, housing changes, institution journals, and emergency notifications. The upper control center was responsible for the opening and closing of cell house doors. (Author's collection.)

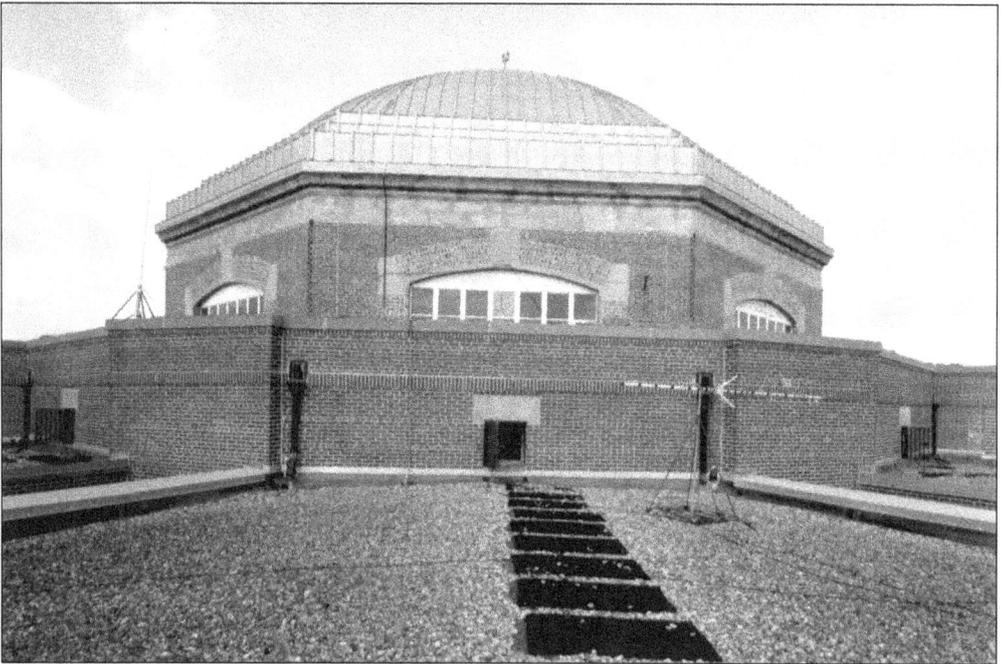

This is the second-most famous dome in Leavenworth. Standing 130 feet above the rotunda, this dome could be seen for miles around. For staff, it was a glimpse of where they worked; for inmates, it was a dim reminder of their home. (Author's collection.)

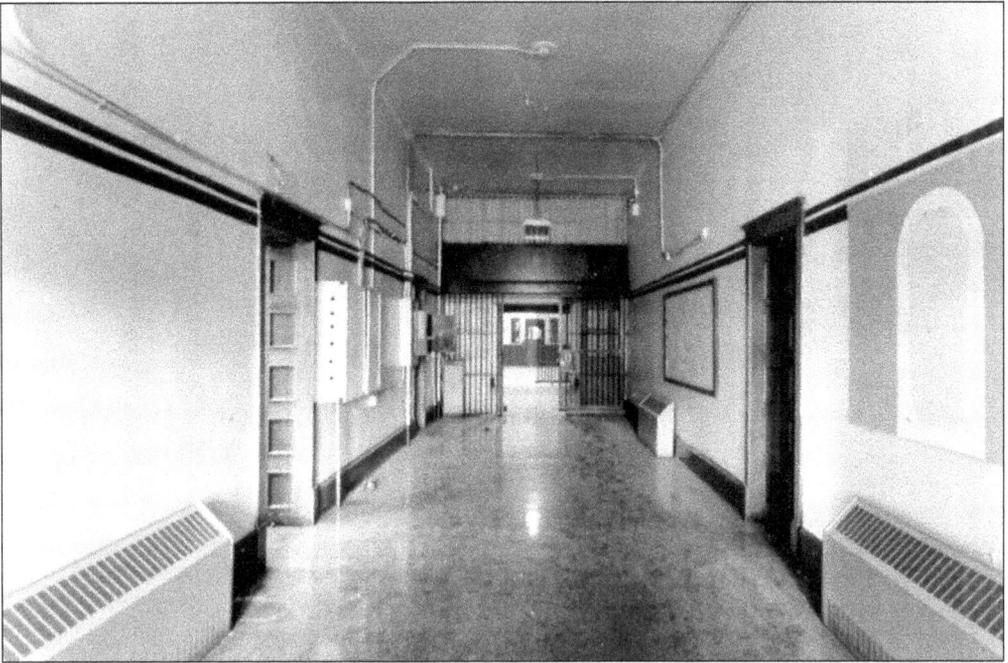

This view looks down the hallway of the administration building shortly after the castle is vacated. This hallway was home to the records office and command sergeant major's office. (Author's collection.)

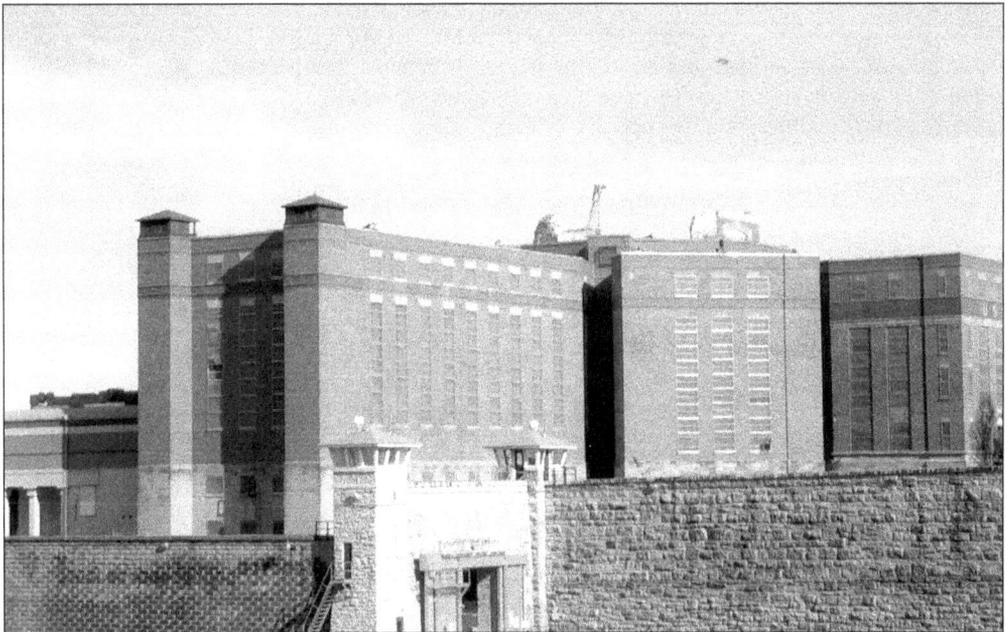

A once-prominent fixture on the landscape of Fort Leavenworth is gone, as the wrecking ball takes its toll on the castle. (Author's collection.)

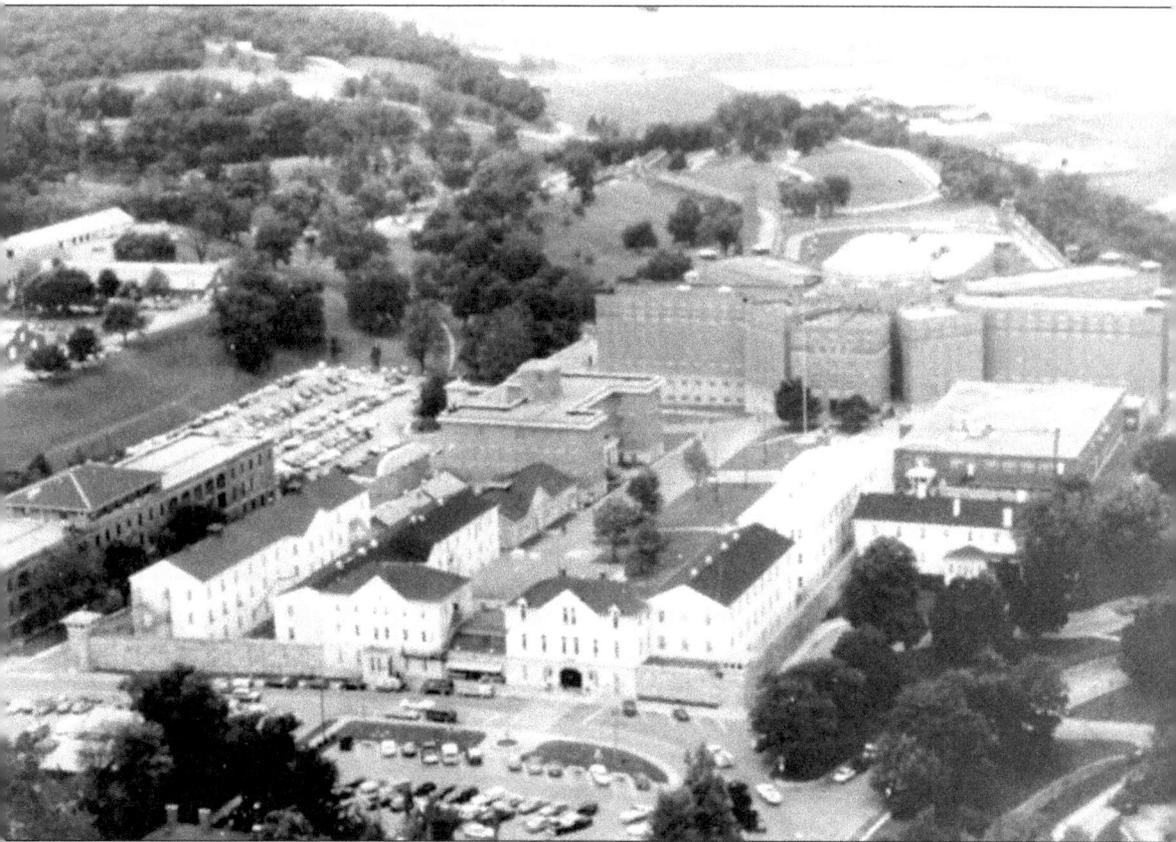

This aerial view of the United States Disciplinary Barracks shows the entire complex from the entrance at the south gate to the recreation yard beyond the castle. The institution's motto, "Our mission, your future," indicated the military's belief in rehabilitation. Enclosed behind these walls were an education department, a mental health facility, a chaplain's division, a barber school, furniture refinishing, an upholstery shop, and an automobile repair and maintenance shop. (Author's collection.)

Two

THE EARLY YEARS

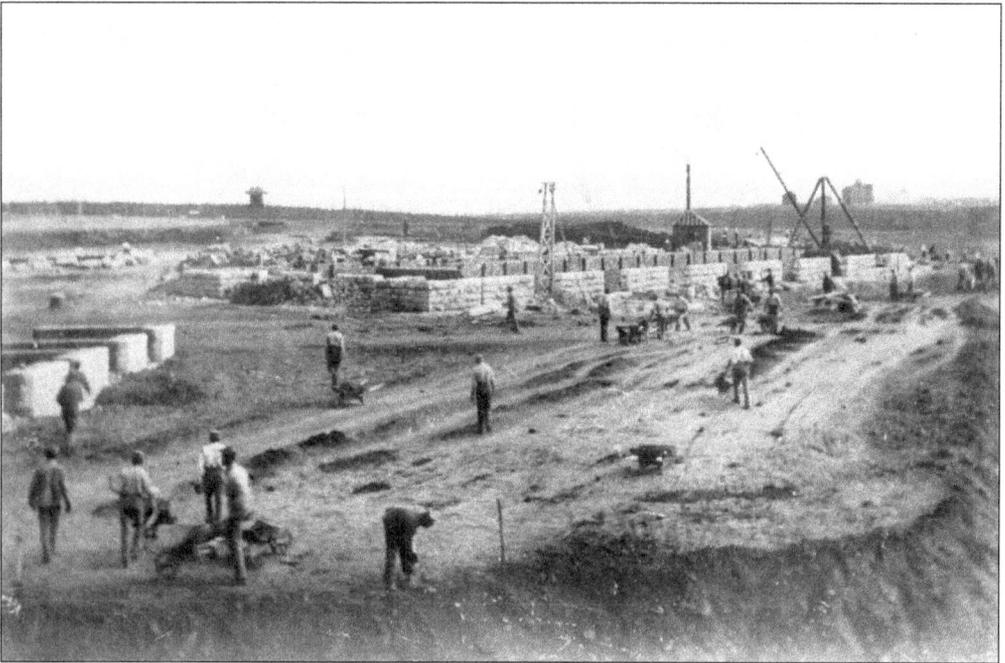

Work began in March 1897 on the new federal prison located on the southwest corner of Fort Leavenworth. Set aside was 700 acres on which the main facility was built and enclosed on 16 of the acres. The new prison contained 1,200 cells, featuring a barred door, electric lights, and running water. (Author's collection.)

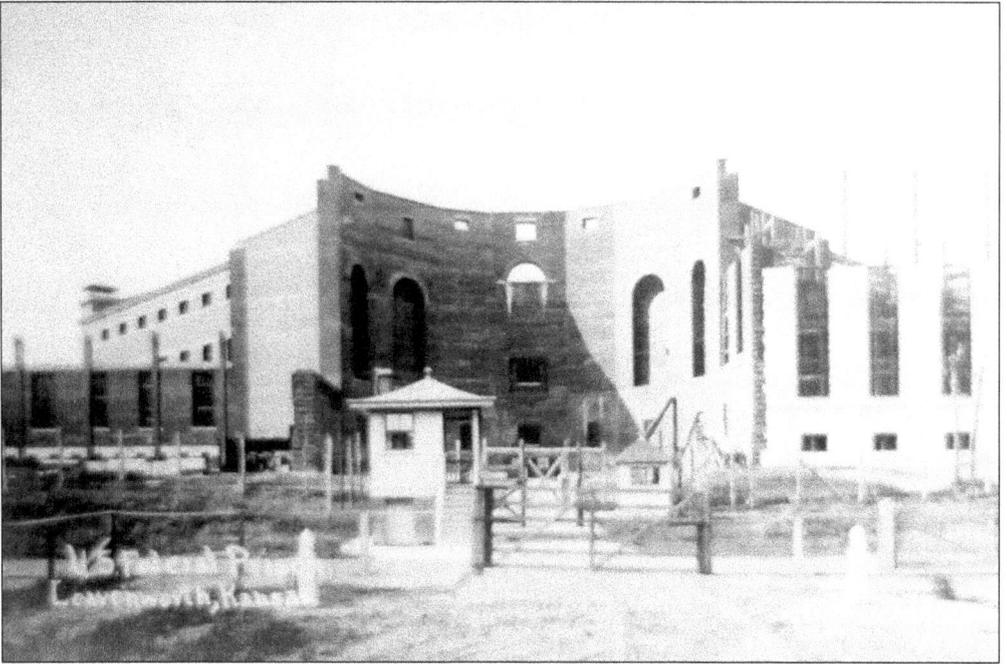

This close-up view of the institution appeared as a postcard around 1908. Cell houses are under construction while most of the rotunda has yet to be built. (Courtesy Jim Will.)

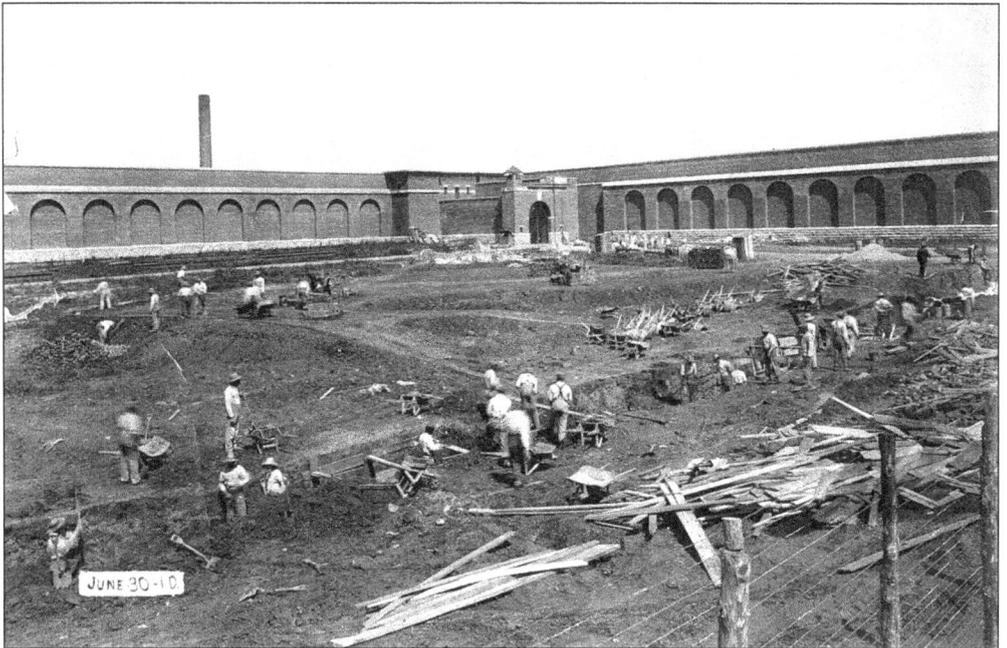

Here inmates are at work just outside the original east wall. This wall originally ran north and south directly behind the institution hospital. The extreme north wall of what became the train chute is visible while inmates work the area that became the institution ball park. (Courtesy the Alexander family.)

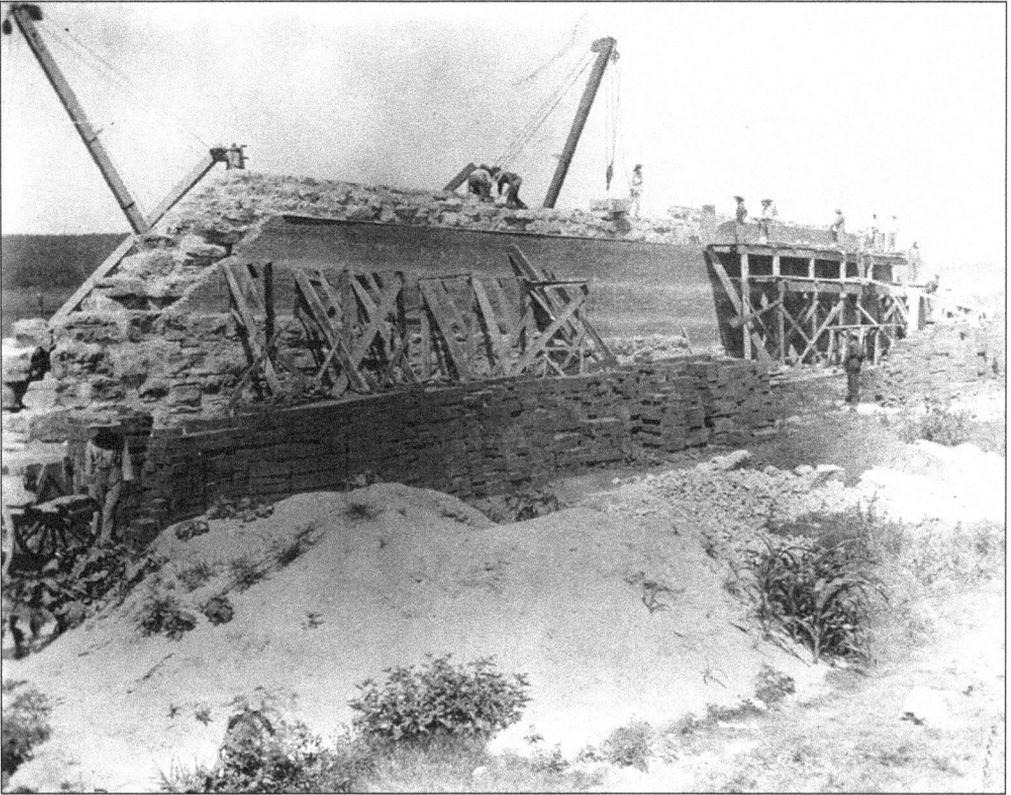

The first section of wall being constructed marks the birth of a legend. Once complete, the wall stood 40-feet high. To discourage escapes, the wall extended 40 feet below the surface. (Courtesy Chuck Zarter.)

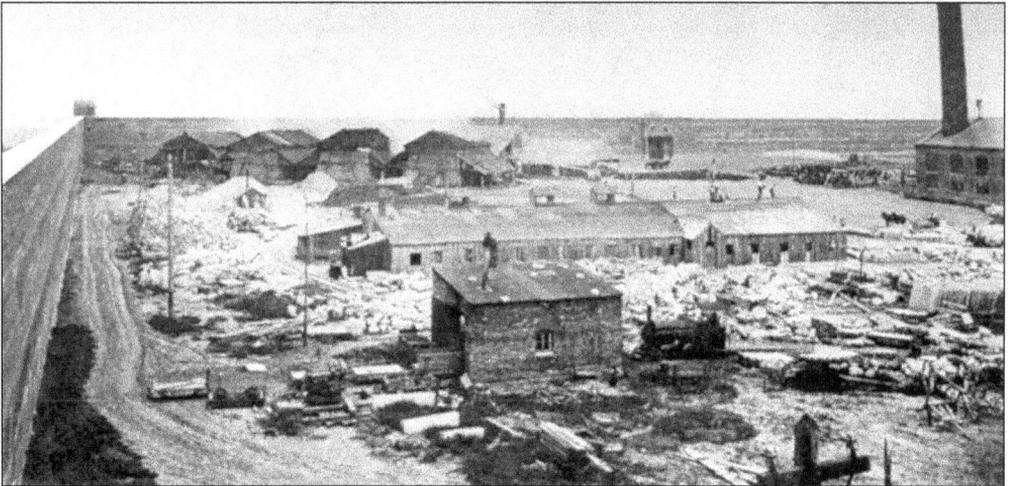

Located on the northeast corner of the construction site, the brick factory operated from 1897 until 1936. Running at full capacity, the factory produced more than one million bricks per month. (Courtesy Benedictine College.)

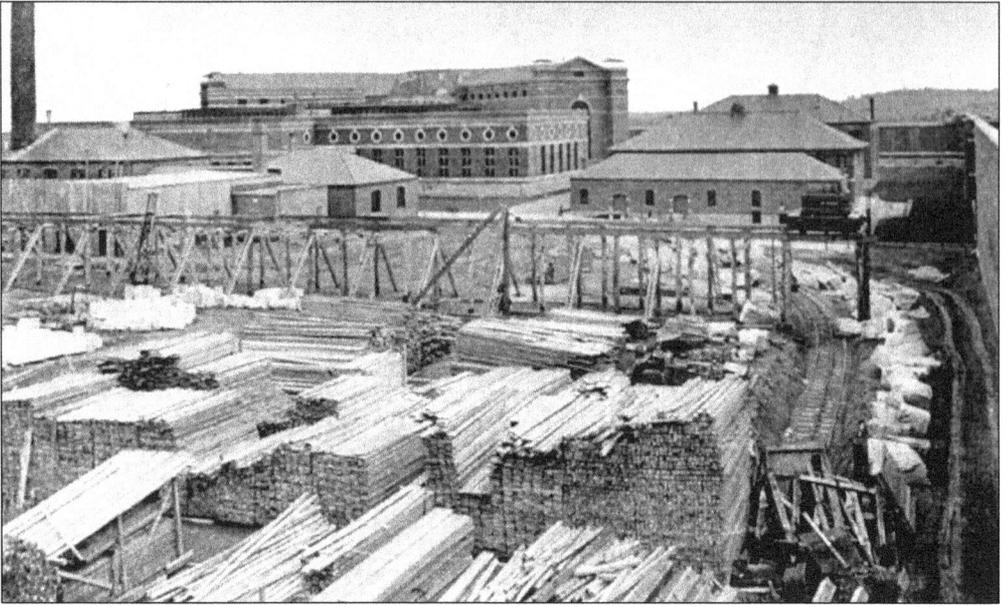

Stacks of building material are located on the northwest corner of the institution. A crane was constructed to assist with loading and unloading of trains and moving materials from one area to another. (Courtesy Benedictine College.)

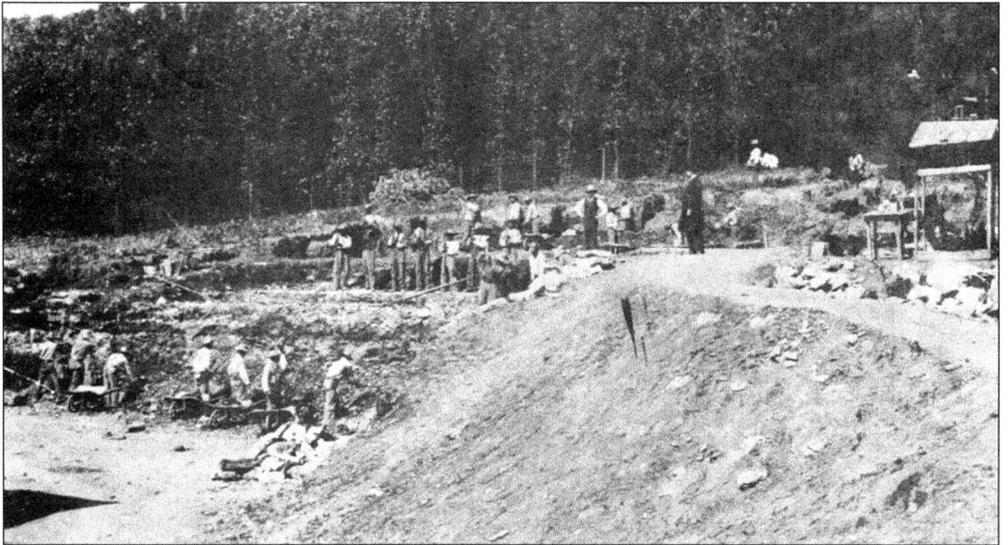

West of the institution, a stone quarry provided the materials used in the foundations of the wall and buildings. Mule-drawn wagons delivered quarried stone to the construction site. Later a small steam engine and rail line were added. (Courtesy James Will.)

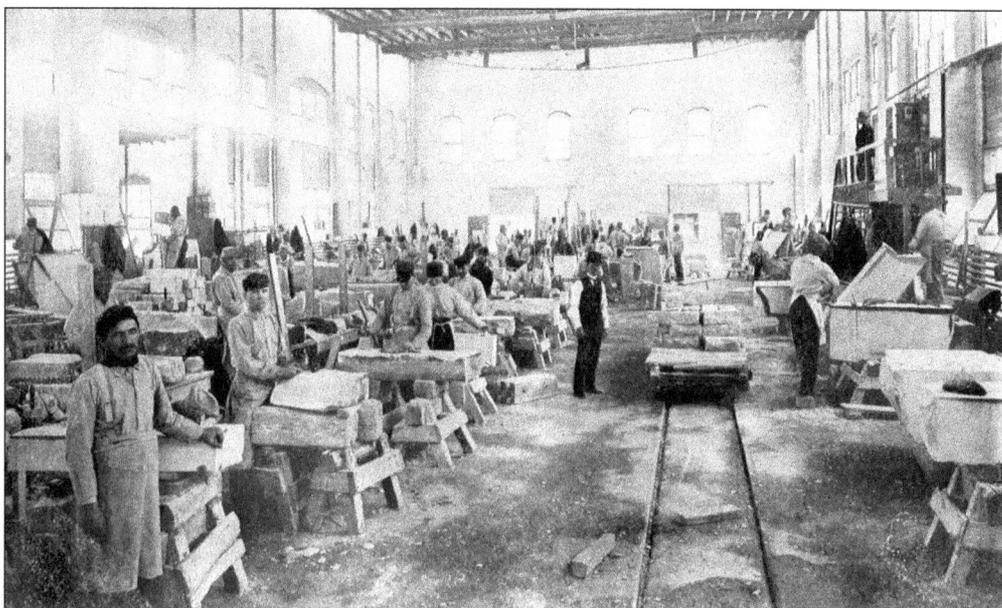

Inmates working the stone-cutting shop were tasked with cutting, shaping, and finishing all of the limestone used on the front of the institution. While some stone was quarried, other was purchased and delivered by train from quarries near St. Louis. (Courtesy Benedictine College.)

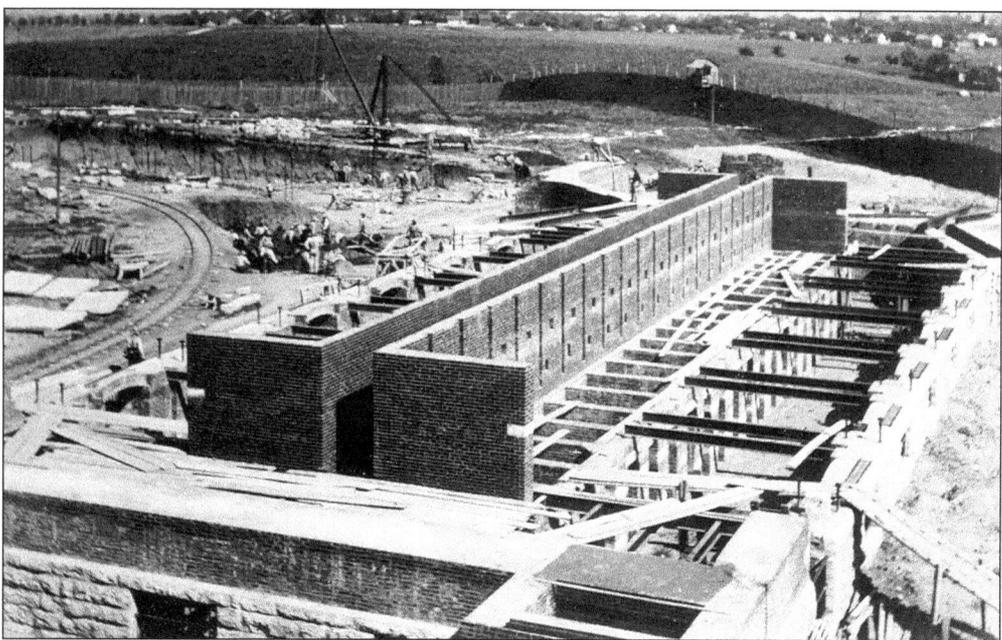

This photograph shows the foundation of the first cell house springing up and the institution taking shape. A steam winch was used to lift the stone into the trench; afterwards inmates manhandled it into place. (Author's collection.)

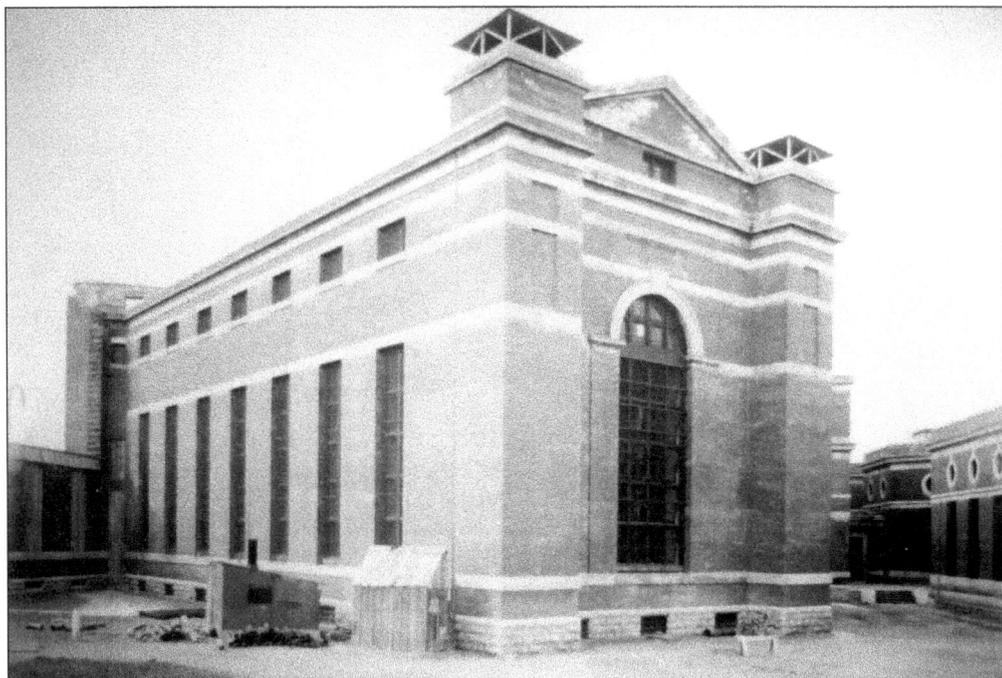

Here is an exterior view of D cell house. This was the second cell house completed and photographs of the unit were used as publicity for the Stewart Ironworks Company. (Courtesy Jim Will.)

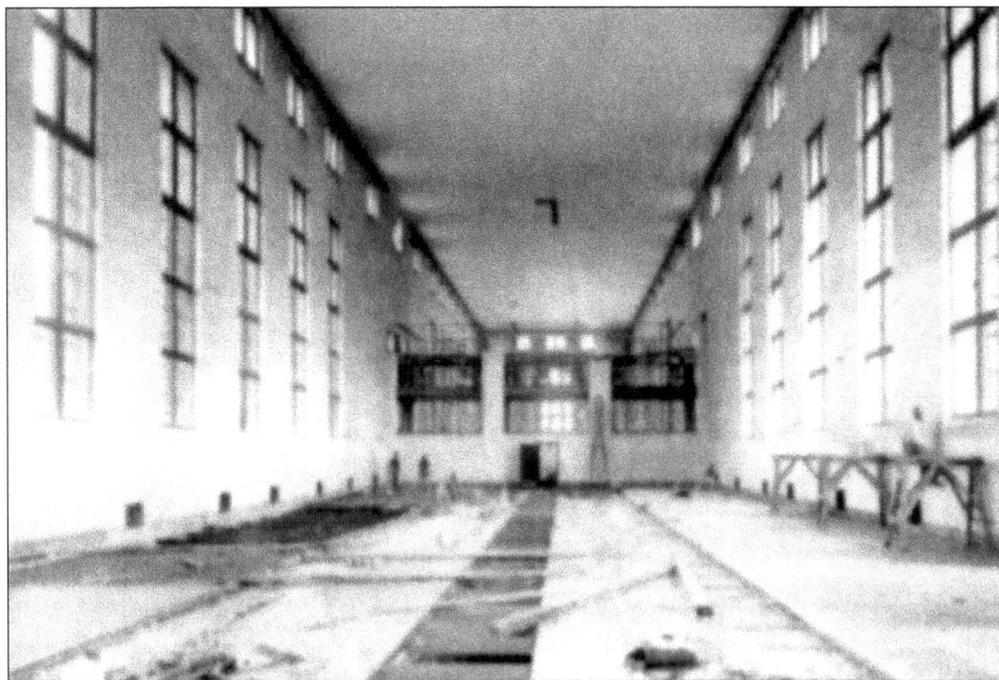

This is an interior view of A cell house prior to the construction of cells. (Author's collection.)

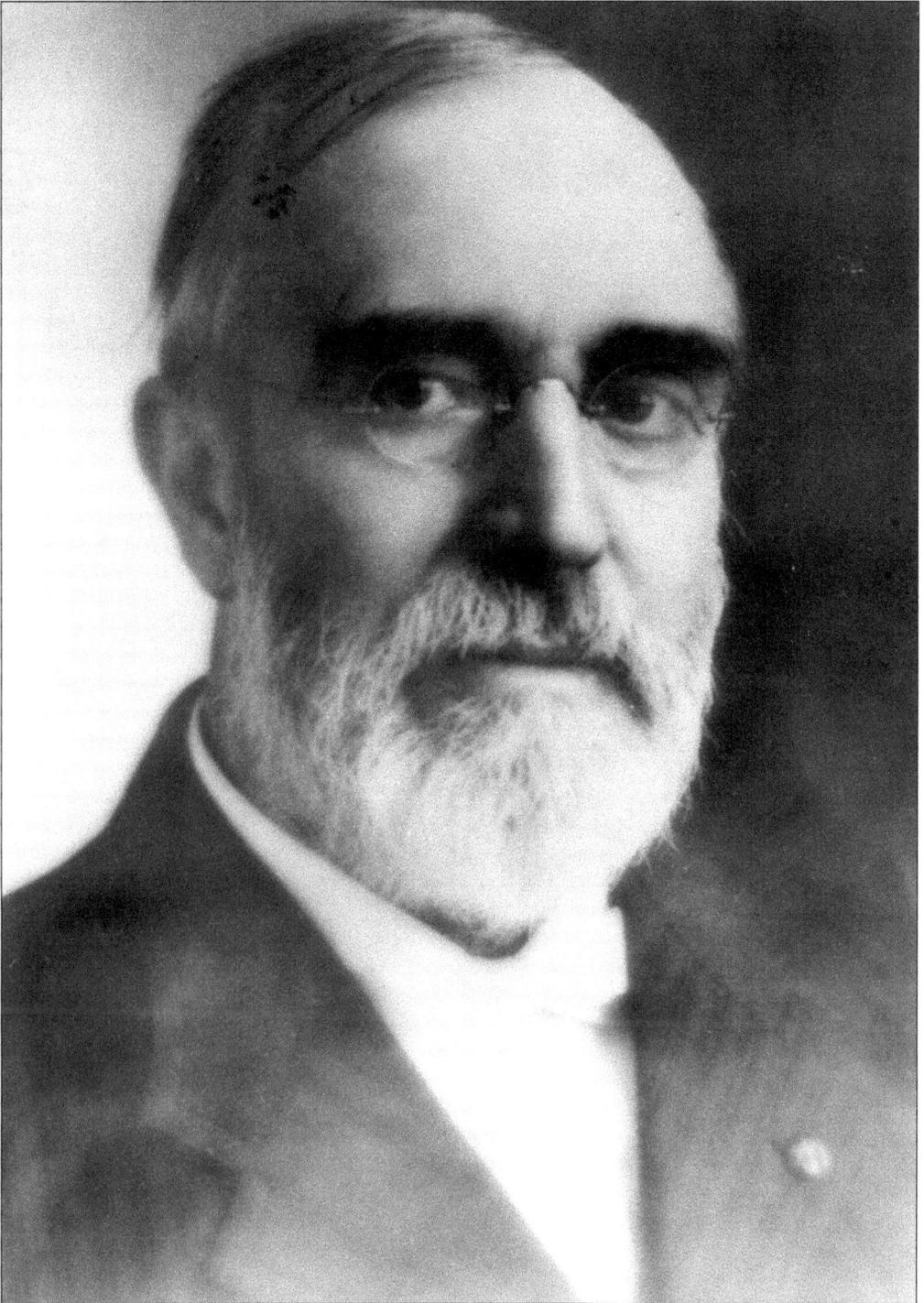

Robert W. McClaughry, a Civil War veteran, Chicago police chief, and warden of the Illinois State Reformatory and State Prison, succeeded James French as warden at Leavenworth on July 1, 1899. During an interview, the new warden was asked what inmates could expect if they got out of line. McClaughry replied, "Leavenworth is hell." (Author's collection.)

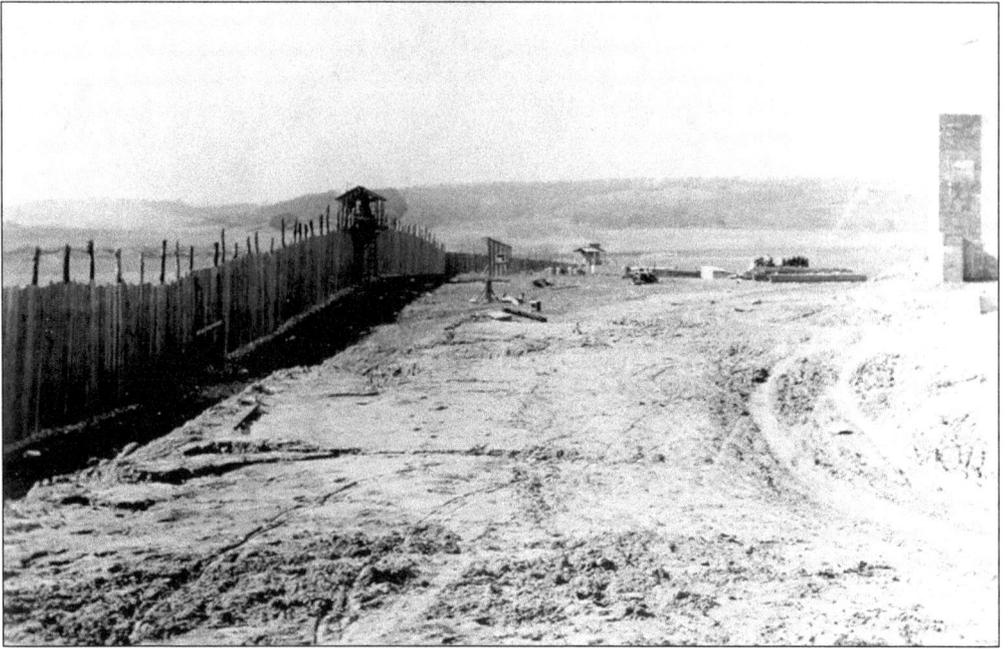

A wooden barricade and guard boxes were built to insure the custody and control of inmates. According to the *Leavenworth Times*, visitors could ask the warden for a tour of the site at anytime. Train loads of visitors arrived daily from Kansas City to view the construction. (Courtesy Chuck Zarter.)

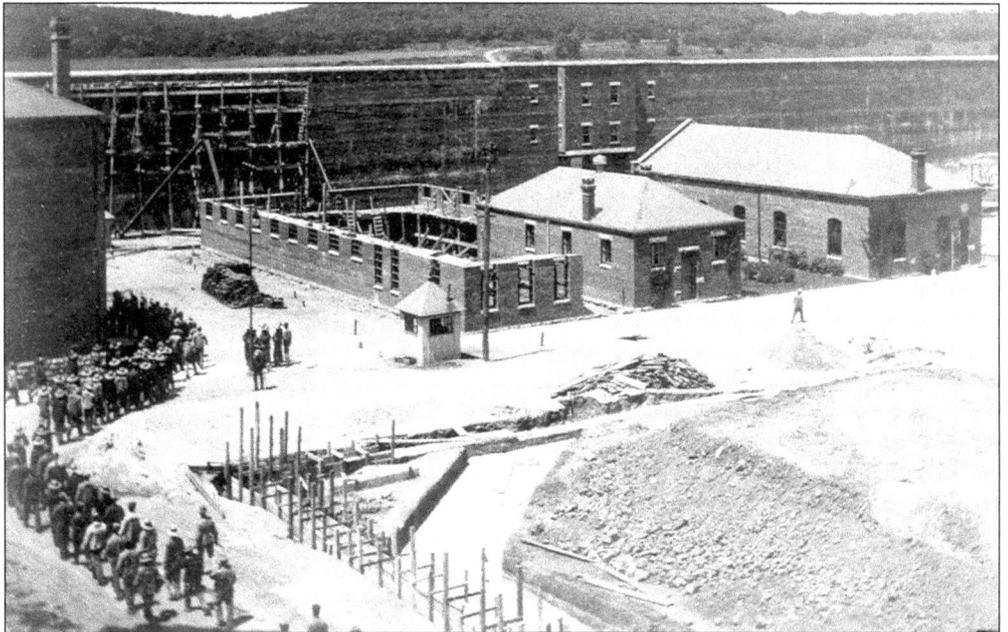

By the early 1900s, the west wall had been completed. Inmates were marched daily back and forth from the old military prison. Early buildings included, from left to right, the laundry, deputy warden's office and segregation, and inmate barbershop. The footing and foundation for the institution dining room is also in place. (Courtesy Chuck Zarter.)

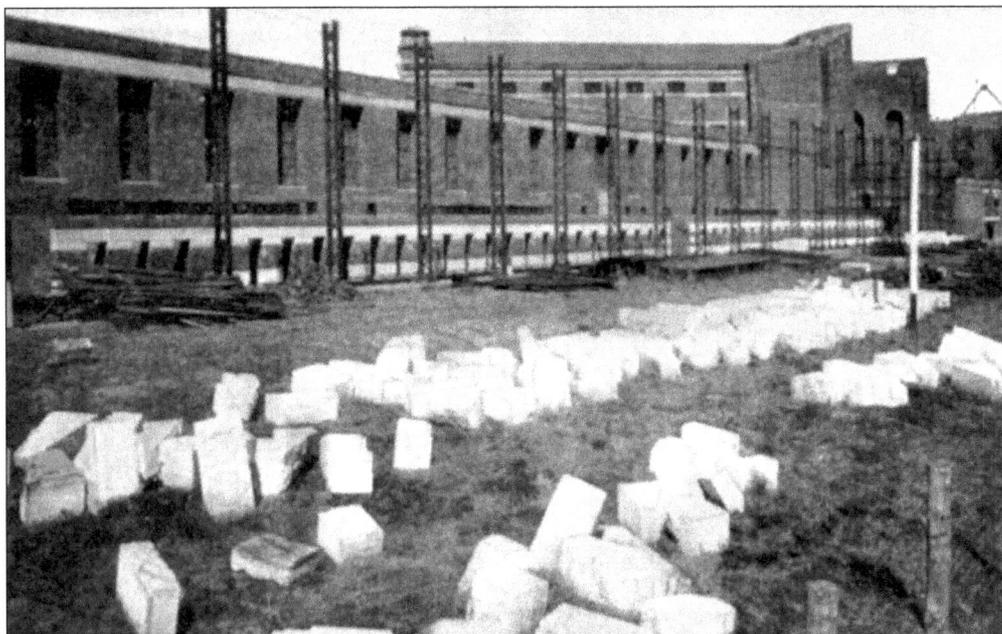

Limestone lays waiting for inmate laborers to start the outer wall of A cell house. The institution is built in what is called radical style, meaning the outer wall of the main cell house makes up the outer wall of the facility. Both of the two main cell houses took about 20 years to complete. (Courtesy James Will.)

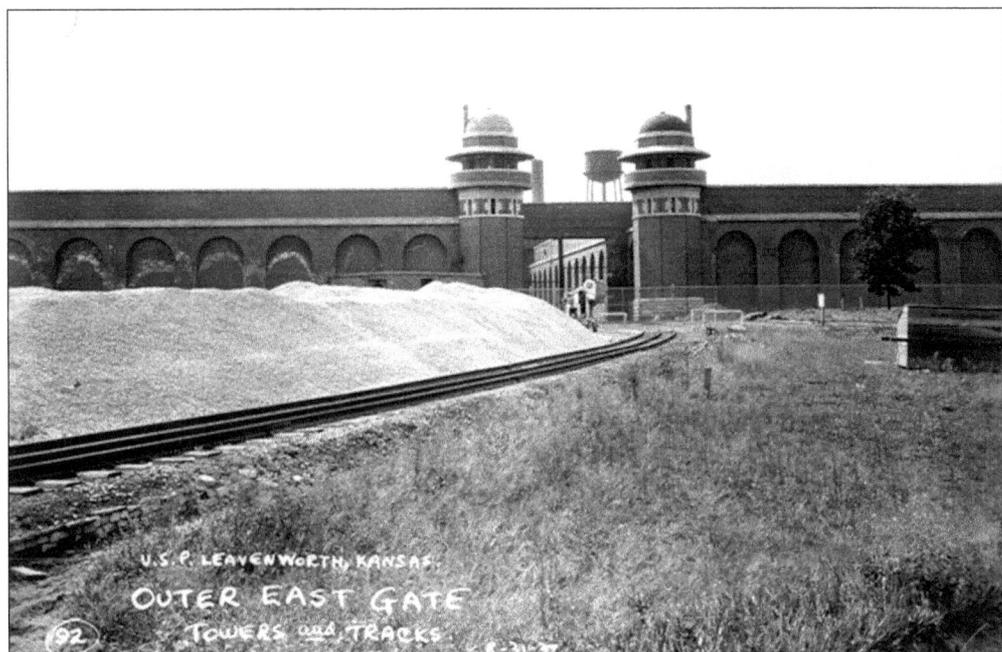

U.S.P. LEAVENWORTH, KANSAS.
OUTER EAST GATE
TOWERS and TRACKS.

Derby hat towers keep vigil on the train chutes. Trains entered the institution carrying supplies on a daily basis. They also delivered new inmates. Guards inspected the trains and escort them to an area in front of the powerhouse where inmates unloaded them. (Author's collection.)

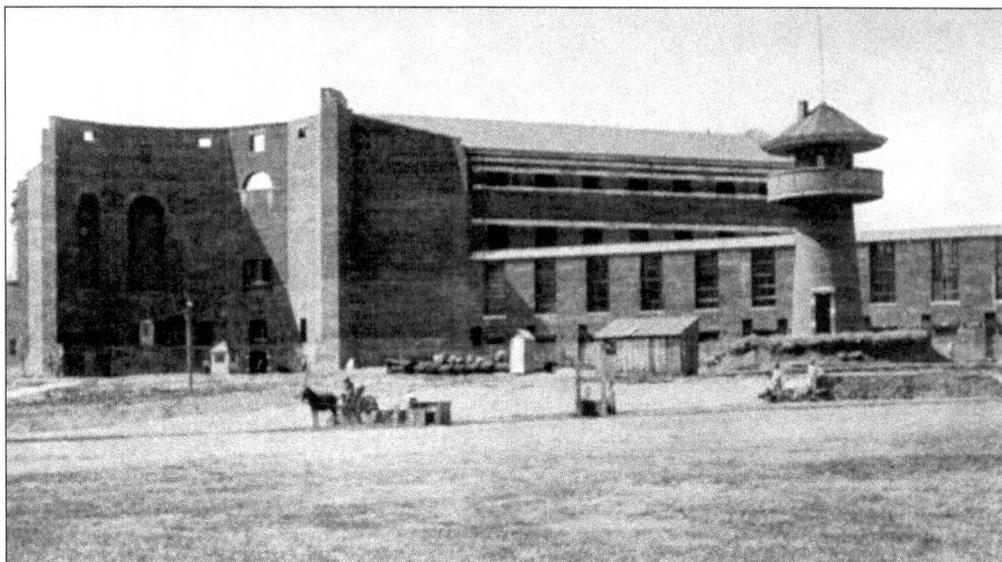

Here is an exterior view of the institution facing north around 1908. The south wall of B cell house is present as is the exterior of D cell house. There is an early tower in an area that later became the B cell house. Early photographs such as this one became the subject of postcards. (Courtesy Benedictine College.)

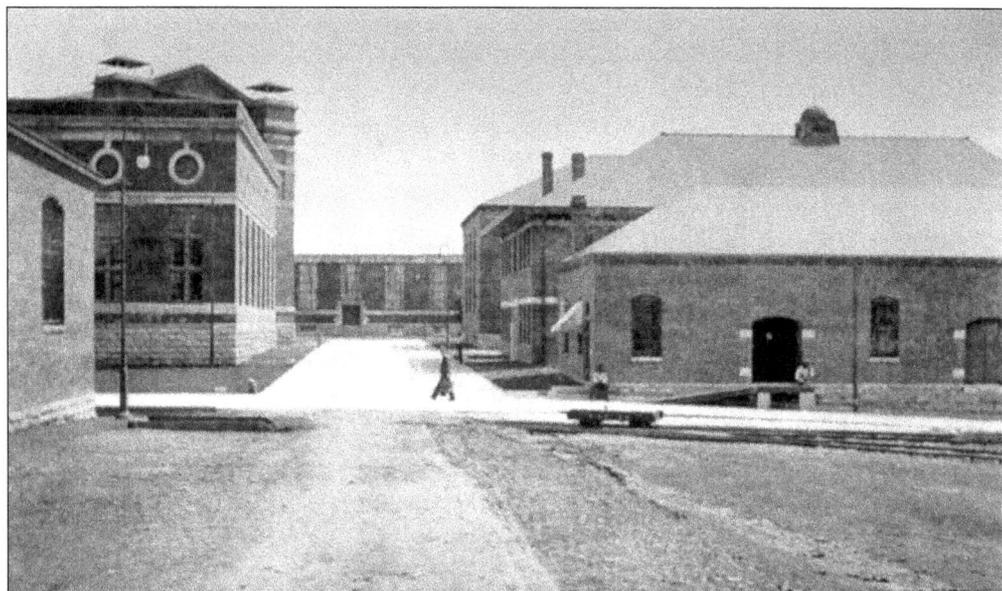

Anyone entering the institution in the early years did so through the west gate. All business was directed to the deputy warden's office and new inmates were processed through the inmate barbershop. Inmates leaving were escorted to the edge of the property to ensure that they left the area. (Courtesy Benedictine College.)

Three

FOR BAD MEN ONLY

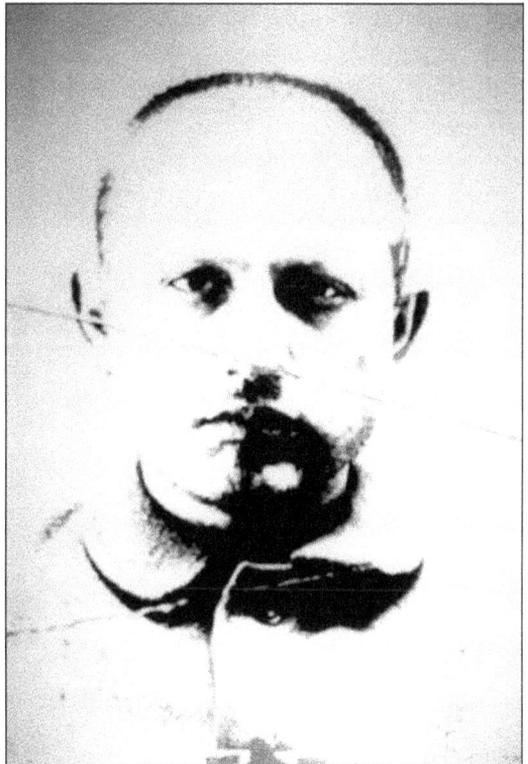

John Grindstone was sentenced in 1895 to 10 years in prison for murder in the Native American territory of Oklahoma. In February 1903 when 413 inmates were transferred to the new prison, several inmates wanted to number one. In a rush to load the first wagon, they forgot, "first on, last off!" Grindstone became inmate number one by default. (Courtesy National Archives and Records Administration.)

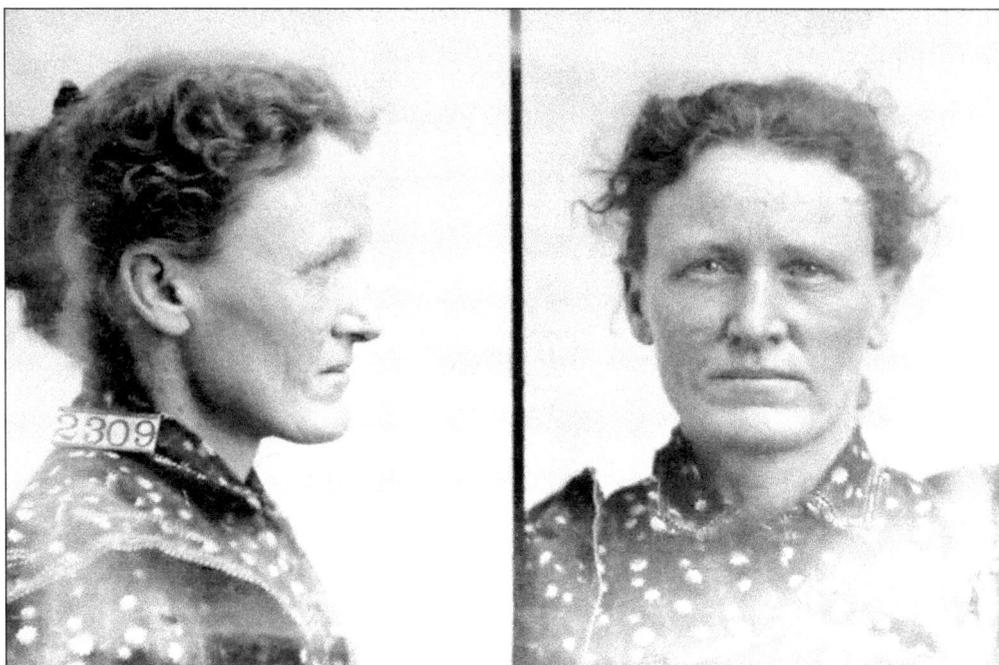

Between 1897 and 1910, 12 women passed through the gates of Leavenworth. A women's dormitory was being built to accommodate the likes of No. 2309, Becky Cook, who was sentenced for robbing a post office in Texas. Though they were received at the federal prison, all 12 were housed at the women's farm at the Kansas State Penitentiary. At the direction of warden Robert McClaughry, the plan to house women was abandoned in 1910. (Courtesy National Archives and Records Administration.)

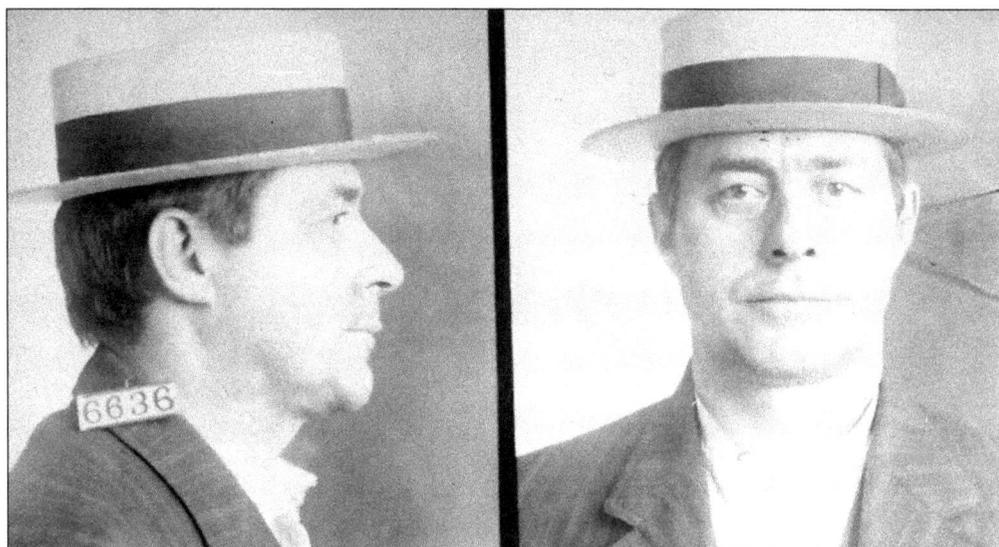

A professional athlete in trouble is nothing new. Bill Wilson, No. 6636, played Major League Baseball in 1890 in Pittsburgh and in Louisville in 1897 and 1898. He was sentenced for stealing postal money orders totaling $18. Ironically the presiding judge in his case, Kennesaw Mountain Landis, was the future commissioner of Major League Baseball. (Courtesy National Archives and Records Administration.)

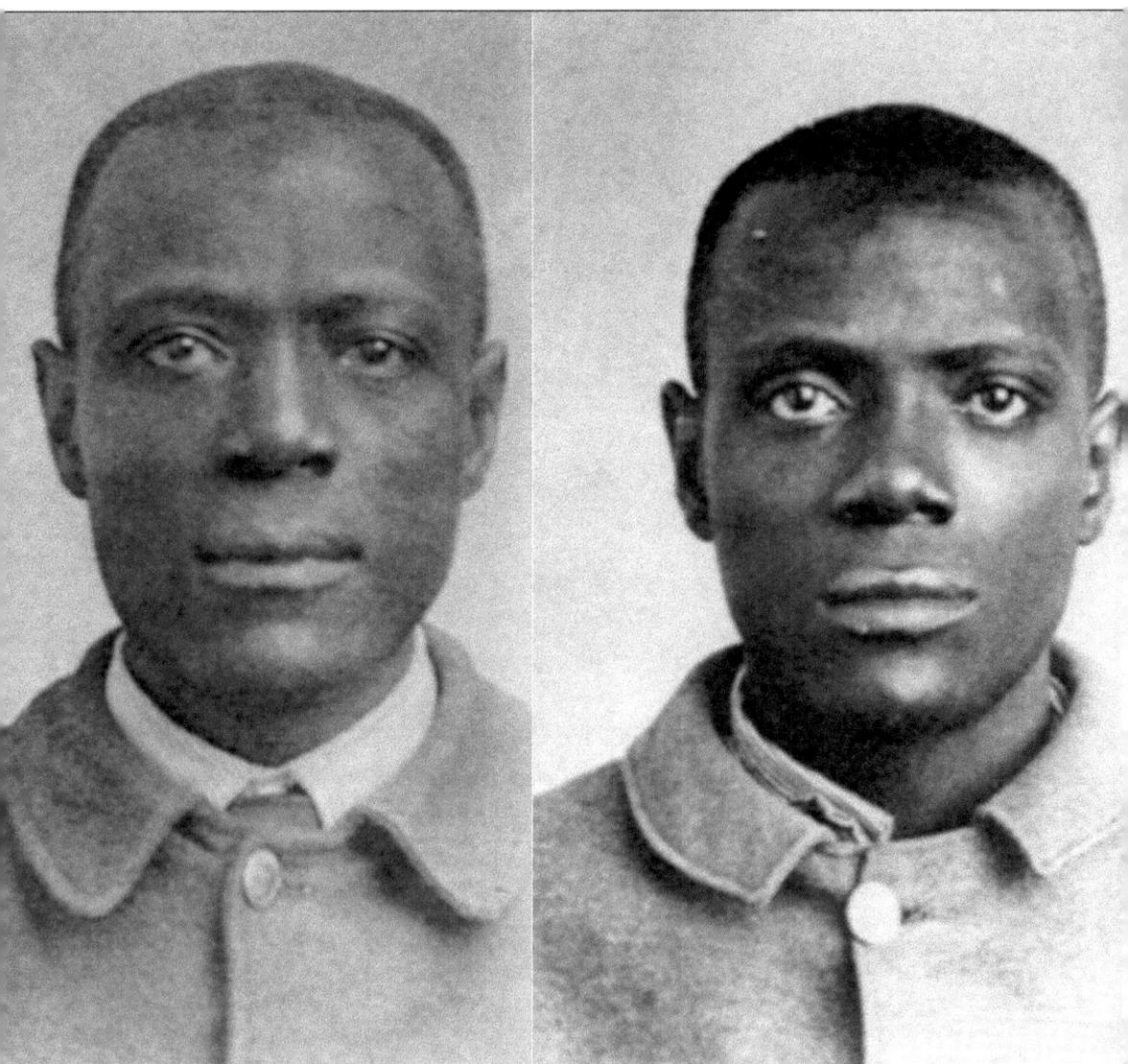

Upon being received at the institution in 1903, Will West, No. 3426, became the center of controversies that eventually lead to fingerprinting becoming the primary source of criminal identification in the United States. Records clerk M. W. McClaughry thought West looked familiar and asked if the inmate had ever been at Leavenworth before. The inmate insisted he had not. McClaughry searched the files and found the picture of William West, No. 2626, who had been received in 1901 on a murder conviction. Upon further investigation, McClaughry found that the Bertillon measurements of both men were practically the same. By 1904, all of the institutions inmates had been fingerprinted and, by 1909, Leavenworth became the home of the Bureau of Criminal Identification. (Author's collection.)

Robert F. Stroud received a 12-year sentence for manslaughter in 1909 for killing a bartender over a prostitute in Juneau, Alaska. After attempting to murder another inmate at the federal prison at McNeil Island, Washington, Stroud was transferred to Leavenworth in September 1912. His antisocial behavior caused him to be a constant disciplinary problem and subject to harassment from other inmates. On March 26, 1916, Stroud murdered guard Andrew F. Turner. He was tried three times for the murder and sentenced to hang twice. Stroud's death sentence was commuted to life by Pres. Woodrow Wilson. Stroud later became somewhat of a folk hero after the release of the book and movie titled *The Birdman of Alcatraz*. All of his experiments were conducted while in segregation at Leavenworth. When he was transferred to Alcatraz in 1942, guards discovered his aviary was actually hiding the fact that he was making 180-proof liquor. Often boasting that his death would be front-page news, Stroud died at the Medical Center for Federal Prisoners in Springfield, Missouri, on November 21, 1963, and was relegated to the back page by the assassination of Pres. John F. Kennedy. (Courtesy National Archives and Records Administration.)

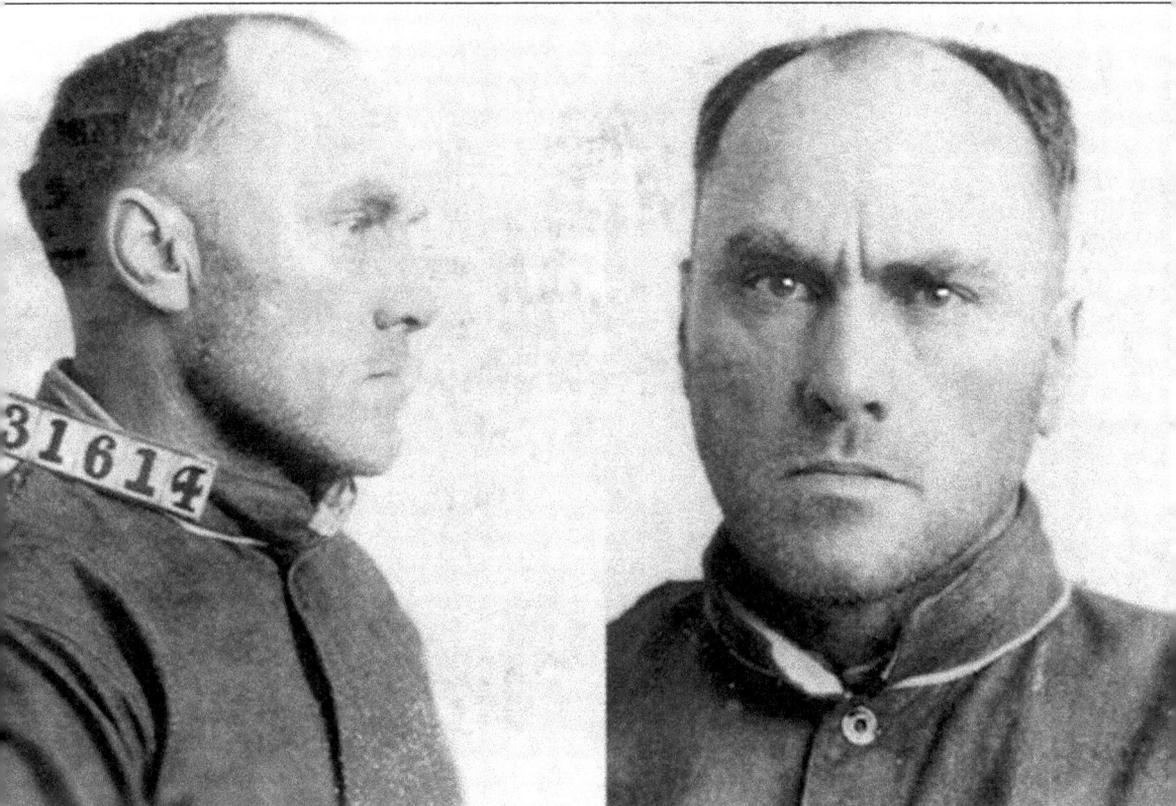

Inmate Carl Panzram, No. 31614, was received at the institution on February 1, 1929, charged with house breaking and larceny. Panzram's criminal history began at the age of 12 when he was sentenced to the Minnesota Training School for Boys in 1902. Panzram began writing his life story while at the asylum and jail in Washington, D.C. An officer at the jail named Henry Lesser began smuggling the writings out to the press. Panzram wrote, "In my life I have killed twenty-one human beings. I have committed thousands of burglaries, robberies, larcenies, arson and last but not least I have committed sodomy on more that one thousand male human beings. For all of these things I am not the least bit sorry. I have no conscience so that does not worry me, I don't believe in man, God nor Devil. I hate the whole damn human race including myself!" On June 20, 1929, Panzram killed foreman R. G. Warnke in the laundry room. Sentenced to death, Panzram was hanged on September 5, 1930. After ascending the gallows, Panzram told the executioner, "Hurry up you Kraut bastard I could kill a dozen men while you're screwing around!" (Courtesy National Archives and Records Administration.)

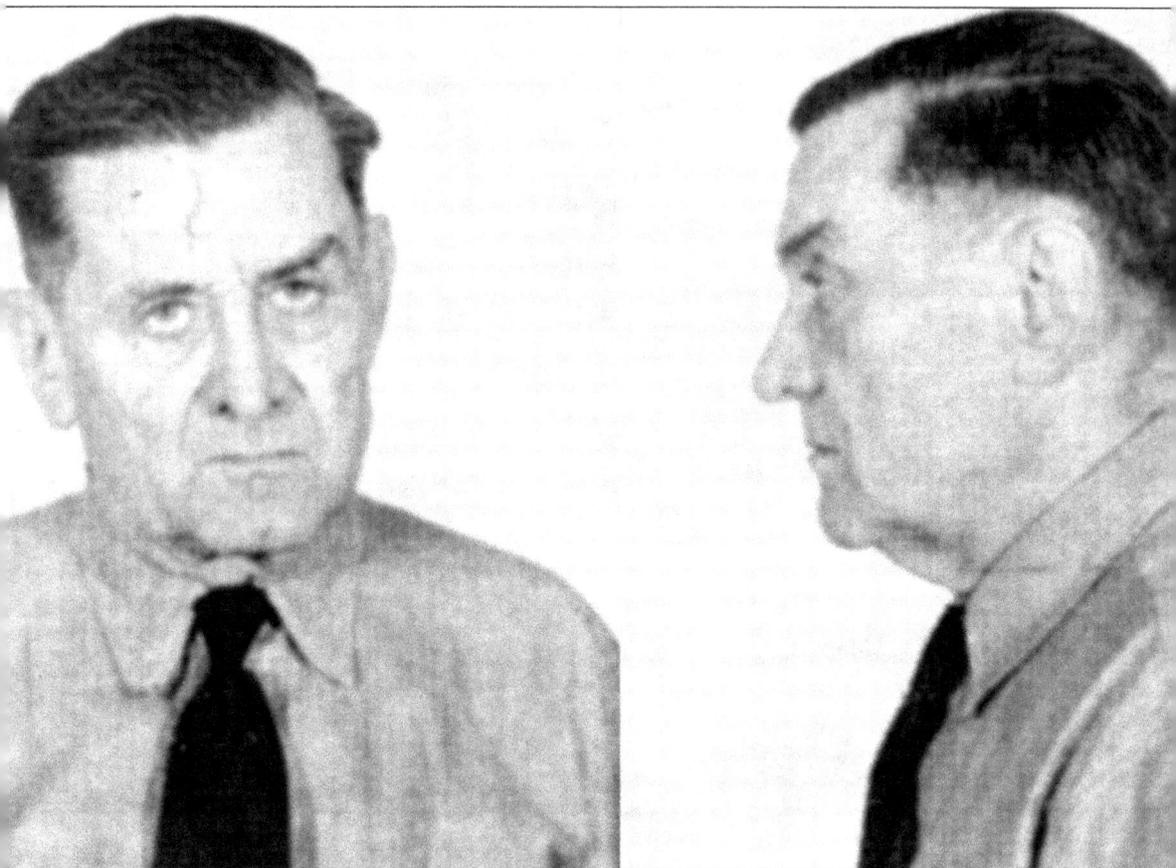

George "Bugs" Moran (above), Dion O'Bannion, Earl "Hymie" Weiss, and Vincent Drucci formed the Northsiders gang in Chicago's 42nd and 43rd wards during Prohibition. The Northsiders became bitter enemies with the John Torrio- and Al Capone-run Southsiders gang. Moran's gang suffered a huge blow when six members were gunned down inside a garage by Capone's hit men on February 14, 1929. This became known as the St. Valentines Day Massacre. Moran was arrested in July 1946 and received a 10-year sentence for robbing a bank messenger. Once released from the Ohio State Penitentiary, Moran received another 10-year sentence for bank robbery. Received at Leavenworth on January 15, 1957, he died of lung cancer on February 25, 1957, and was buried in an unmarked grave in the institution cemetery. (Author's collection.)

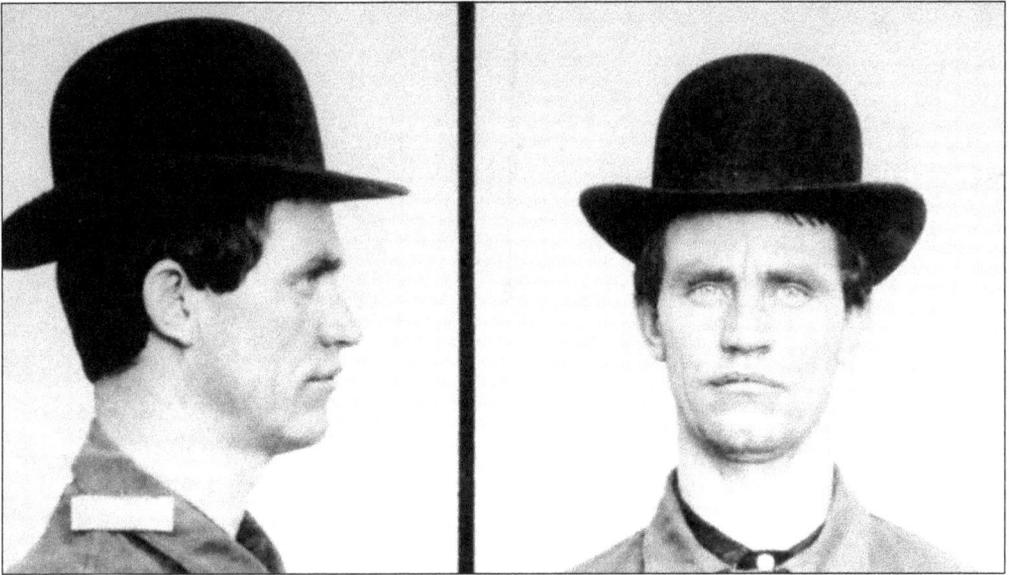

Inmate Allison Poe found his Leavenworth experience to be unpleasant and hated warden Robert W. McClaughry. His book, titled *Sequel to a Conspiracy the Brothers Poe*, was released in 1910 and told about the grim reality in the early days of Leavenworth. It was also the first book ever written about the institution. (Courtesy National Archives and Records Administration.)

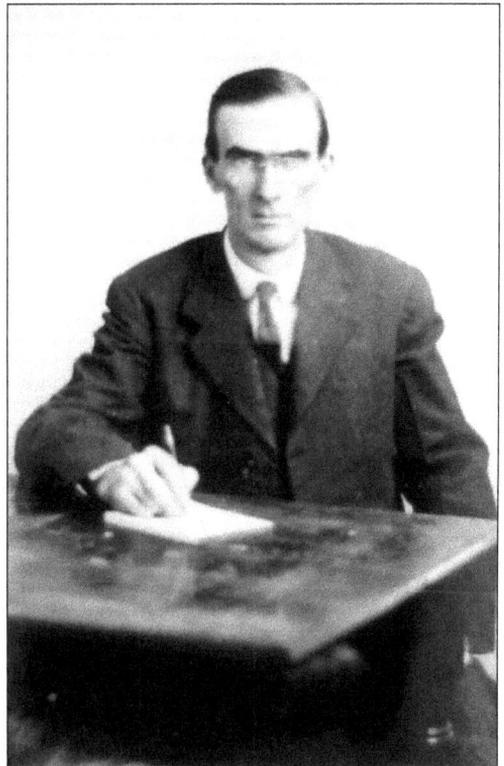

On the other hand, George Bert Wright enjoyed his stay. The second book about the institution, titled *My Two Years Experience at the Model Prison of the World, the United States Penitentiary at Leavenworth, Kansas*, made each day sound better than the one before. (Courtesy National Archives and Records Administration.)

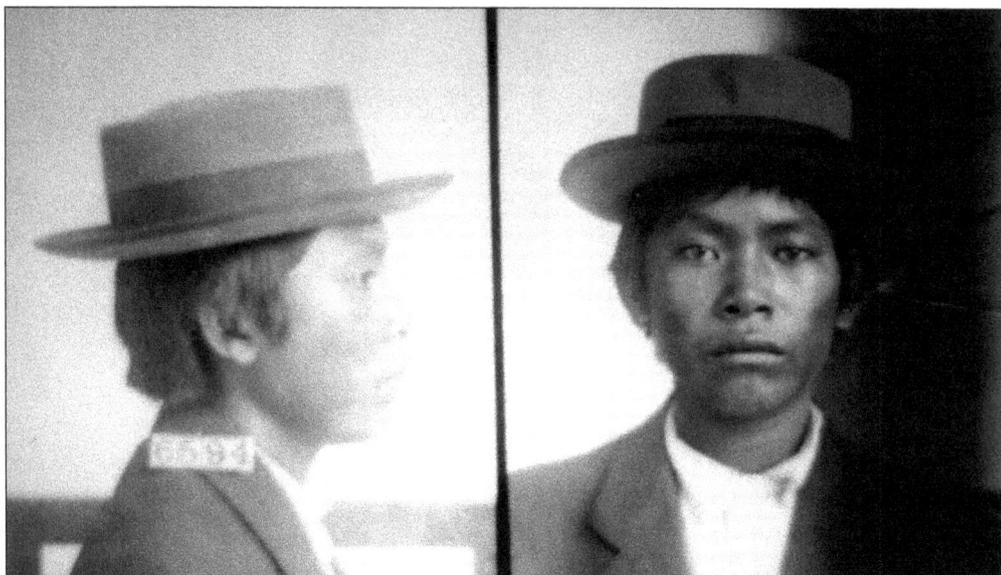

During his trial, Dan Tso-Tse, No. 6594, was called "nature boy" because of the tattered clothing he wore and his inability to communicate. Tso-Tse murdered three uncles who had abused him and a sister he believed was a witch. He became the youngest inmate ever to be received at 12 years old. (Courtesy National Archives and Records Administration.)

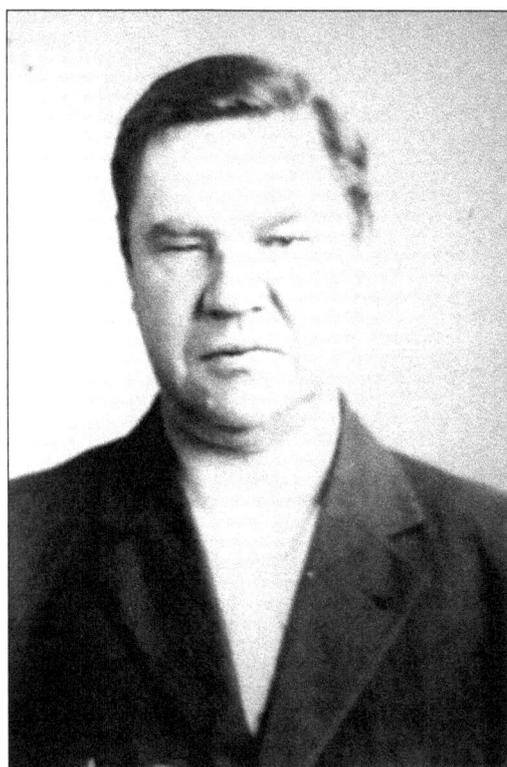

As a leader of the Industrial Workers of the World labor union, William "Big Bill" Haywood spoke out against America's involvement in World War I. Sentenced along with other Wobblies for seditious conspiracy and obstruction of military service in 1918, he received a 14-year sentence. While he was out on appeal, he escaped to Russia and died there in 1928. He was the first American citizen to be buried in the Kremlin. (Courtesy National Archives and Records Administration.)

Dr. Frederick Cook made headlines in April 1908 when he claimed to have discovered the north pole and later became the first man to climb Mount McKinley. After his conviction in 1923 for stock fraud, he made headlines as the editor of the prison newspaper. (Courtesy Library of Congress.)

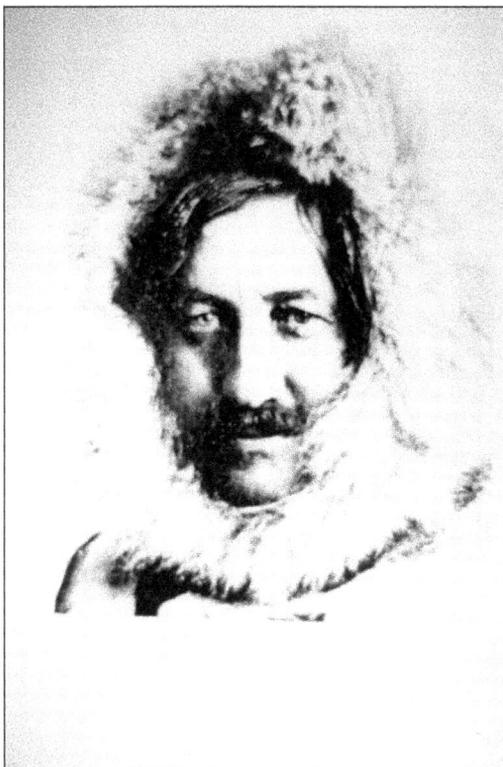

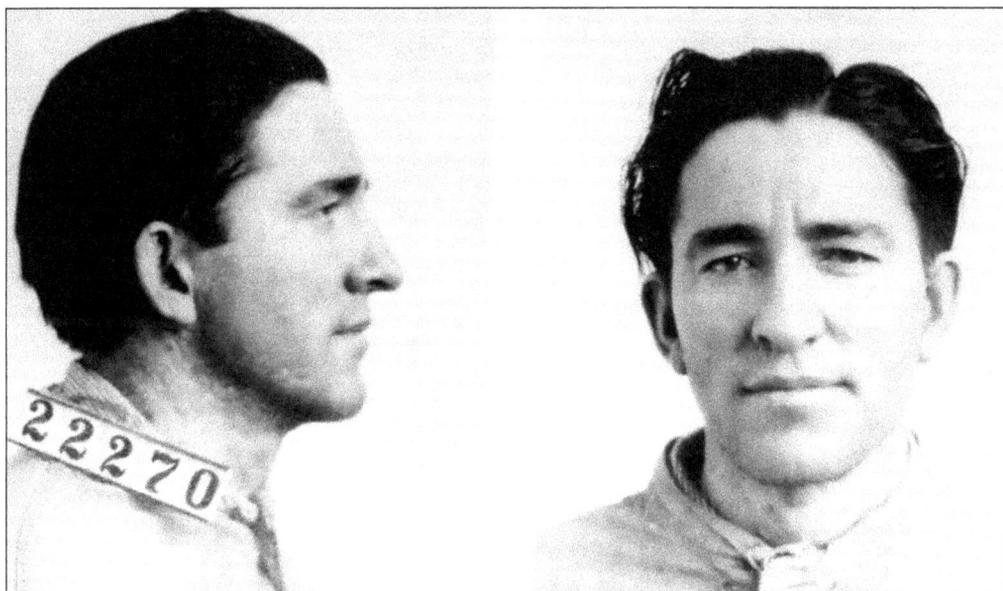

Joe Newton, along with his brothers, Willis, Jess, Doc, and friend Brentwood Glasscock, robbed trains, banks, and the Toronto Currency Clearing House. On June 12, 1924, they pulled off the most successful train robbery in U.S. history at Roundout, Illinois, netting more that $3 million. Joe and Willis later wrote a book titled *The Newton Boys: Portrait of an Outlaw Gang.* The book was made into a movie titled *The Newton Brothers.* (Courtesy National Archives and Records Administration.)

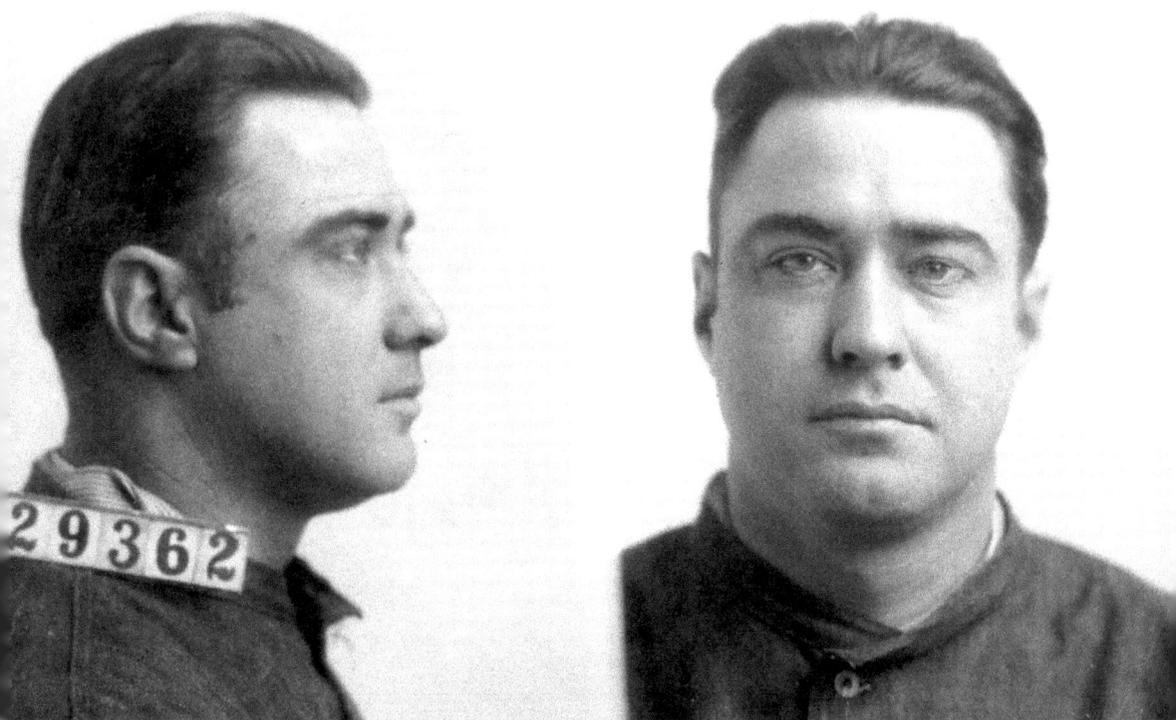

Born to an upper-middle class Memphis family, George Kelly Barnes attended college at Mississippi State, married, and had two children. Unable to make ends meet, he became a bootlegger and was first sent to Leavenworth in 1928 for smuggling liquor onto a Native American reservation. After an early release from prison for being a model inmate, he married Kathryn Thorne, who purchased him his first machine gun and began introducing him as George "Machine Gun" Kelly. On July 22, 1933, he kidnapped Oklahoma oil tycoon Charles F. Urschel. Urschel was released on July 31st after a $200,000 ransom was paid. After the couple's arrest in September 1933, the trial made history. It marked the first time movie cameras where allowed to record a federal trial and the Kellys were the first to be tried and convicted under the new Lindbergh Law. Kelly arrived at Alcatraz on September 4, 1934, and was transferred on May 29, 1951. Kelly was returned to Leavenworth on March 25, 1954, and died of a heart attack at age 59 on July 17, 1954. (Courtesy National Archives and Records Administration.)

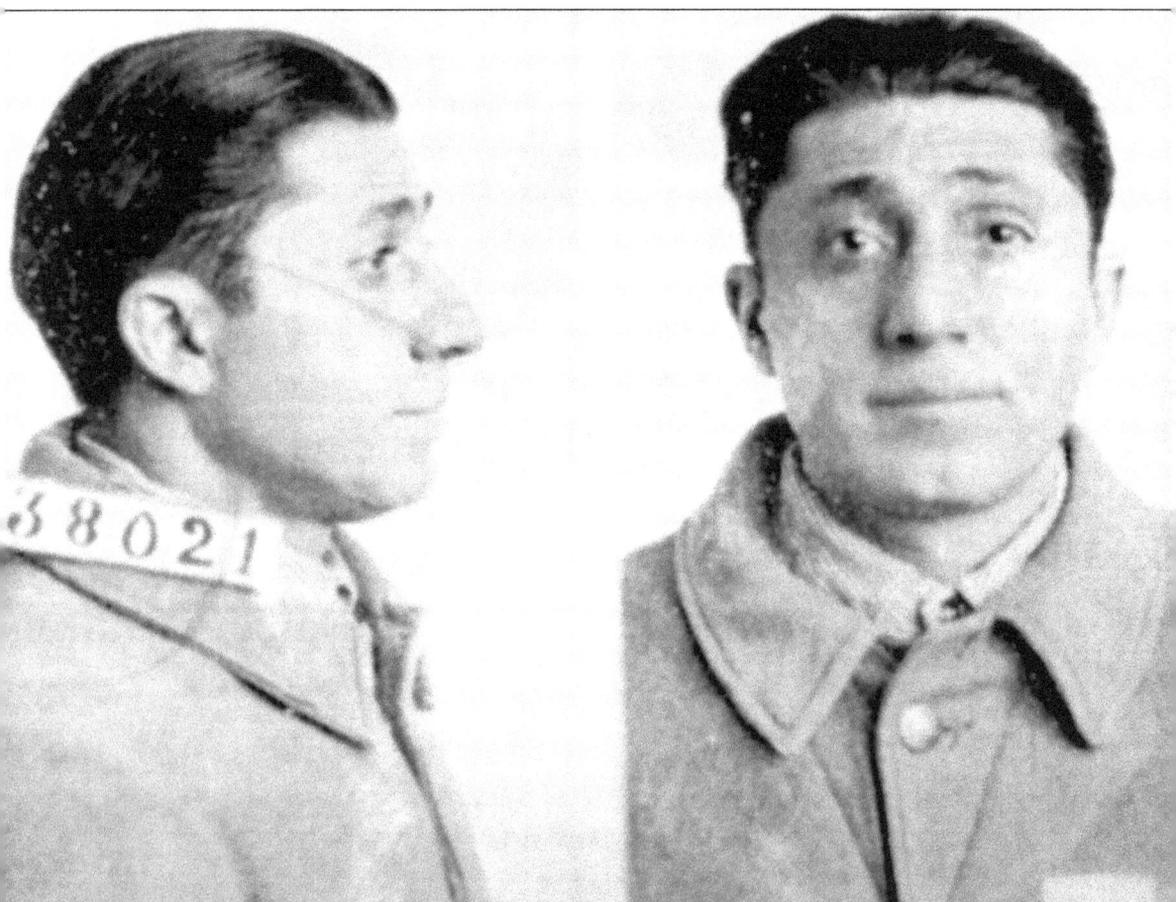

Frank "the Enforcer" Nitti received an 18-month sentence for income tax evasion in 1930. Nitti started his criminal career buying and selling stolen property through his barbershop. Rising through the ranks, he became the go-to man when Al Capone needed a job done. After Capone was sent to prison, Nitti was the front man for the Chicago outfit. In March 1943, Nitti was indicted on racketeering and extortion charges. Though movies and television depict Nitti as a ruthless killer, the only person he ever pulled the trigger on was himself. Facing more time at Leavenworth, Nitti committed suicide in a Chicago rail yard on March 19, 1943. (Author's collection.)

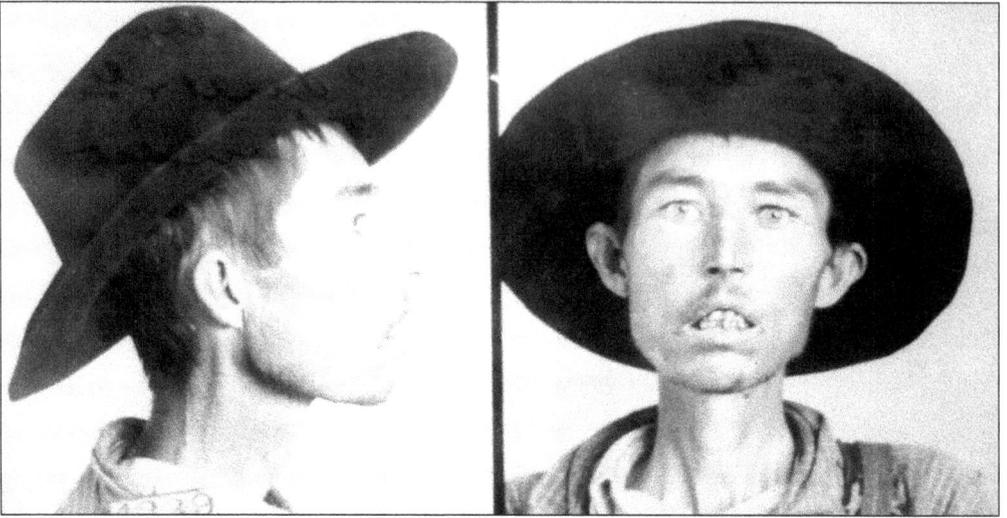

Early inmates received at the institution brought many problems with them. Dr. A. F. Yohe reported high numbers of inmates received with contagious diseases and drug addictions. The inmate above is an example of someone with a morphine addiction. (Courtesy National Archives and Records Administration.)

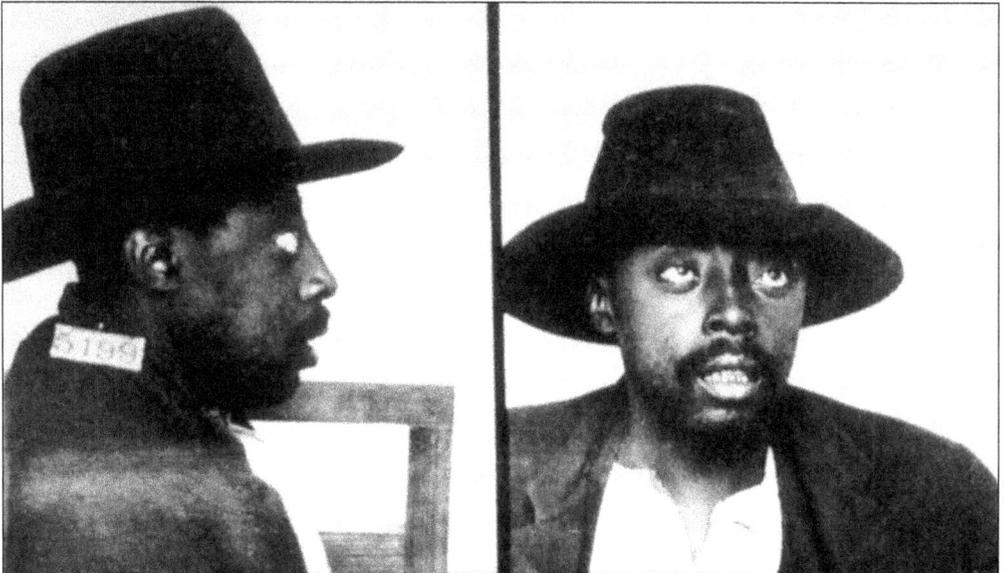

Inmate Leonard Moore was received at Leavenworth and was one of the first inmates admitted directly to the institution hospital. Received on April 27, 1906, for larceny, Moore was not only one of the first inmates treated in the hospital, but he also became the first inmate buried on Peckerwood Hill when he died eight days after his arrival on May 5. (Courtesy National Archives and Records Administration.)

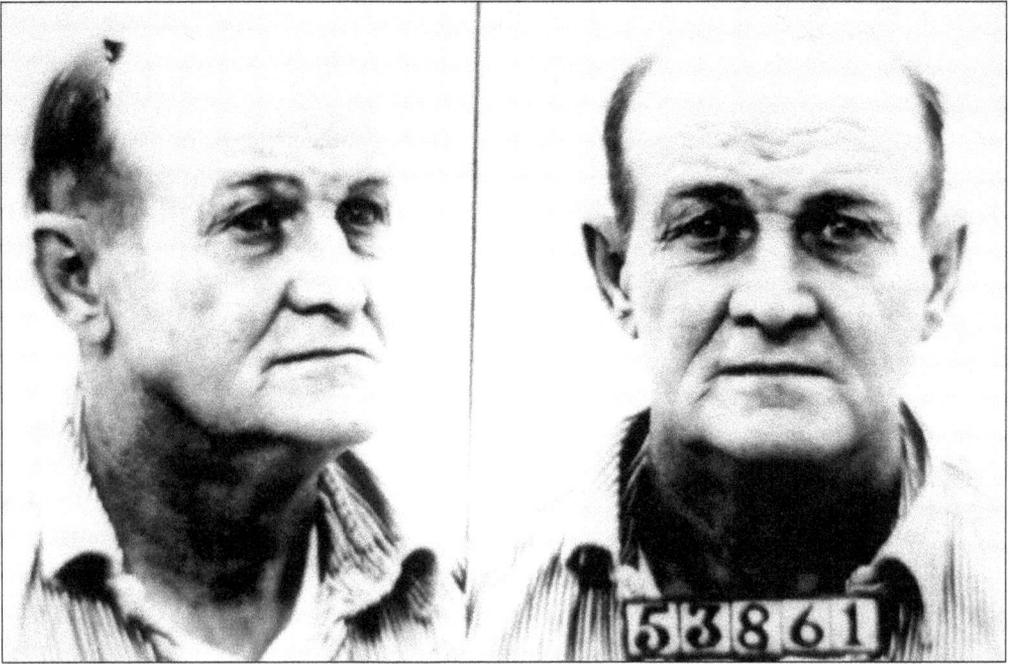

Samuel R. Caldwell, No. 53861, was received October 8, 1947, from Denver. Caldwell was sentenced to two to four years and was the first person convicted for violation of the marijuana tax act. (Courtesy National Archives and Records Administration.)

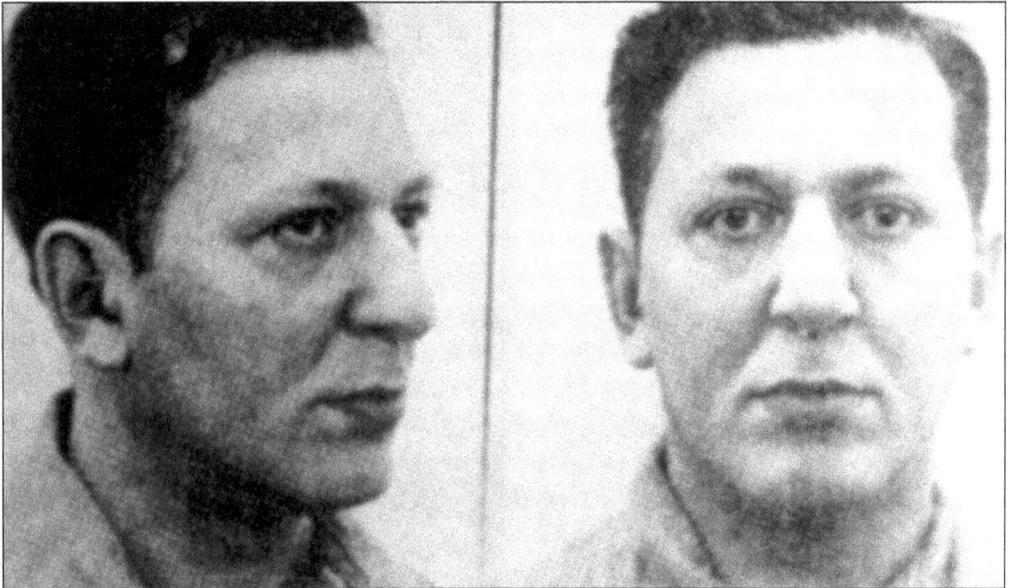

Louis "Lepke" Buchalter was a New York mobster, who, along with Benjamin "Bugsy" Siegel, Meyer Lansky, and Albert Anastasia, formed a group of hit men known as Murder Incorporated. His first conviction for narcotics trafficking netted 14 years, while a later conviction on union racketeering gave him another 30. In 1940, Buchalter was convicted in New York for a 1936 murder. In 1944, he was extradited back to New York where he was executed in Sing Sing Prison's electric chair. (Author's collection.)

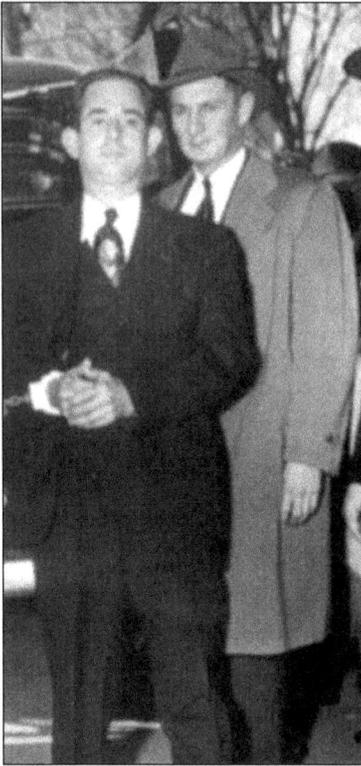

On November 1, 1950, Oscar Collazo (left) and Griselo Torresola attempted to assassinate Pres. Harry Truman at his temporary quarters at Blair Lee house. The gun battle resulted in the death of police officer Leslie Coffelt and Torresola. Collazo was convicted and sentenced to death, but his sentence was later commuted to life imprisonment by Truman. In 1979 after 29 years in Leavenworth, Collazo was pardoned by Pres. Jimmy Carter. (Courtesy Library of Congress.)

James Earl Ray was convicted of passing forged postal money orders in 1955. In 1968 while on escape status from the Missouri State Penitentiary, Ray was charged with the assassination of Dr. Martin Luther King Jr. (Courtesy National Archives and Records Administration.)

USP-LX 72498 7-8-55

44

Four

ESCAPE

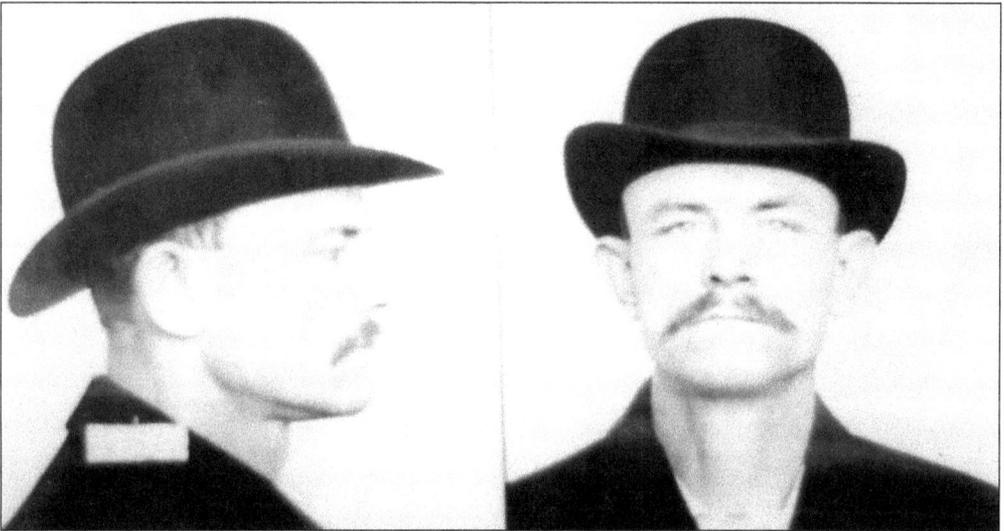

William Pearce, No. 69, was also known as James McCloud and Driftwood Jim. Pearce was an expert house and post office burglar as well as a gun shooter of national fame. Pearce was sent to Leavenworth for robbing a Wyoming post office and, on July 1, 1898, along with inmates John Adams, No. 88, William Worth, No. 3, and Ulysses Ritter, No. 19, he became the first inmate to escape. After arriving at the construction site, Pearce and others were able to take control of the weapons of guards Duffy and Earnest. Taking the guards hostage and using them as a shield, the inmates approached the guard box of guard King, forcing him to throw down his weapon and keys. Once the gate was opened, the four inmates made a break for it. Three were captured, but Pearce was arrested two years later for robbing another post office. (Courtesy National Archives and Records Administration.)

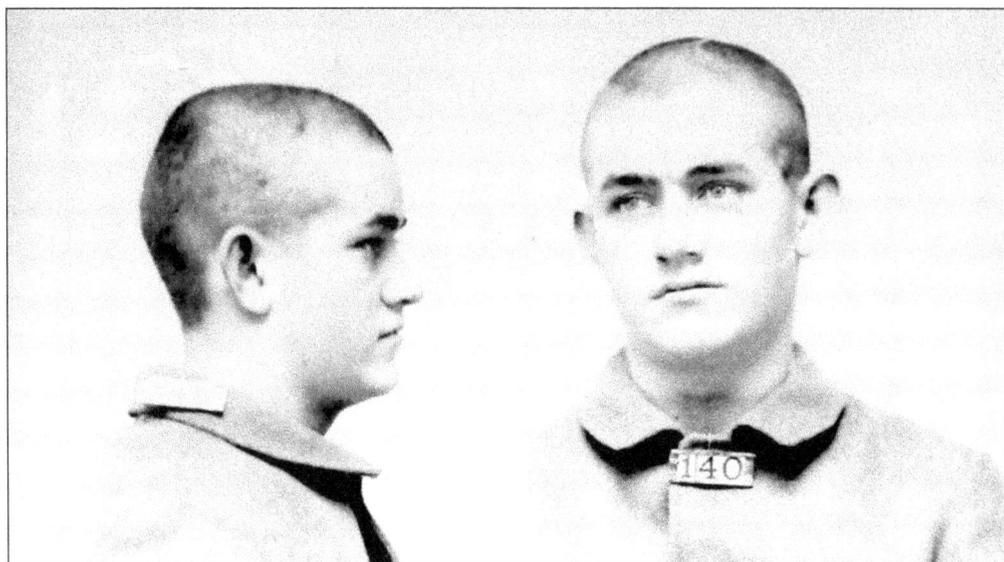

On November 7, 1901, a riot and mass escape of 26 prisoners occurred. Former inmates had hidden guns at the unguarded site the evening before. As work was being completed for the day, inmates took up the weapons. As the gun battle raged, inmate Quinn Fort, No. 140, was exiting with other inmates when he received a shotgun blast to the head, killing him instantly. (Courtesy National Archives and Records Administration.)

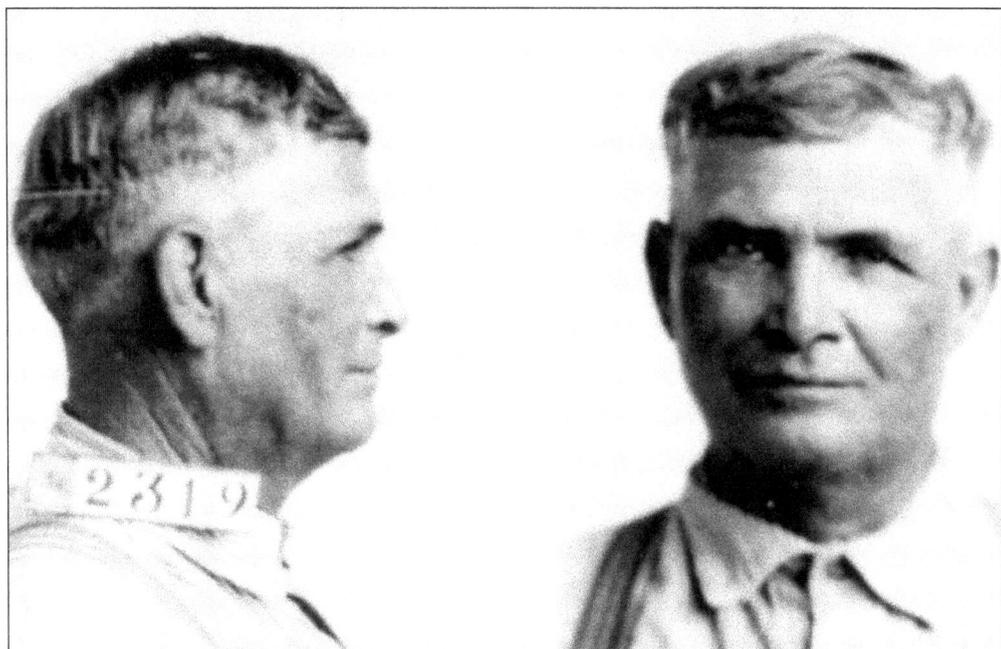

Of all the escaped prisoners from the 1901 riot, none made the news more than inmate Neal Jaco. Able to remain free until 1928, Neal became embattled in a bitter divorce in Fort Worth, Texas. While fighting over kitchen appliances, his wife stood and told the judge, "I don't know what he needs them for, he escaped from Leavenworth and he won't need them when he returns!" (Courtesy National Archives and Records Administration.)

While working one afternoon in 1910, an observant guard noticed a smoke stack in the mail room appeared out of place. Upon further inspection, 10 revolvers, bullets, several sticks of dynamite, blasting caps, and fuses were discovered. (Courtesy Alexander family.)

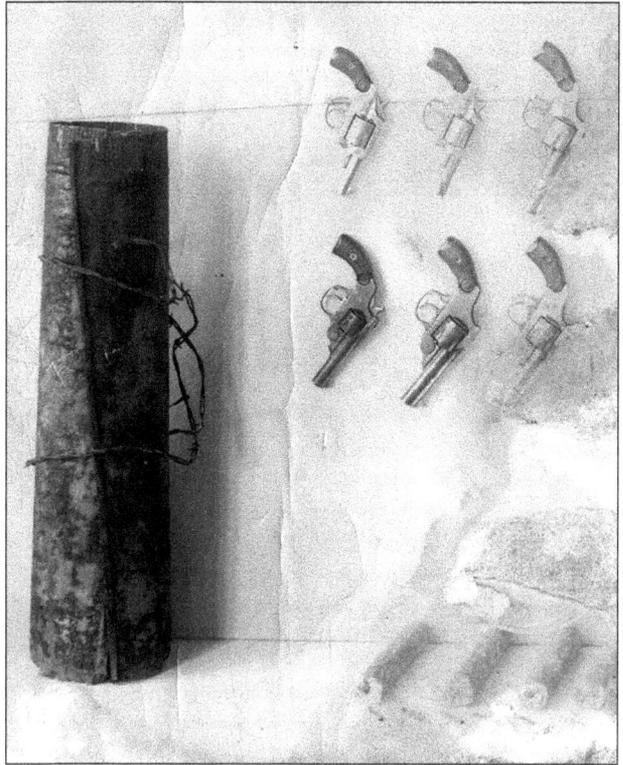

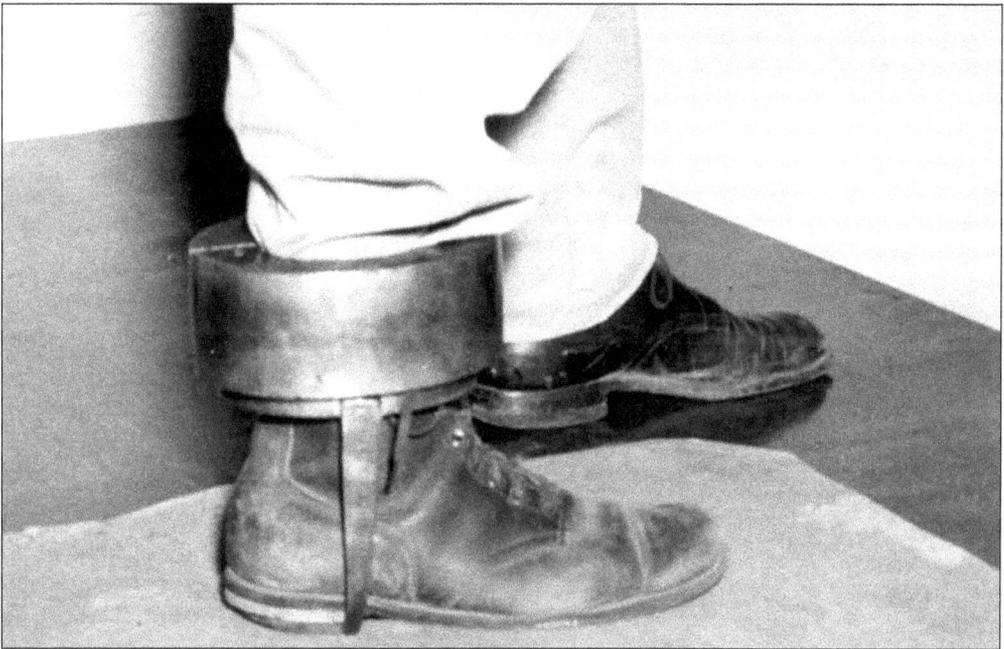

The Oregon Boot was a lead weighted appliance that was applied to an escapee once he was returned. Inmates continued with their daily routine of working around the institution while wearing the 15-pound device. Ball and chains were also used. Inmates dubbed it, "carrying the baby." (Courtesy Chuck Zarter.)

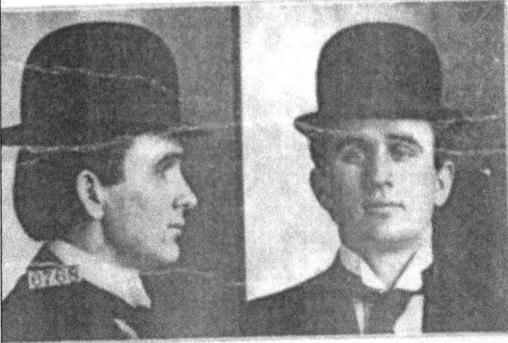

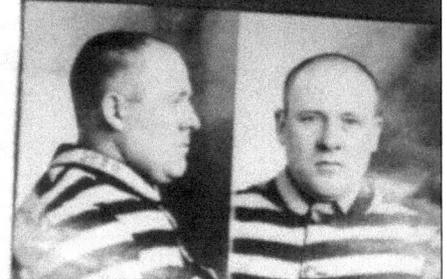

On April 21, 1910, a supply train entered the institution carrying a load of lumber. Inmates Theodore Murdock (No. 6624), Thomas Keating (No. 5903), Bob Clark (No. 4768), Arthur Hewitt (No. 5956), Thomas Gideon (not pictured), and Frank Grigware (No. 6768) forced their way onto the train and ordered the engineer to open the throttle and ram the gates. All but Grigware were captured a short time later. (Courtesy National Archives and Records Administration.)

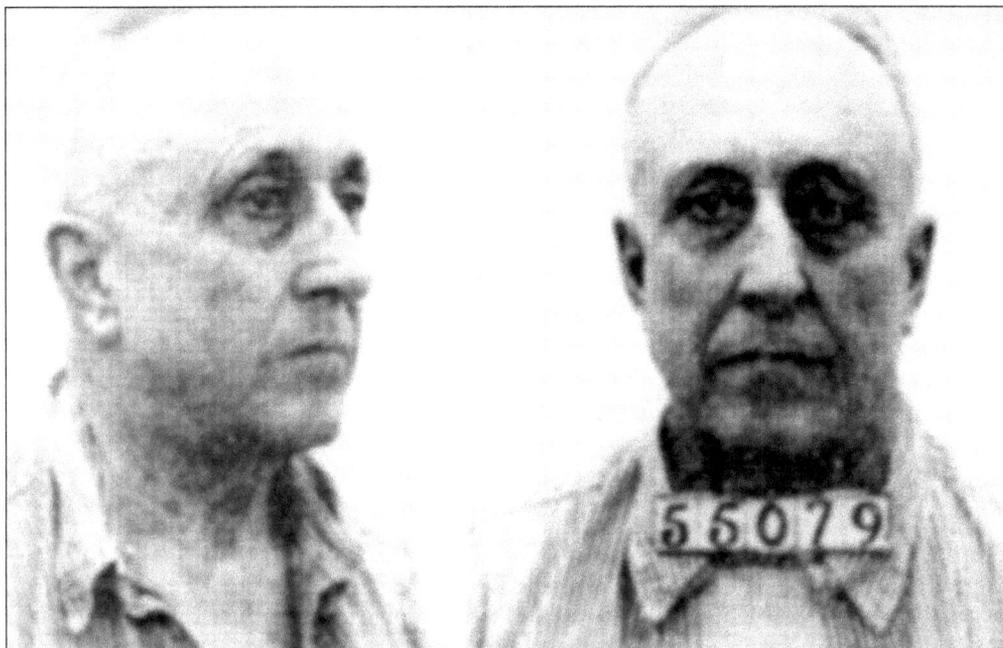

Frank Nash was sentenced in 1924 to 25 years for his part in the train robbery at Okesa, Oklahoma. Nash escaped on October 19, 1930. Along with coconspirators Frances Keating, Thomas Holden, Earl Thayer, George Curtis, and Grover C. Durrill, plans were laid for one of the most daring prison escapes ever. (Author's collection.)

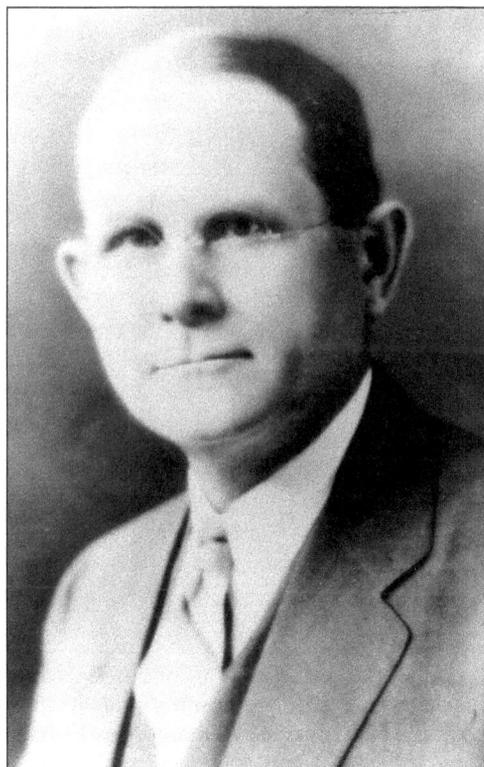

Thomas B. White began his career as a Texas Ranger and as an investigator for the Federal Bureau of Investigation (FBI). White investigated and testified against William Hale and John Ramsey in the Osage Indian murders in Oklahoma. He became Leavenworth's warden on March 27, 1927, in time to welcome Hale and Ramsey to their new home. (Author's collection.)

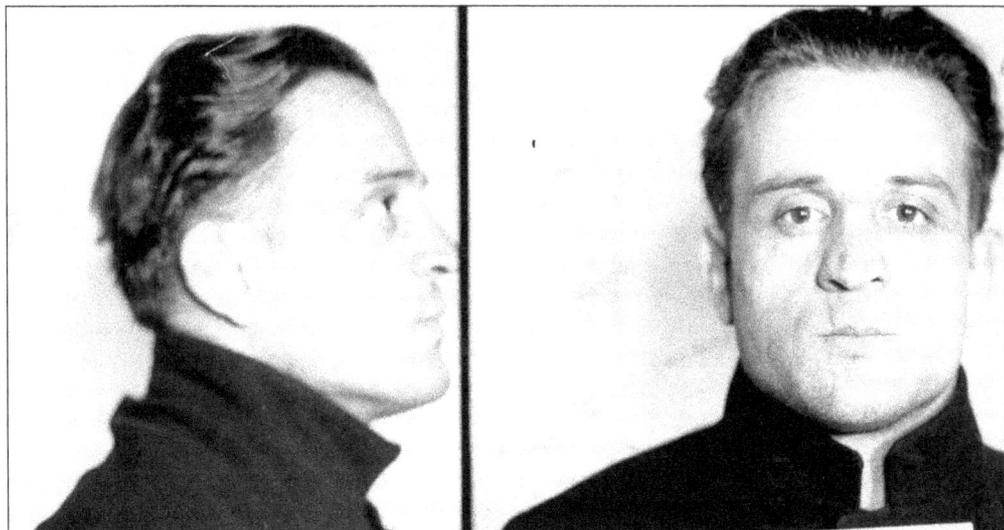

On the morning of December 11, 1931, Charles Berta (above), along with inmates William Green, Tom Underwood, Stanley Brown, Earl Thayer, George Curtis, and Grover C. Durril, made their way to warden Thomas B. White's office along with weapons smuggled into the institution. Taking everyone in the office hostage, they approached the front entrance of the institution and demanded the front doors be opened. Once out of the prison, the escapees led police, soldiers, and even citizen posses on an all-day manhunt throughout the county. By the time it was over, three inmates were dead and White was seriously wounded. (Author's collection.)

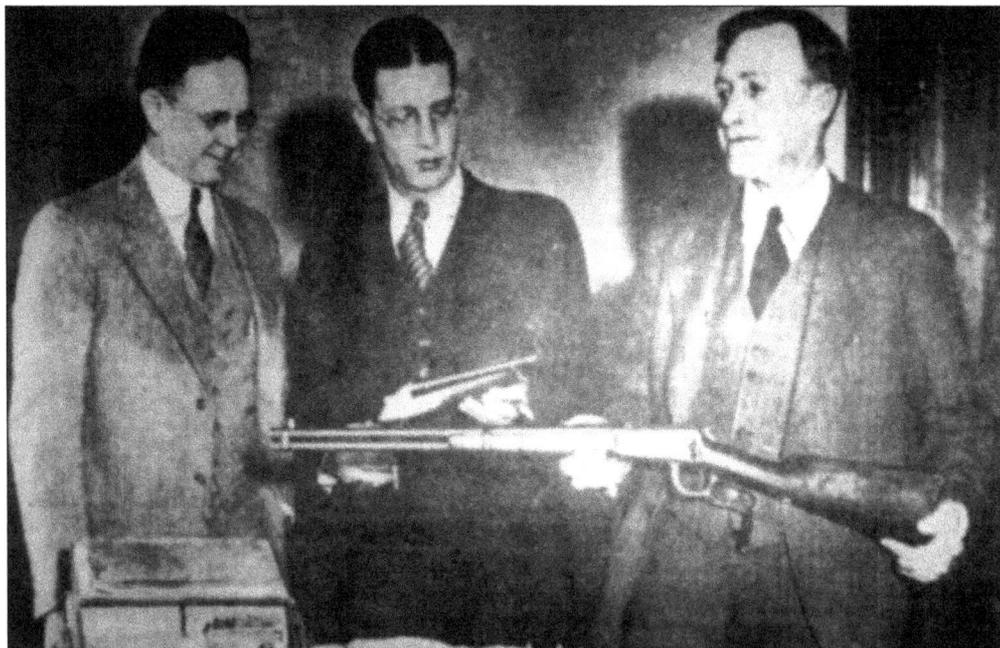

From left to right, federal agent Hugh Larimer, assistant U.S. district attorney Dan Cowie, and special agent J. B. Burger inspect weapons smuggled into the institution. The weapons, purchased by Frank Nash, included a shotgun, a .30-06 rifle, four revolvers, ammunition, dynamite, blasting caps, and fuses. (Author's collection.)

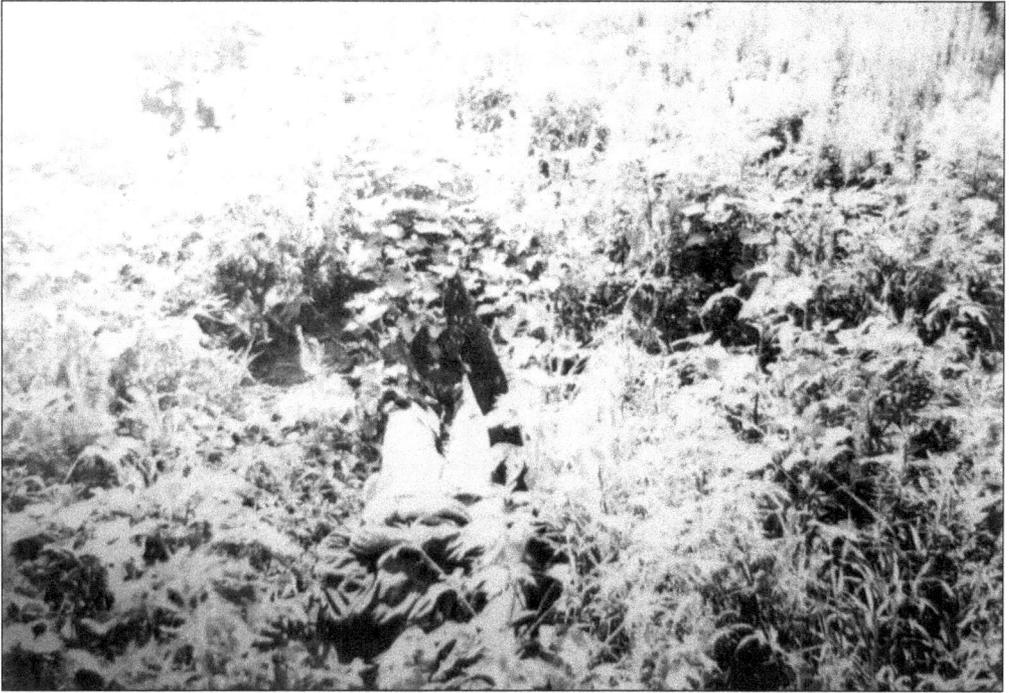

Berta lays wounded in the grass after being shot by soldiers dispatched from Fort Leavenworth. Berta was attempting to light dynamite and throw it at posse members during a brief gun battle. (Courtesy Rick Edgell.)

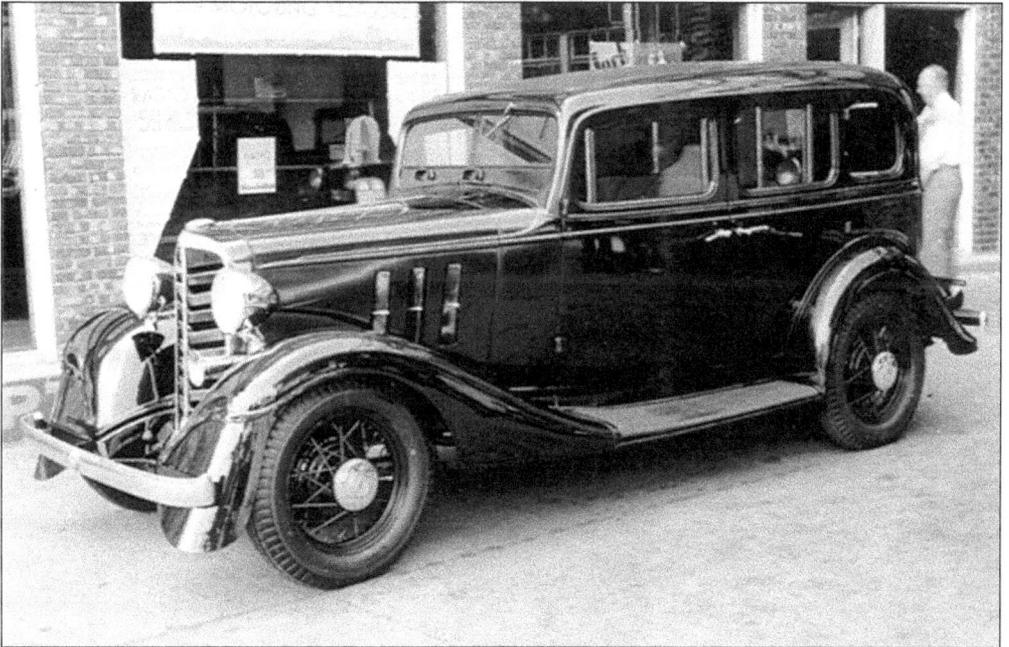

In the spring of 1932, the institution's bulletproof car was received at Collard Chevrolet. It featured expanded fenders, gun ports, heavy doors, and bulletproof glass. (Courtesy Jimmy Trum.)

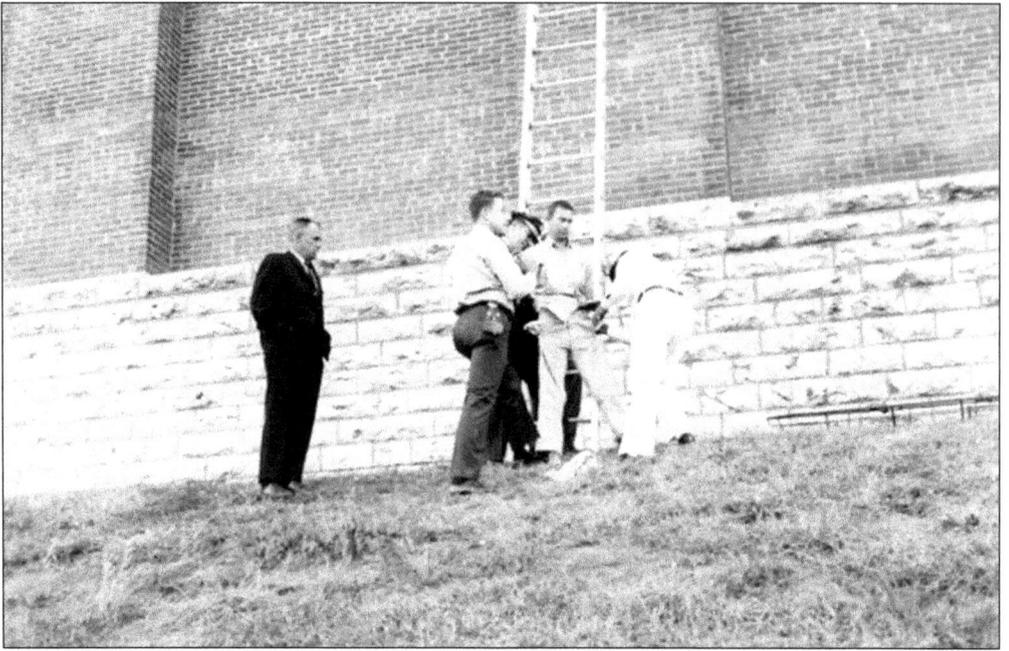

On November 12, 1963, inmates attempted a daring daylight escape. After assaulting staff in B cell house, inmates gained access to a ladder and attempted to scale the wall. As the first inmate dropped over the wall, an alert tower officer shot the inmate in both legs. His accomplice held on to him as guards came to their rescue. (Courtesy Steven Fox.)

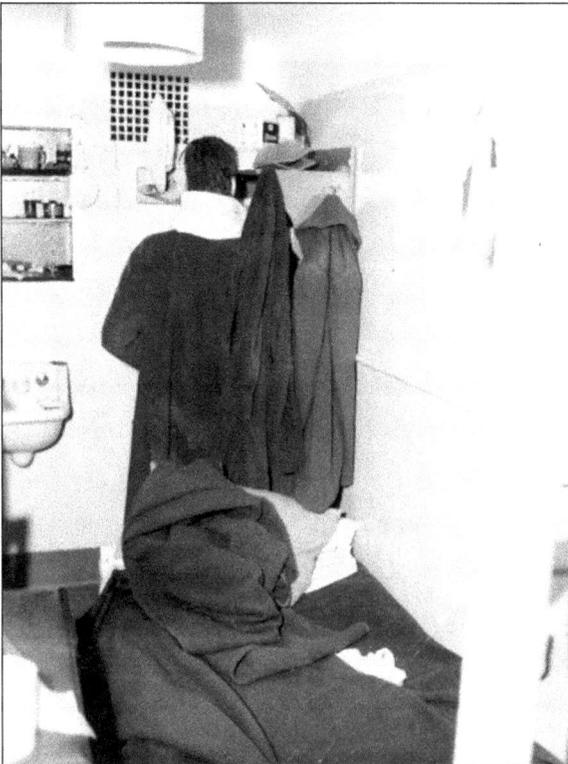

What is wrong with this picture? Is this an inmate standing at the back of a cell? Actually it is an artist easel with a house coat draped over it, with an inmate-made mannequin head. (Author's collection.)

Five

CELL HOUSES

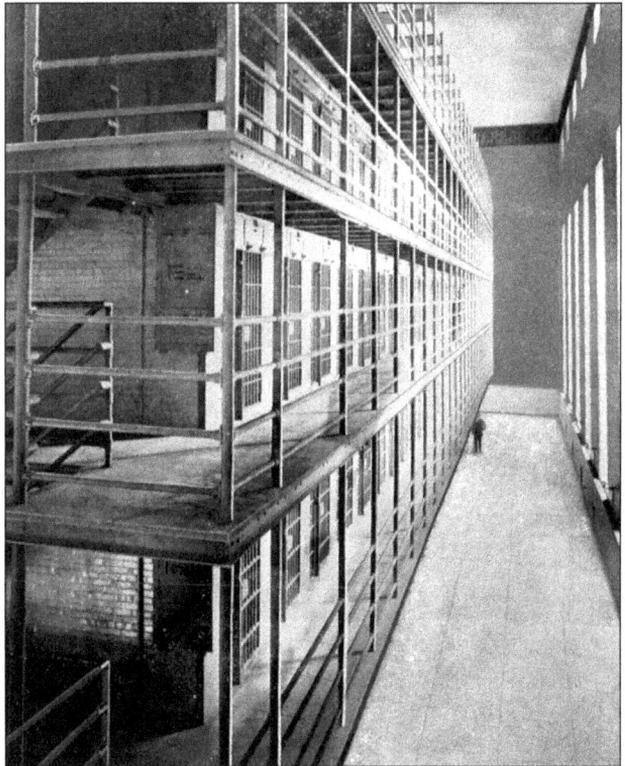

With four galleries complete and construction of the fifth floor underway, C cell house was open for inmates in 1903. After being transferred from the old military prison on Fort Leavenworth, 413 inmates were housed in this cell house and the second floor of what became the laundry building. (Courtesy Jim Will.)

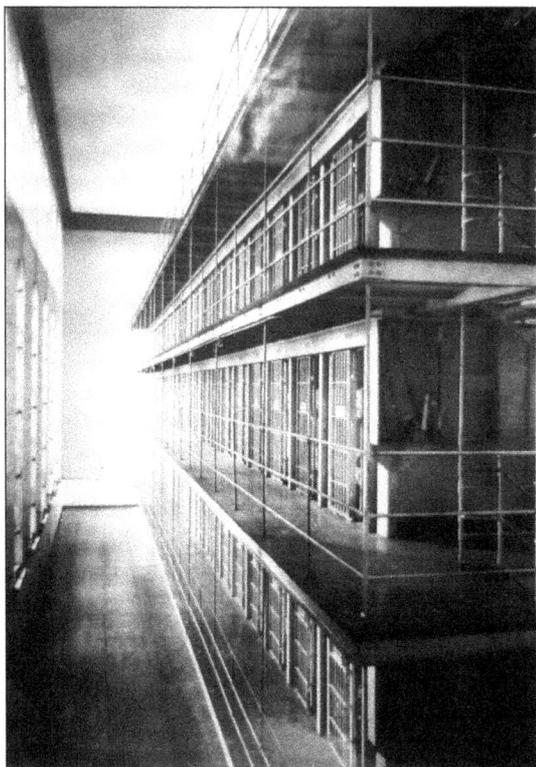

By 1910, the second cell house was complete. This interior view was used by the Stewart Iron Works company as an example of their work. Once complete, each cell house contained cell space for 330 inmates. Leavenworth was the first institution west of the Mississippi River to have running water, toilet facilities, and electric lighting in each cell. Each cell house has open-face cells and a utility corridor between each row of cells. A flow-through ventilation system helps cool the cells in the summer. Inmates are issued gasoline heaters during the winter months. (Courtesy Jim Will.)

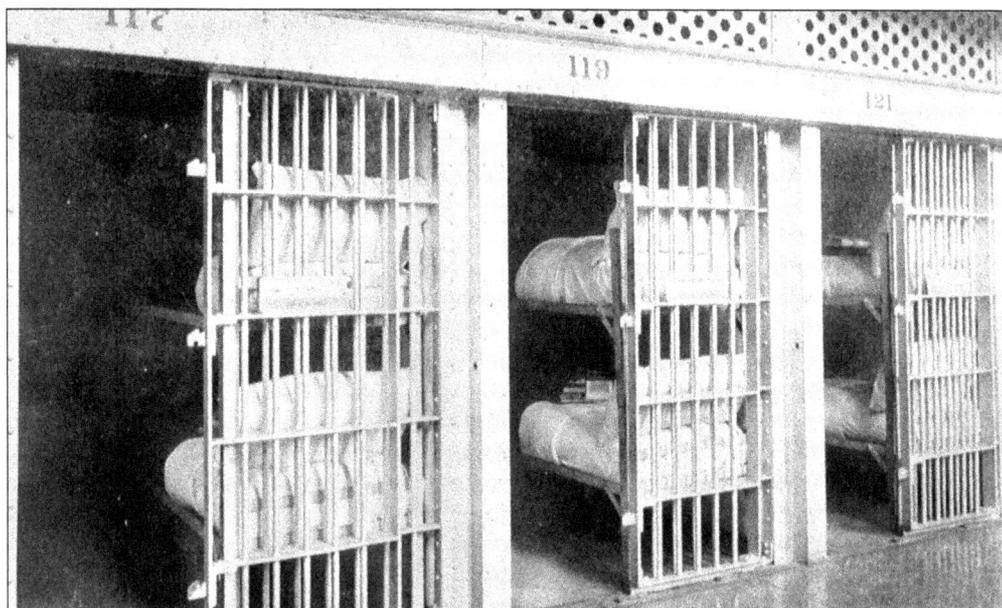

Two-man cells became common as the population grew. By the time prohibition came along, an institution designed for 1,500 had a population of 3,500. In order to keep the spread of infectious diseases under control, guards working the cell houses in the winter were instructed to open all the windows every two hours and leave them open for 30 minutes. During the summer months, inmate orderlies walked the galleries passing out water and ice. (Courtesy Benedictine College.)

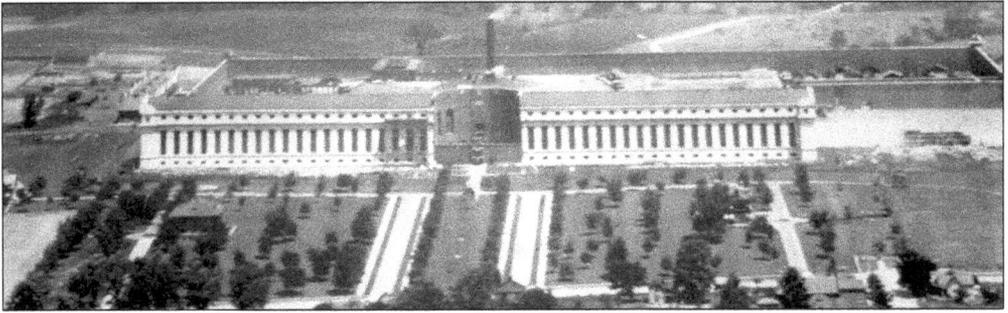

Here are the two main cell houses under construction. Each became two-and-a-half city blocks long and five galleries high. A cell house contained eight- to 12-man cells, while B cell house contained two-man cells. Both cell houses have a front stairwell that is for guard use only; a center stairwell is for inmate use. (Author's collection.)

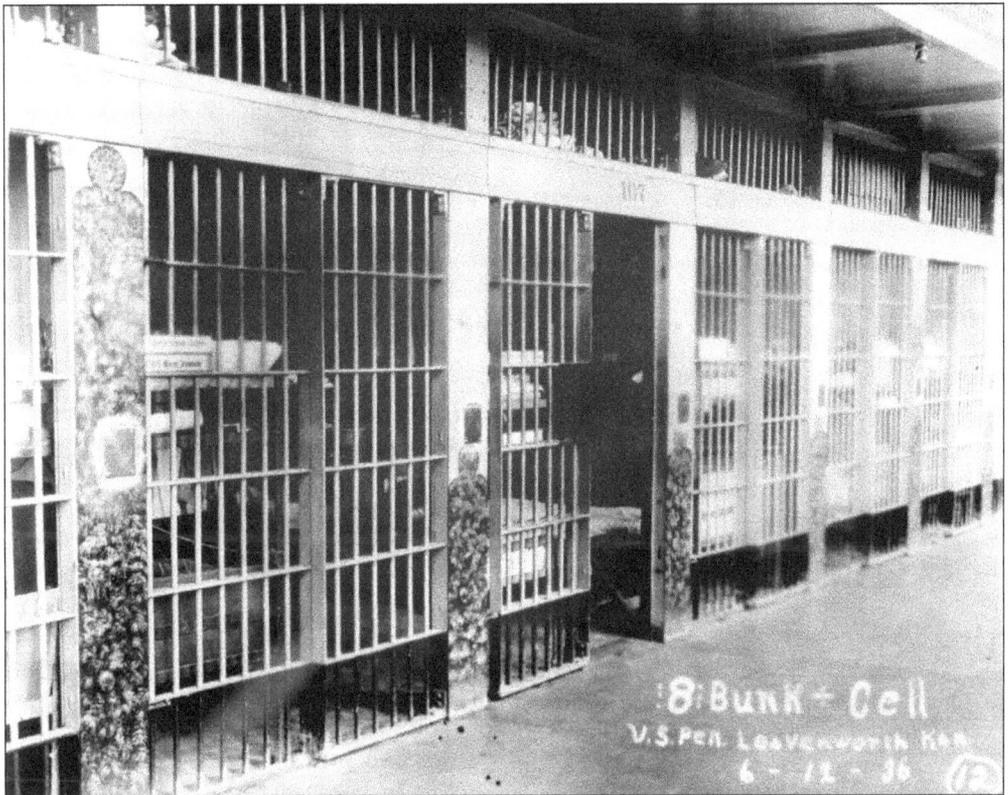

This exterior view shows the eight-man cells of A cell house. Construction began in 1908 and was near completion in 1919 when a fire was set to wooden scaffolding. Inmate and Leavenworth city fire fighters fought the blaze that was believed to have been set by members of the Industrial Workers of the World. Two days prior, a letter was intercepted in the mail that was written by one of their members claiming the fire was to be set on the Fourth of July. Construction on the cell house was completed and the unit opened in 1924. (Author's collection.)

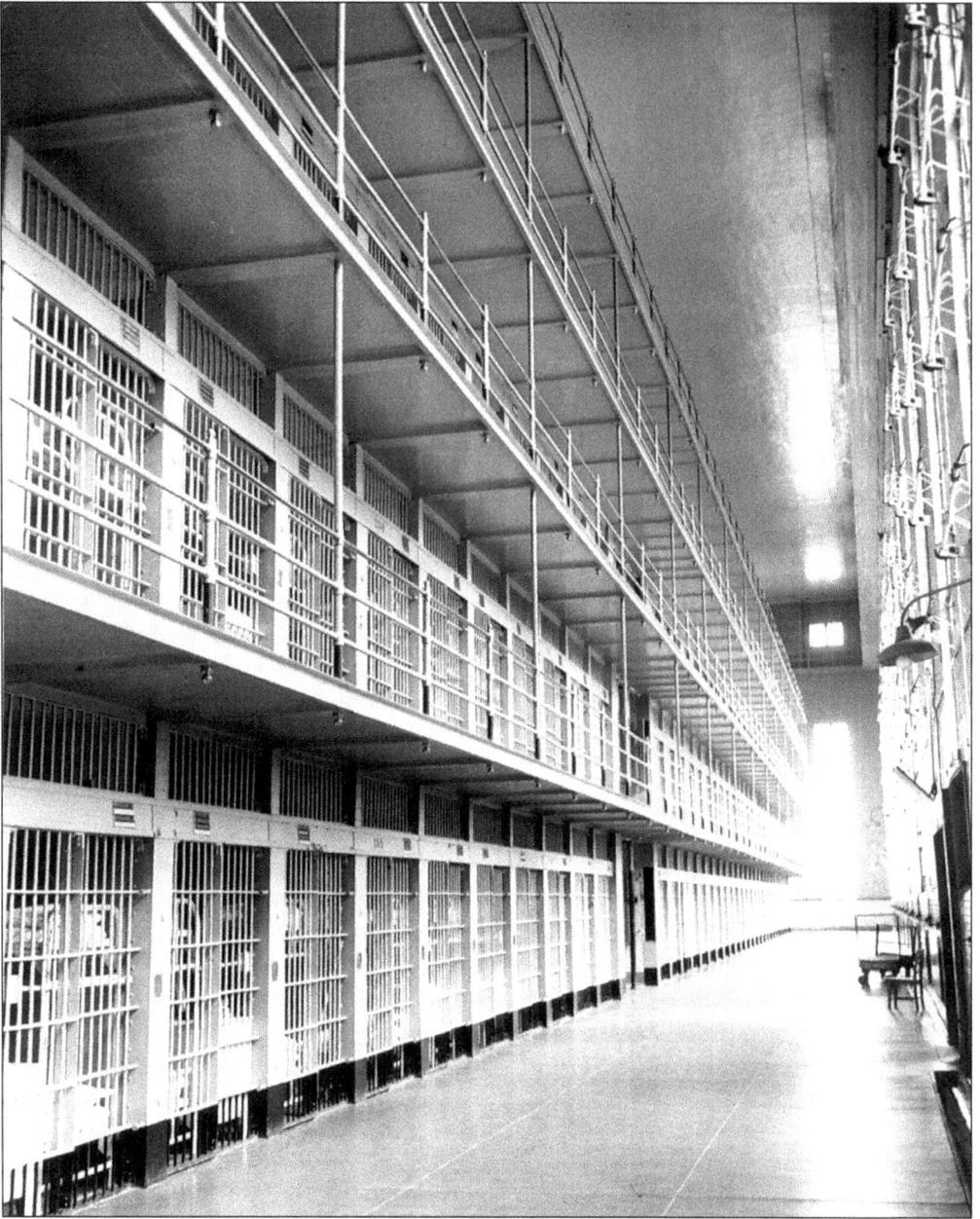

A cell house, looking from front to back, is seen in this photograph. The first floor was known as the flag, and the second through fifth floors were known as galleries. The front side facing the street became know as the light side and the back facing the inside of the institution became know as the dark side. Housing anywhere from 800 to 1,200 inmates, this cell house has six guards assigned to patrol, a number one guard, and one guard for each gallery. Inmates start their day at 6:30 a.m. During the 4:00 p.m. count, all inmates are to be standing and facing the front of the cell. Once count is complete, each gallery is released one at a time as they are called for the evening meal. The cell house remains open until 9:00 p.m. After the 10:00 p.m. count, guards rotate galleries and pull each and every door in the cell house insuring it is secure. (Courtesy Chuck Zarter.)

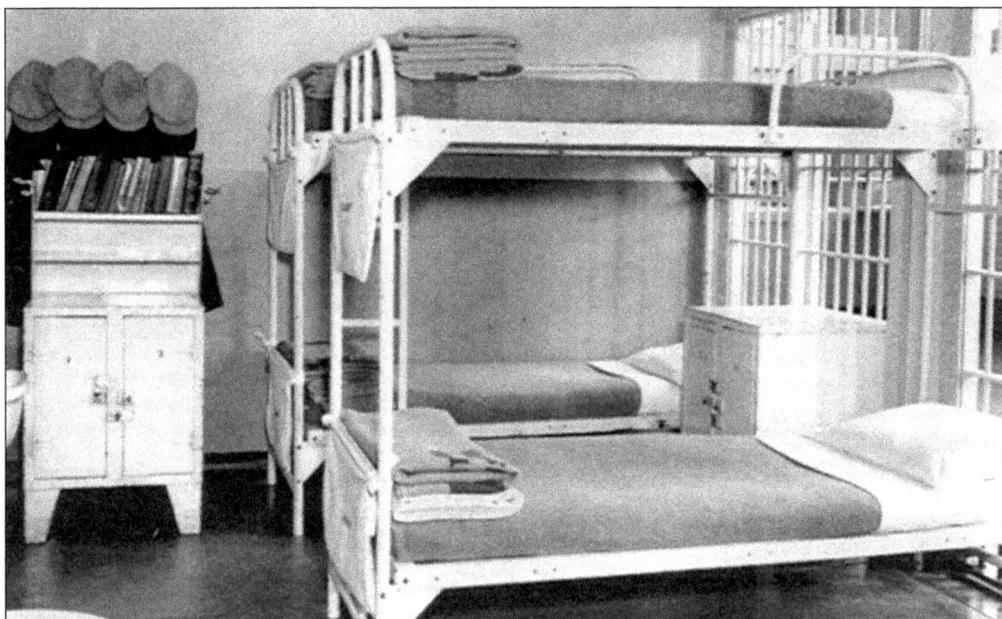

An interior view of A cell house shows the eight- to 12-man cells. Inmates are issued two sheets, two blankets, one pillow, a locker for personnel belongings, a laundry bag, and a book shelf. Each cell contains two writing desks that are attached to the walls. Inmates are responsible for the sanitation of their assigned cells. Each cell contains a head phone plug-in so the inmates may listen to the institution radio station. (Author's collection.)

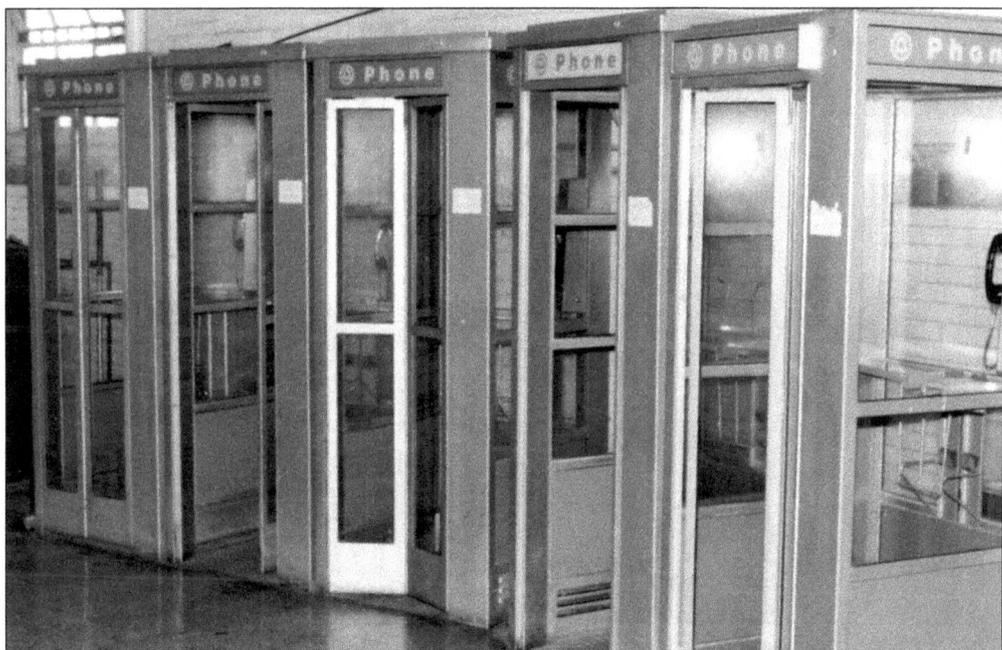

To strengthen family ties, telephone booths were installed by the 1970s. Each inmate is allowed to make collect calls and given a 15-minute time limit. By the 1990s, inmates were responsible for paying for their own phone calls by placing money they have earned or received from their family in a phone account. (Author's collection.)

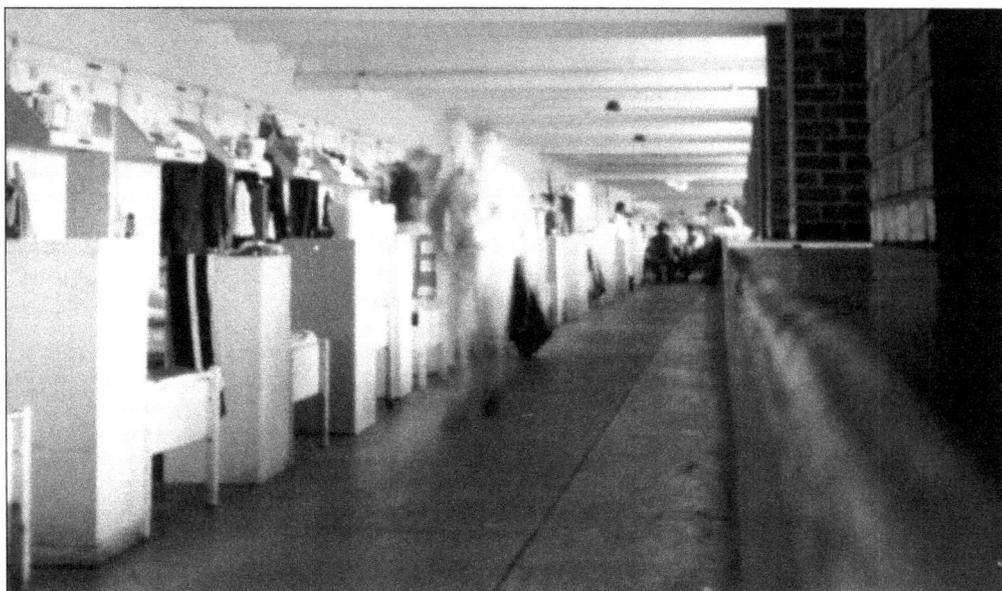

A dormitory was located in the basement of A cell house and provided inmates with a more relaxed atmosphere. Charles S. Wharton wrote about dormitory life in his book, *The House of Whispering Hate*. Inmates were allowed to stay up later and every inmate's duty was to smuggle something in to eat during the evening hours. Early inmates living in this dormitory were prison trusties that worked outside the walls. It has also served as the parolee dormitory. (Courtesy Leavenworth Public Library.)

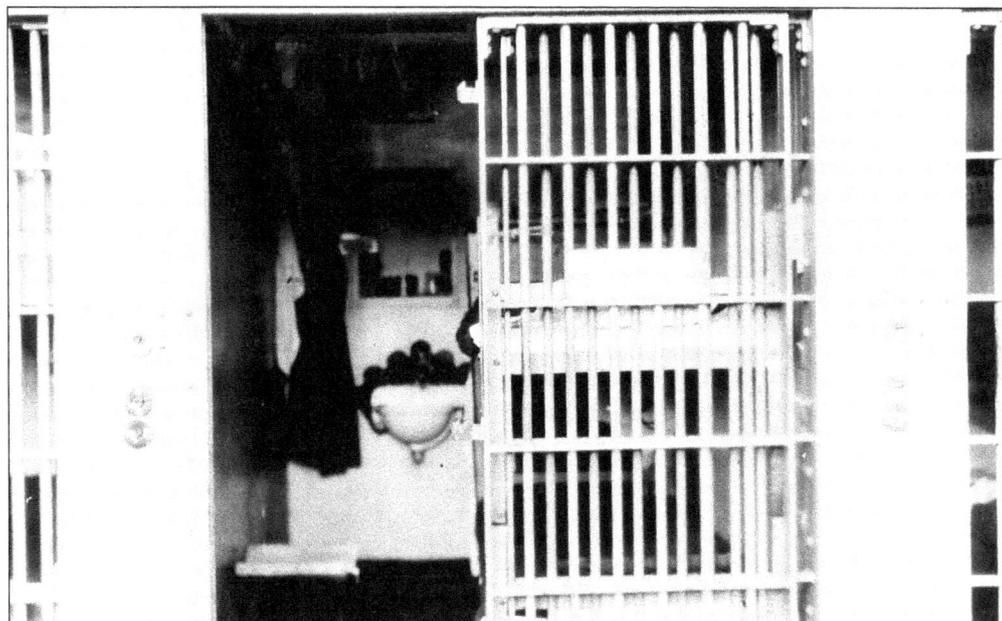

This is a typical view of the two-man cells in B cell house. These cells measure five feet wide by six feet deep with seven-foot ceilings. Housing mostly new arrivals, this is an inmate's first taste of life in Leavenworth. Early inmates showered once a week, shaved twice a week, and had their hair cut twice a month. Most wear the third grade black and white stripped uniform and perform menial labor. (Author's collection.)

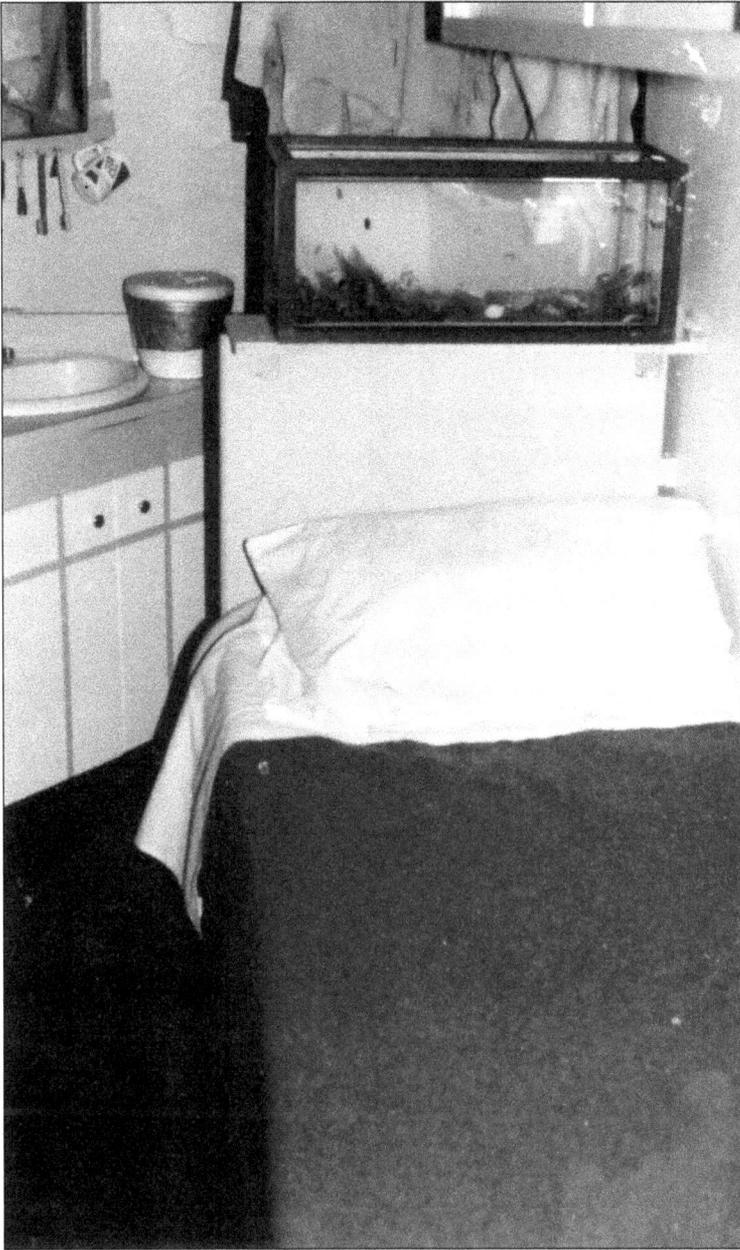

As the social climate on the outside changes so does the climate of most prisons. In the early days, D cell house, which opened in 1910, housed mostly inmates of color. By the 1980s, it housed older, quieter inmates. A typical one-man cell contains a corner cabinet with a sink, a toilet, a bed, a mirror, an overhead cabinet, and a writing table. These cells are smaller than most, measuring under five feet wide and less than six feet deep. Note the fish tank located above the head of the bed. After riots at Atlanta and Oakdale, Louisiana, in 1988, the cells were stripped of all these amenities and one-piece stainless steel sinks and toilets were added along with bunk beds attached to the walls. This became home to the Cubans who had participated in those riots. Since the close of the 1990s, this unit has been used as an honor wing and is currently the only cell house that remains unrenovated. (Author's collection.)

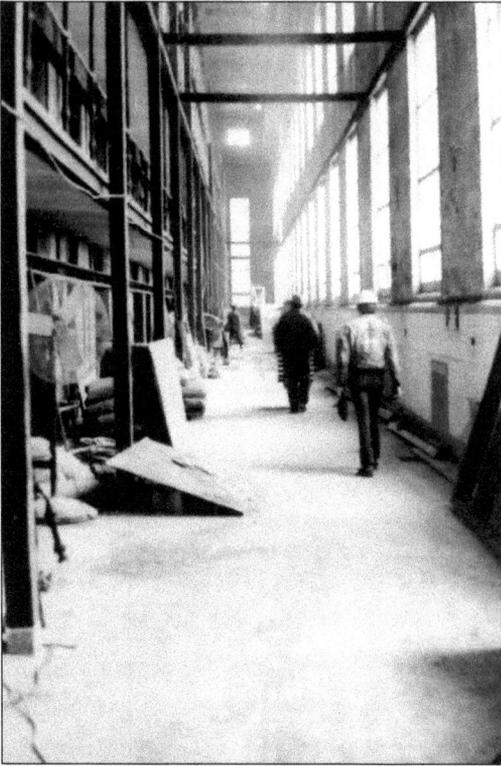

By late 1983, a massive renovation project was underway in B cell house. Cells were made larger, plumbing was updated, showers were renovated, and air conditioning was added. The cell house was converted from one unit to two separate units by a new concrete floor. This made the units smaller, quieter, and easier to manage. (Courtesy National Archives and Records Administration.)

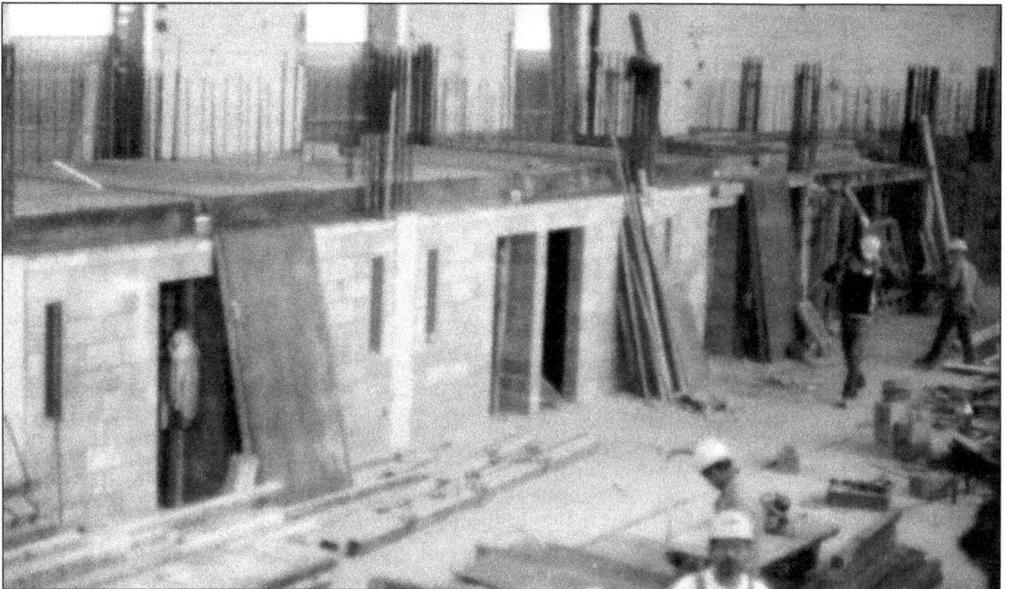

By 1986, A cell house was closed and renovation had started. During the next two years, bulldozers and dump trucks were placed inside the cell house as the unit was totally gutted to the original foundation and outer shell. As construction neared completion, the riots in Atlanta and Oakdale, Louisiana, broke out. Leavenworth staff worked alongside construction workers 24 hours a day hanging doors, painting, and doing what ever it took to get the cell house up and operational. (Author's collection.)

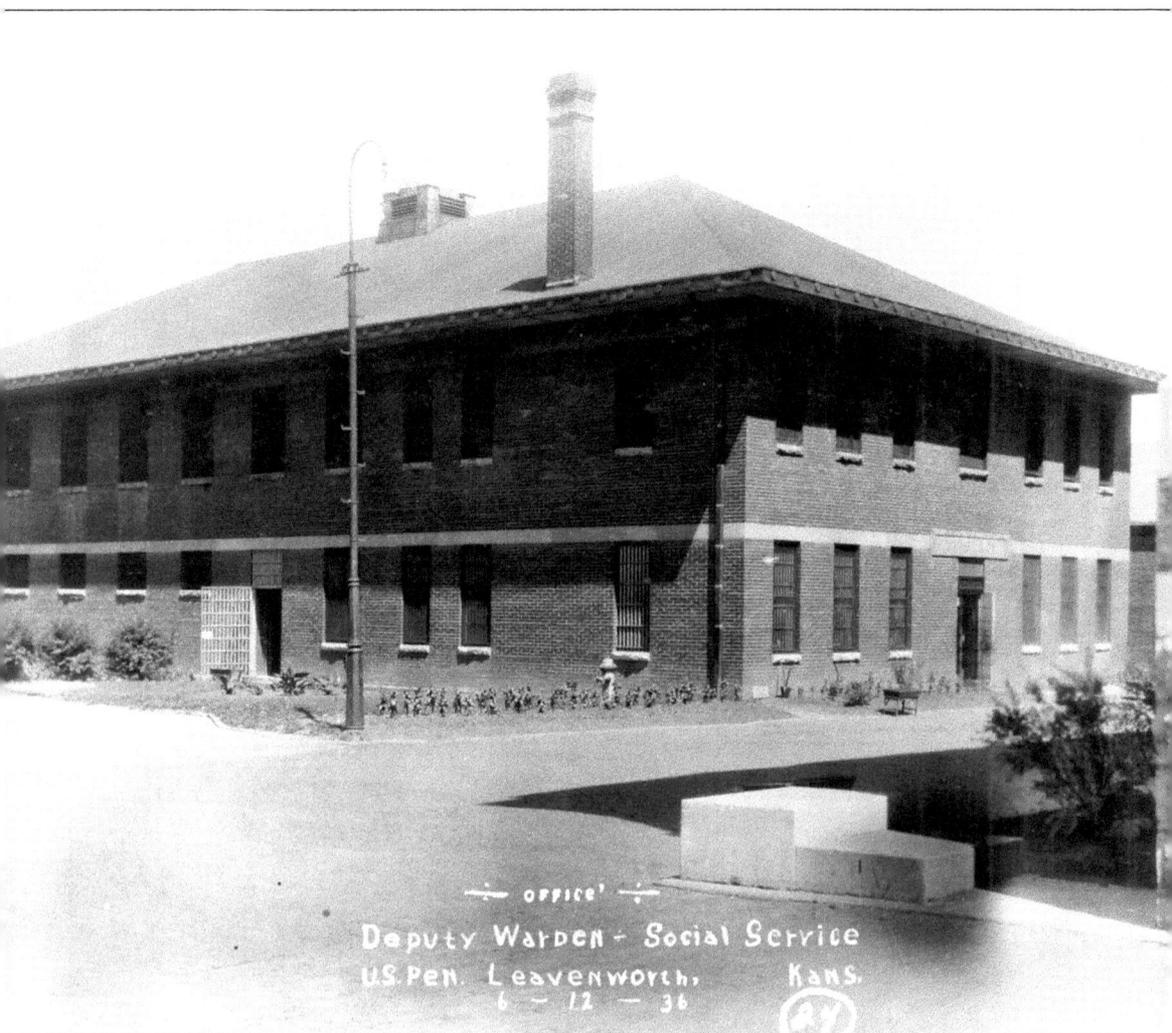

One of the oldest buildings on the compound is building 63. Originally opened in 1898 as the deputy warden's office, it has served as the segregation unit. It is in this building that inmate Robert Stroud had his aviary and conducted his experiments on birds. Behind this building on September 5, 1930, inmate Carl Panzram was executed for the murder of laundry foreman R. G. Warnke. On August 12, 1938, the last execution to occur at Leavenworth was again behind this building. Robert Suhay and Glen J. Applegate were hanged simultaneously for the murder of FBI agent Wimberly W. Baker on March 16, 1937, during the Topeka Post Office shootout. (Author's collection.)

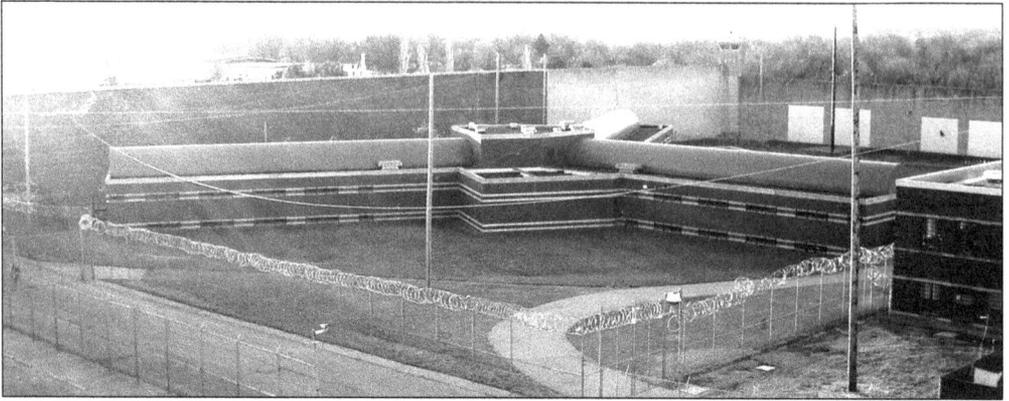

The newest building on the compound is the special housing unit. Using staff ideas, construction began in August 1987 and the unit was opened in March 1989. Cells were constructed entirely off site and trucked into the facility. All wiring, fixtures, beds, and windows were installed prior to the cell's arrival. The building includes an inmate law library, staff offices, property room, indoor and outdoor recreation yard, and a no-contact visiting room. (Author's collection.)

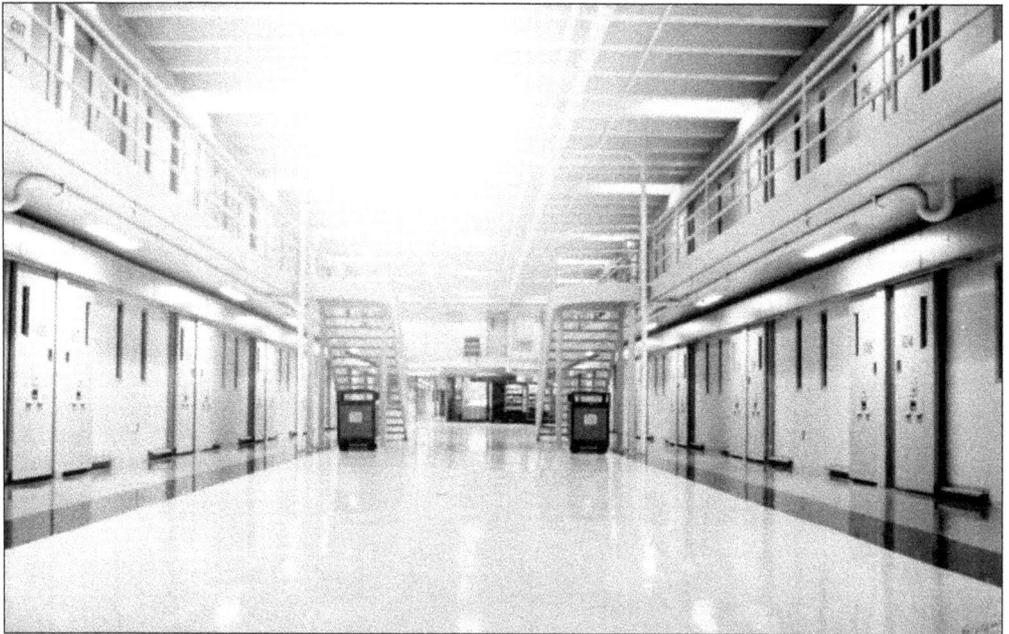

Today very little but photographs remain of the old Leavenworth. With the renovation of living areas, the institution is more manageable, as well as safer for inmates and staff alike. Newer cell houses are more quiet and feature climate-controlled heating and air. There are cells provided for inmates with disabilities. Prior to the installation of air conditioning, inmate and staff assaults were a constant problem. Since then, there has been a dramatic decrease in the amount of such assaults. (Author's collection.)

Six

INMATE HANDS ARE NOT IDLE HANDS

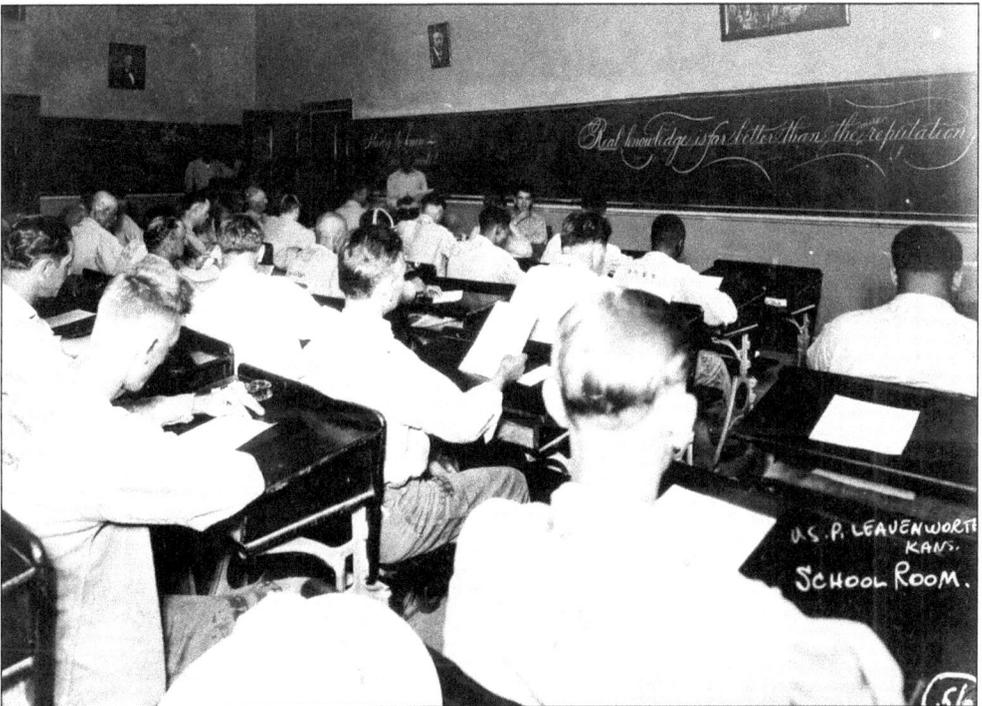

From the beginning, services and programs were designed to aid in an inmate's rehabilitation process and keep them busy. The message on the chalkboard reads, "Real knowledge is far better than the mere reputation." Education, religious, medical, recreational, and drug awareness programs are designed not only to help an inmate, but also make him more self aware and responsible when he returns to society. (Author's collection.)

Inmate Albert Leon, No. 1809, was a Russian immigrant received on December 21, 1911, on a 10-year sentence for counterfeiting. During his incarceration, Leon was responsible for the most famous piece of art work ever done at the institution. In an open letter addressed to warden Thomas W. Morgan in August 1913, Leon wrote, "I am making an appeal not alone for myself but chiefly for the mental and spiritual uplift of my fellow prisoners." (Courtesy National Archives and Records Administration.)

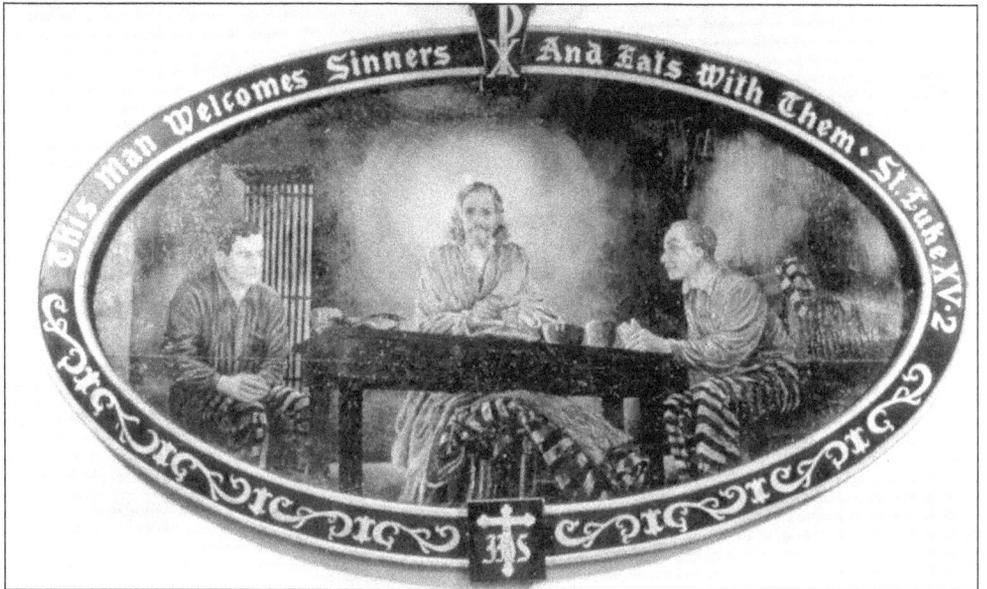

Taken from St. Luke 15:2, Leon titled his work, *This Man Welcomes Sinners and Eats With Them*. Made using old bed sheets and leftover construction materials, Leon credits deputy warden William Mackey, Capt. John Purcell, and assistant superintendent of construction Mr. Carroll, for their help and encouragement during the project. Featured in magazines throughout the 1920s and 1930s, this painting survived a fire in the chapel in 1925, but it was destroyed by rioting inmates on July 5, 1992. (Courtesy Ken Meyer.)

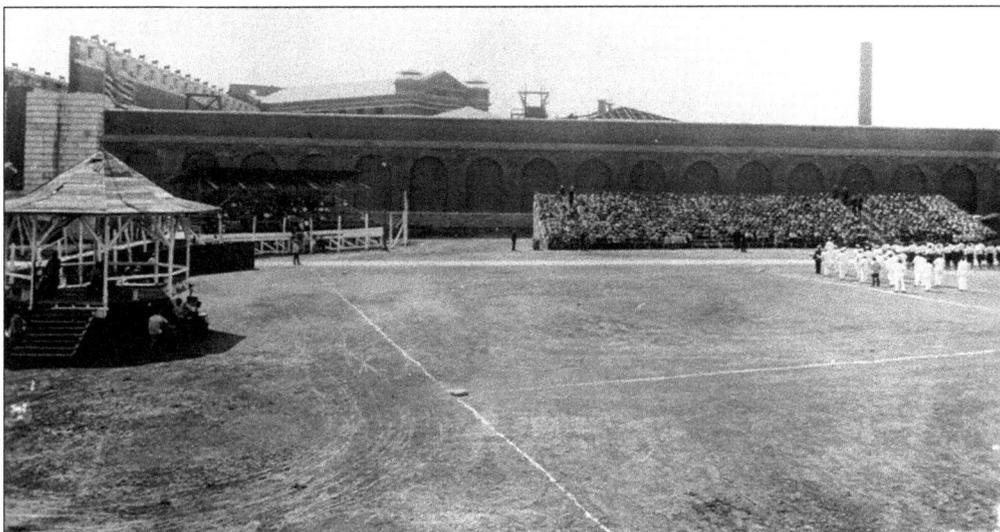

Robert W. McClaughry stated, "Baseball takes the mind of the prisoner off his troubles, stimulates him to better efforts, and is one of the best diversions possible." With that, baseball came to Leavenworth on May 22, 1912. Deputy warden William Mackey built a regulation-size baseball park with bleachers that held 1,500 inmates. Tryouts were held, and regular practices were conducted. Teams and the league were formed along ethnic lines. The whites formed the Brown Sox, Native Americans organized the Red Men, and African Americans formed the Booker T. Washingtons. At stake was the institutional championship and its silken pennant. (Courtesy Tim Rives.)

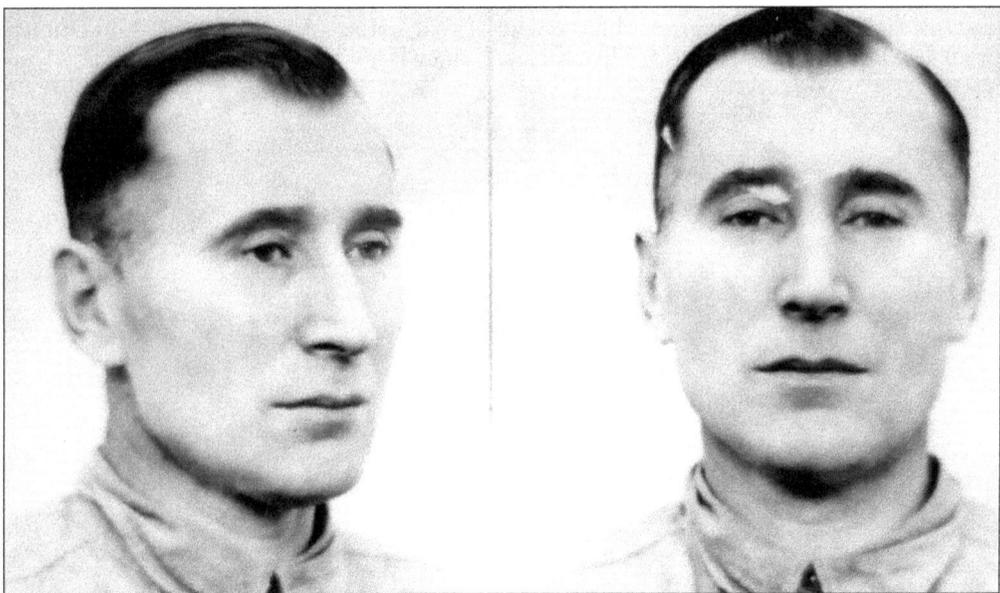

John Mosher, No. 15438, also known as John Schlitz and John Von Schlitz, arrived at the institution on August 16, 1920, after receiving a life sentence for murder. As a private in the 9th Provincial Guard in Coblenz, Germany, after World War I, Mosher, for reasons unknown, murdered a sergeant in his company. Assigned to the stone-cutting shop, Mosher began crafting small pieces of art work and was soon commissioned as an artist for two war memorials. (Courtesy National Archives and Records Administration.)

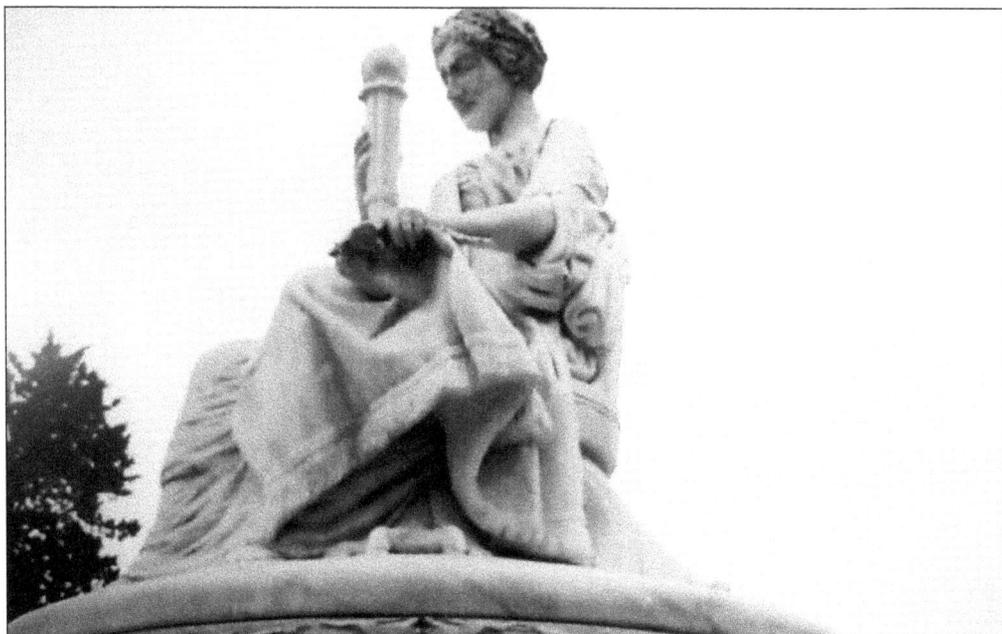

War Angel (above) and *Peace* (below) were both commissioned by the American War Mothers Association and sculpted inside the institution's walls. Both are constructed from limestone and weigh more that five tons. *War Angel* stands in Brookfield, Missouri, and *Peace* is located in a veterans' cemetery in Quincy, Illinois. John Mosher sculpted a third statue that was offered to the Liberty Memorial in Kansas City but was rejected because it was "convict labor" and "prison made goods." No records exist of what became of that statue. (Above, courtesy Gina Smith, Brookfield Library; below, courtesy Mike Kipley, Quincy Herald Whig.)

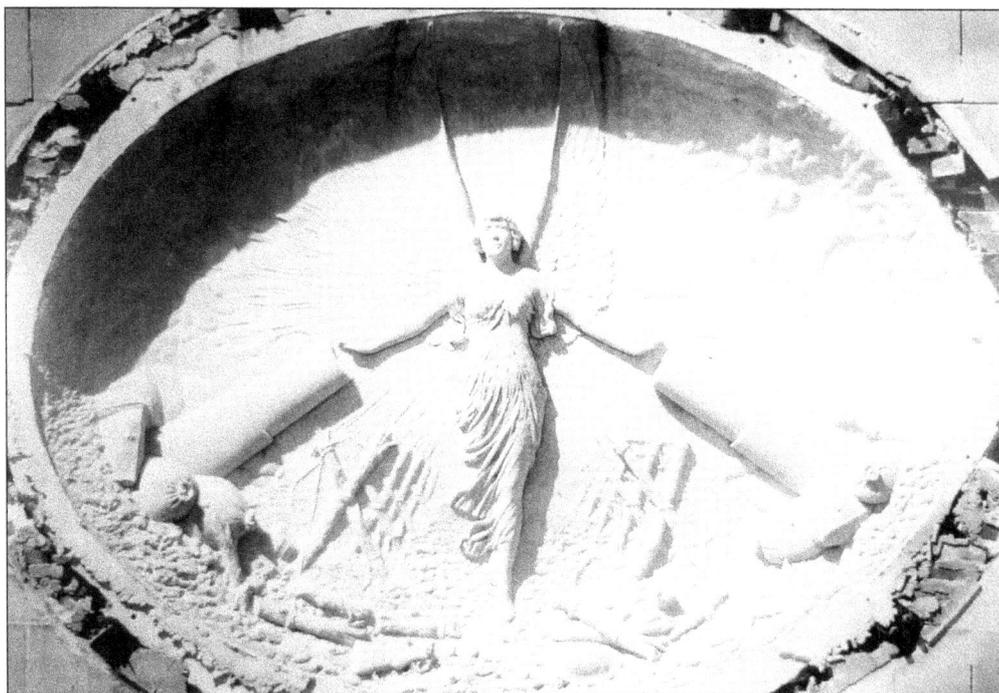

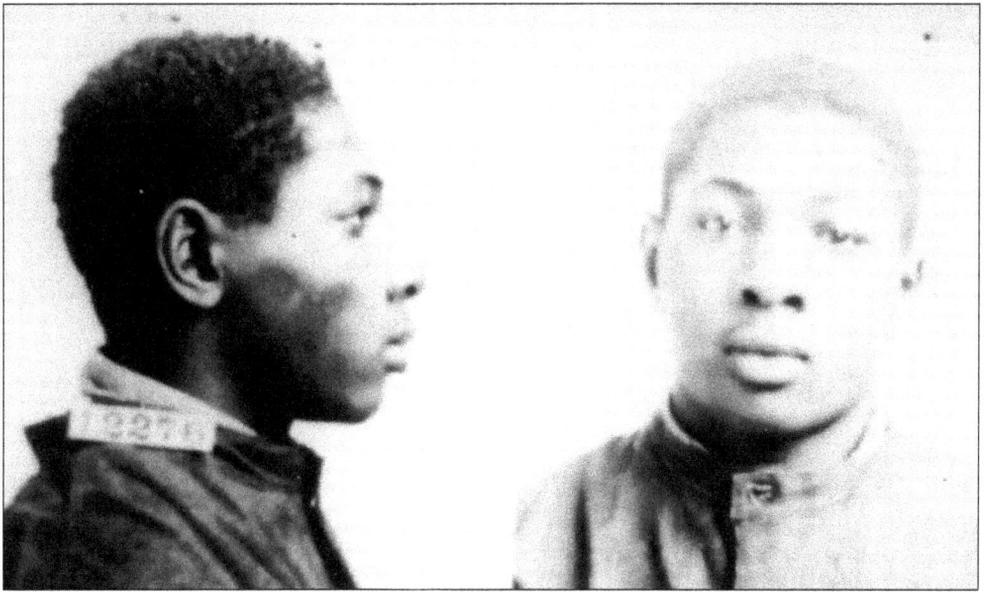

At 18 years old, Roy Tyler joined the 24th Infantry Regiment and became a buffalo soldier. He was convicted of mutiny and murder after the Houston, Texas, riot of August 1917. Between 1921 and 1924, Tyler led the Booker T. Washingtons in hits and base running. In 1925, Tyler was paroled to Andrew Rube Foster, founder of the Negro National League baseball association. Other Booker T. Washingtons players to play Negro National League baseball include David Wingfield, Albert Street, and Joe Fleet. (Courtesy Tim Rives.)

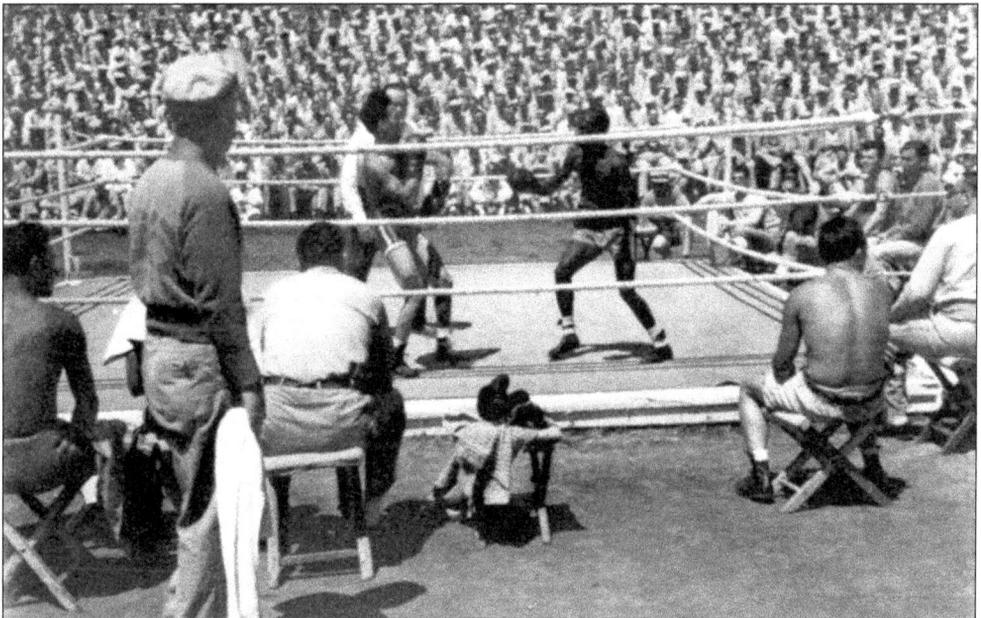

Boxing came to Leavenworth in July 1920 shortly after heavyweight champion John Arthur "Jack" Johnson was sent to prison for violation of the Mann Act. After arriving, an exhibition match was arranged with Johnson fighting his regional namesake "Topeka" Jack Johnson. Boxing would endure inside the prison walls until the late 1960s when gambling and violence outside the ring were fueled by what happened inside the ring. (Courtesy Jim Will.)

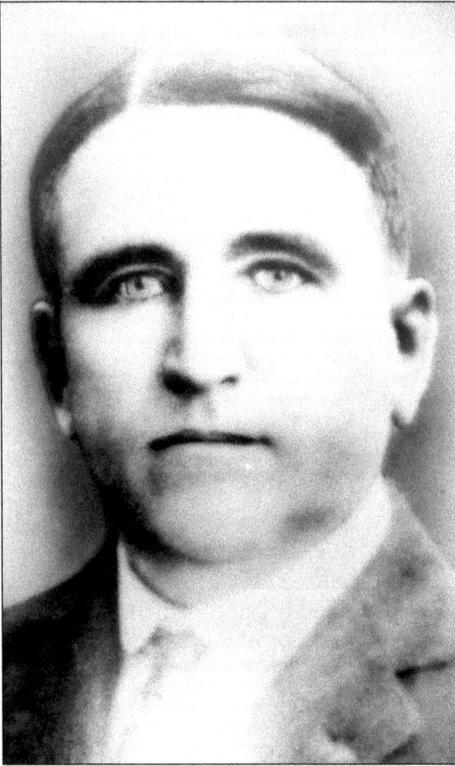

Thomas W. Morgan succeeded Robert W. McClaughry and became warden on July 1, 1913. A respected newspaperman, Morgan began making changes almost immediately. For the first time, inmates were allowed to mingle during the Sunday recreation period and talk freely to each other. A phonograph and records were purchased by the inmates and made their rounds through the cell houses. The first movie was shown in 1914 and an air show featuring Mickey McGuire was arranged. (Author's collection.)

THE NEW ERA

AUGUST-SEPTEMBER, · · · · NINETEEN THIRTY

· · · · · · · · · · · · · · · · ·

TOO MANY of us are so busy finding fault with the world that we haven't any time left to do things that will cause the world to pay the right kind of attention to us. The fact of the matter is, the world is all right. The trouble lies with us. Fault findings and self pity are unproductive occupations and the less time we devote to them the better off we will be.

· · · · · · · · · · · · · · · · ·

LEAVENWORTH, KANSAS

On February 27, 1914, the *New Era* ran for the first time. It began as a weekly newspaper and, over the years, was run as a monthly, quarterly, and biweekly publication. Editors have included explorer Dr. Frederick Cook and Joseph Kerwin, the only man ever convicted of piracy on the Great Lakes. When the *New Era* was discontinued in the 1970s, it had been the longest-running prison newspaper in U.S. history. (Author's collection.)

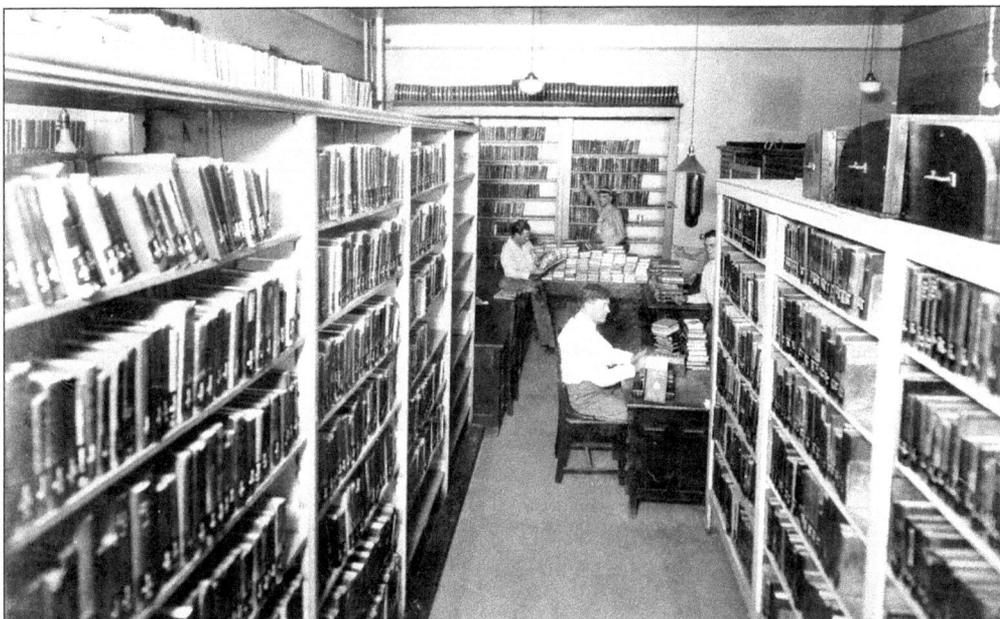

From the very beginning, a belief has existed that education is one of the best tools in rehabilitation. Leavenworth was the first prison to have regular classrooms and a full-service library. Inmates were able to read anytime they were not working. Early classes were taught by the Sisters of Charity of St. Mary's College, the University of Kansas, the Topeka Barbering College, and Kansas City Kansas Community College. (Author's collection.)

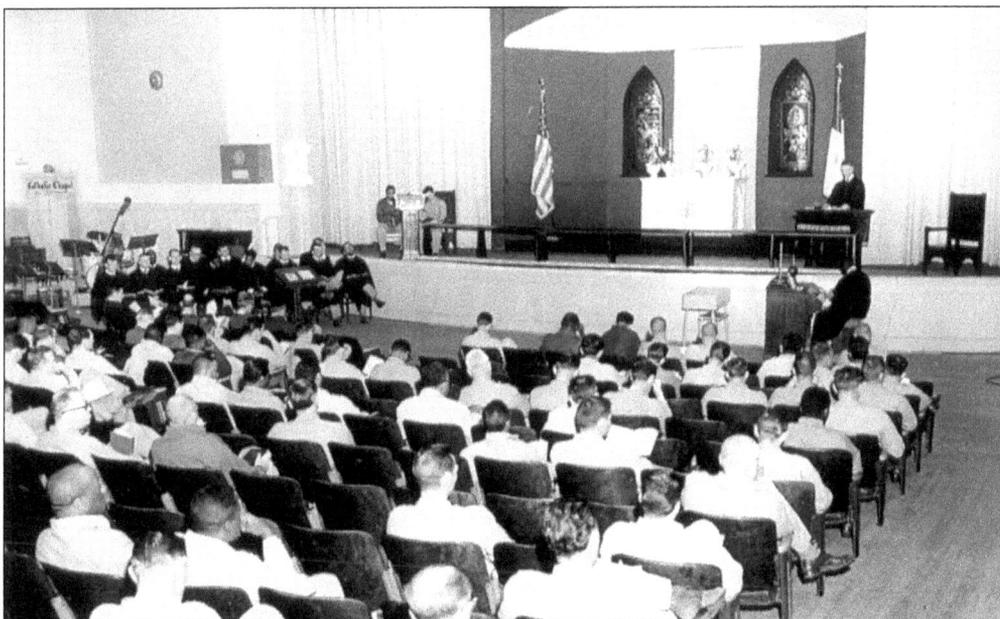

Religious services are held and give opportunity for inmates to grow spiritually. Services are set up in accordance to all denominational needs. Counseling is provided to inmates grieving the loss of a loved one. Classes such as the faith-based Life Connections program provide inmates a chance to better understand the choices they make and how to better their lives once they are returned to society. (Courtesy Chuck Zarter.)

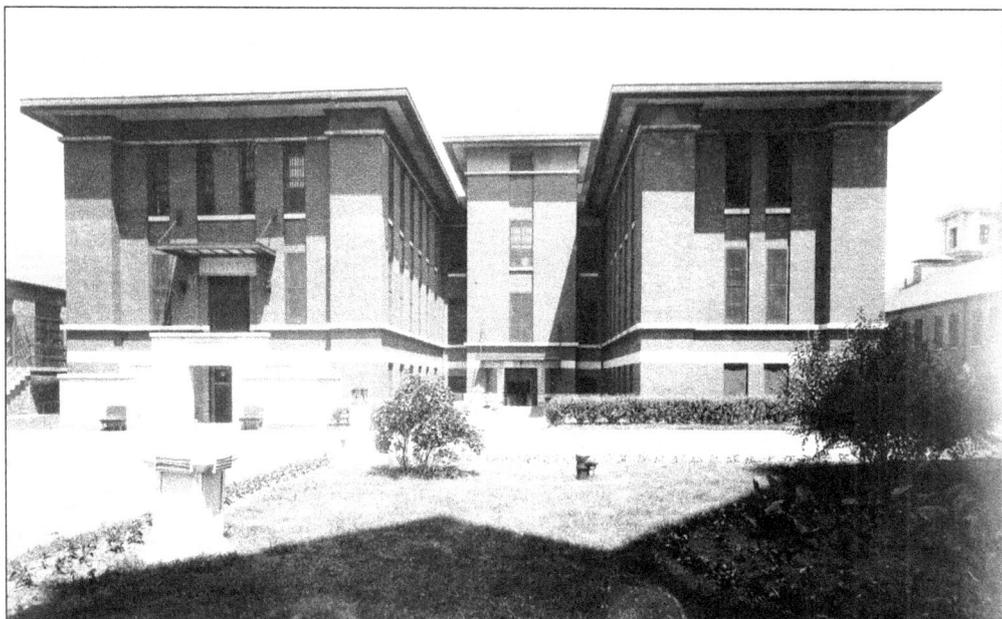

By 1912, the first institutional hospital was built, providing the most comprehensive medical treatment of any prison. Inmates are treated by members of the U.S. Public Health Service, and treatment for any illness is available night and day. Emergency treatment, surgeries, and dental care are provided. One of the first institutional dentists was Dr. Walter Cronkite Sr., the father of the famous television-news journalist. (Author's collection.)

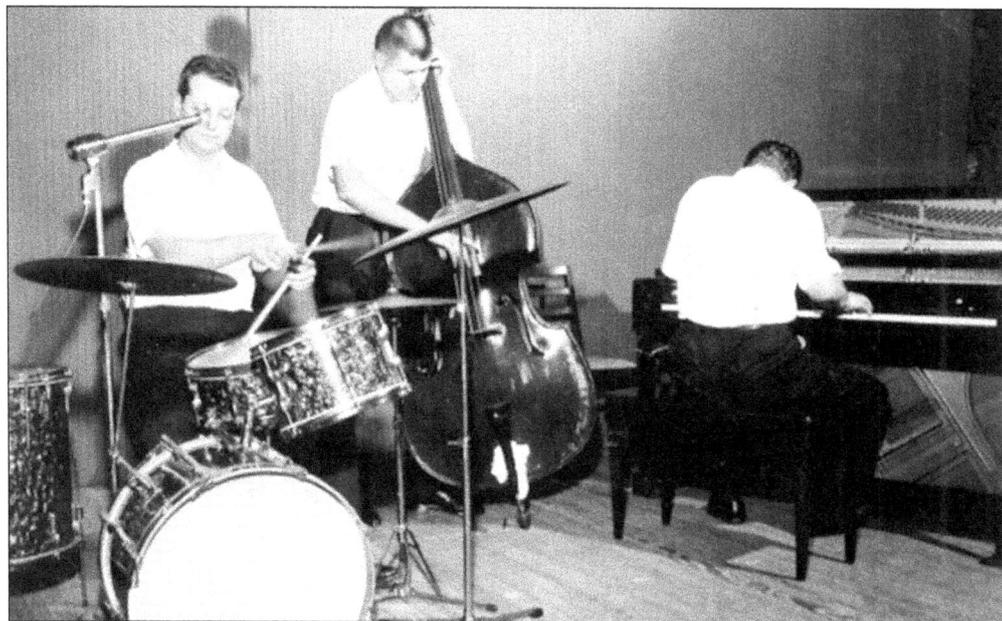

A Carnegie arts program provided inmates with musical and theatrical aspirations and an outlet to refine their craft. Talent shows featuring all genres of music were held regularly. Plays were written, directed, and performed entirely by the inmate population. A fully functional recording studio allowed inmates to record original music. Arts and crafts such as painting, leather work, and ceramics classes were provided. (Courtesy Jim Will.)

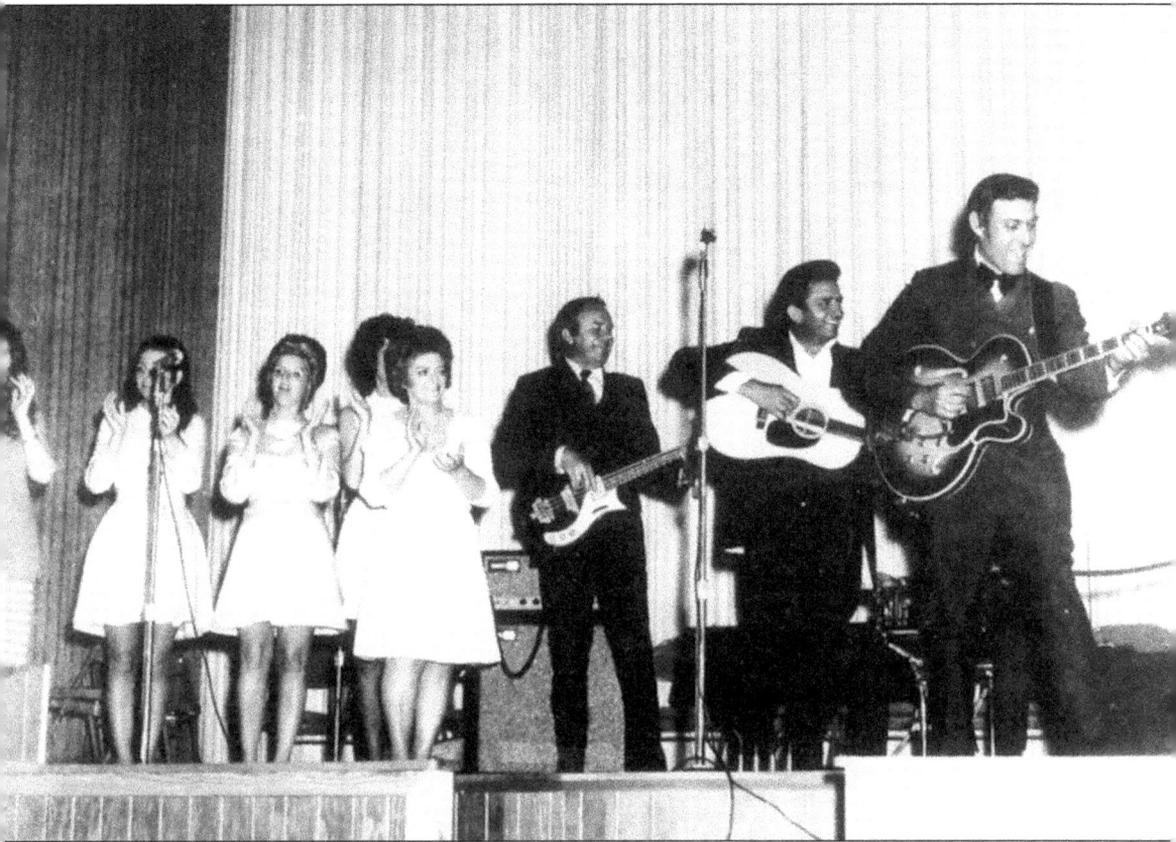

Performances by entertainers such as Johnny Cash, the Statler Brothers, June Carter Cash, Mother Mabelle Carter, and the Carter Sisters were met with loud applause. Lectures by Maud Ballington Booth, founder of Hope Houses and the Volunteer Prisoner's League, brought hope for a better life. Groups such as the Negro National League's Kansas City Monarchs, George Jones, Christi Laine, and National Football League great Paul Horning have stopped by. (Courtesy John Gartz.)

On the afternoon of July 17, 1973, a 40-ton semi-trailer was moved into position just outside the auditorium. It served as the control booth and production trailer for *The Burt Reynolds Late Show*. Reynolds, along with costars Dinah Shore, Jonathan Winters, Merle Haggard, and comedian Jim Hampton, began taping at 7:30 p.m. for the show that aired on October 13, 1973. Taping lasted until 2:30 a.m. with 1,600 of the institution's 1,980-man population attending in two shifts. Thirty-three inmates performed on the show that was produced by Andy Sidaris with coproducer Jack Wohl. (Author's collection.)

Seven

WORK ASSIGNMENTS

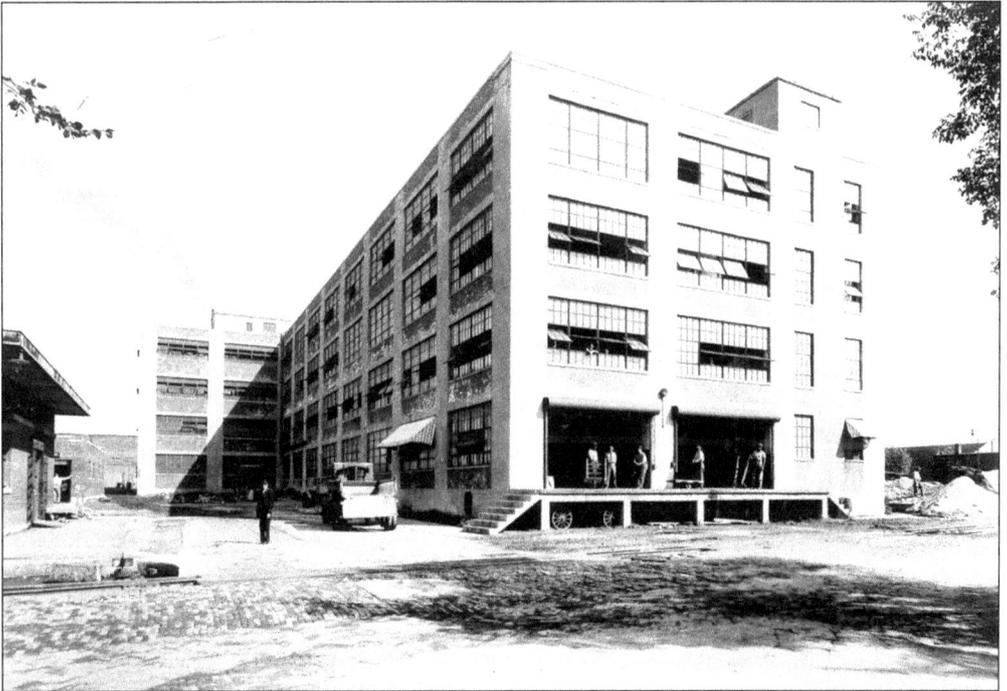

From the beginning, all able-bodied inmates were expected to work. The largest employer of inmates in the institution has been Federal Prison Industries or Unicor. It has provided goods to the government at reasonable cost and provided inmates with not only jobs, but also skills that will help them once they leave the facility. Goods produced throughout the institution's history have included shoes, brooms, brushes, clothing, furniture, mail bags, mattresses, and government documents. (Author's collection.)

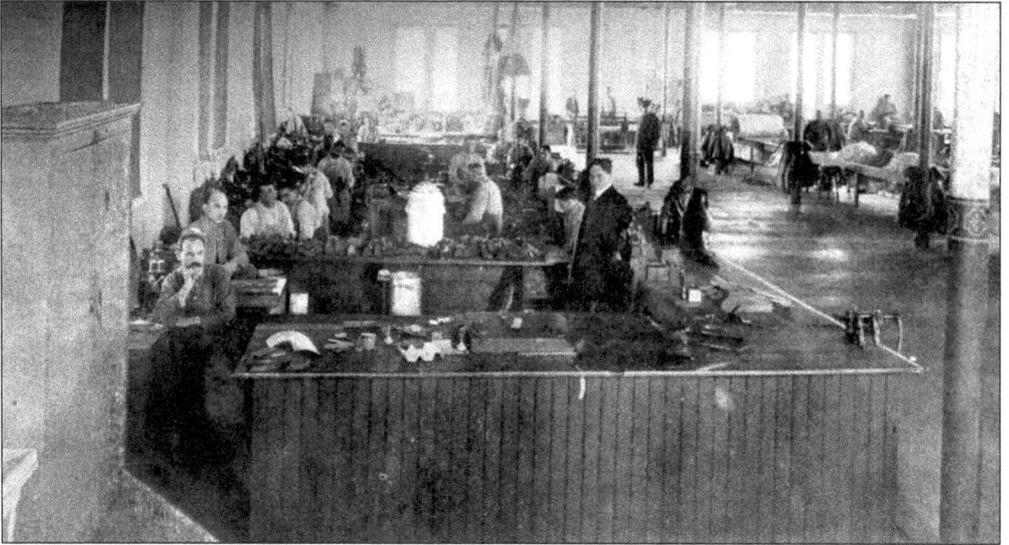

The first ever photograph taken of the institution's shoe factory appeared as a postcard in 1905. Early records indicate that the shoe factory produced boots and shoes for the guards, inmate population, and the military. Records also indicate that the cost for a pair of boots was $2.90, while shoes cost $1.85. Inmates were paid 8¢ per pair of shoes and 16¢ for boots. In the first year, inmates produced 34,164 pairs of boots and 25,944 pairs of shoes. (Courtesy Jim Will.)

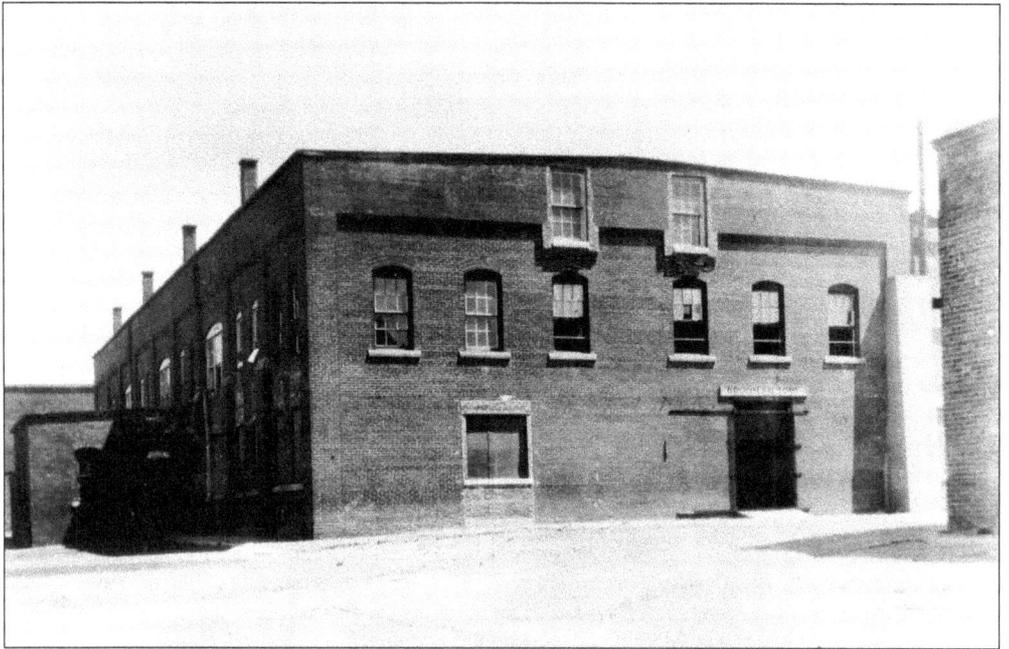

Established in 1924, the broom factory sat in a portion of what is now the institution's recreation yard. Corn brooms were produced for the institution and the military. The first year, inmates produced 4,356 corn brooms costing 16¢ of which an inmate was paid 4¢. (Author's collection.)

74

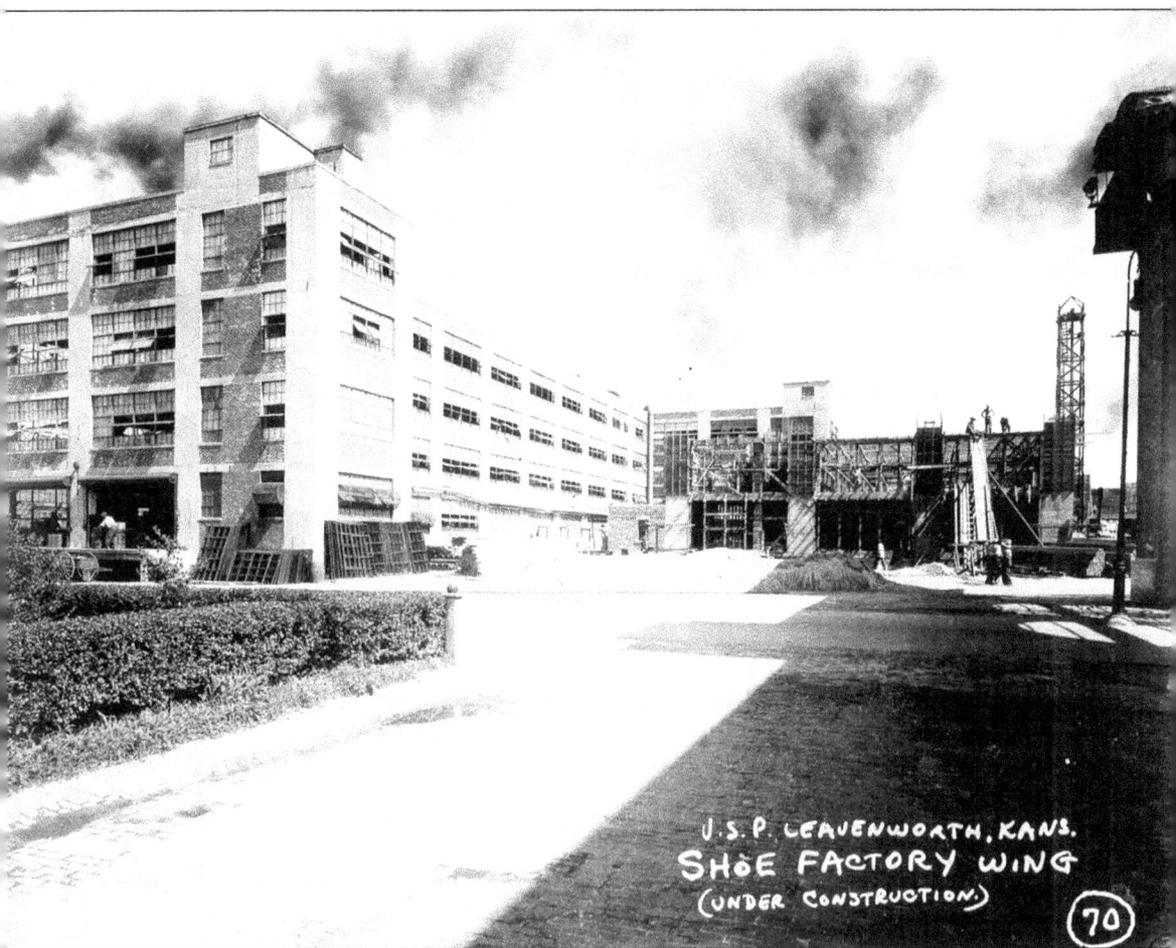

J.S.P. LEAVENWORTH, KANS.
SHOE FACTORY WING
(UNDER CONSTRUCTION)
70

The year-end report of 1921 indicates that the population of Leavenworth was 1,721 inmates. By mid-summer in 1925, the population had risen to 3,345. Warden W. I. Biddle pleaded congress for money to build a new, more modern brush, broom, and shoe factory. By 1924, congress approved the money and construction of the new facility was underway. Once opened, 37 percent of the inmate population was hired in the first year. (Author's collection.)

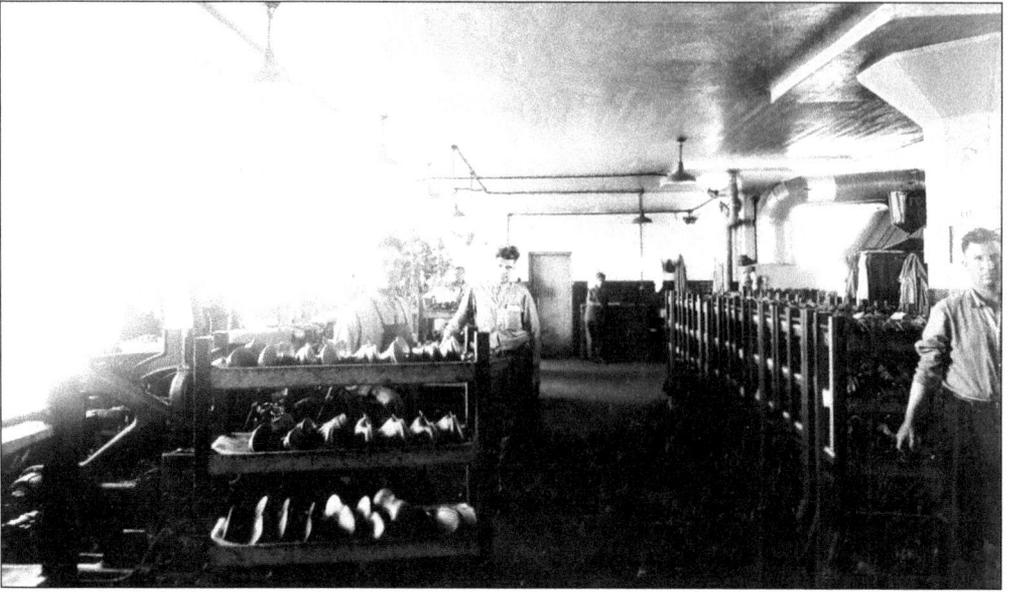

By the end of the 1930s, Unicor was producing boots and shoes not only for the military, but also for seven other government agencies. With sales of all manufactured goods totaling near $1 million quarterly. After the bombing of Pearl Harbor on December 7, 1941, the shoe factory showed the most significant increase of any factory. Three months prior to the bombing, a total of 124,582 pairs of shoes had been produced. In the three months following the bombing, a total of 181,039 pairs were produced, which was an increase of 56,457 pairs. (Author's collection.)

March 26, 1944, marks the first-ever radio broadcast originating from a federal prison. Aired on CBS radio under the direction of warden Walter Hunter, seven inmates told the country about the institution's war efforts. In 1944, inmates purchased $43,000 in war bonds, and donated $1,548 to the American Red Cross. Inmates voluntarily conserved and recycled raw materials, conserved energy, organized blood drives, and worked longer hours. (Author's collection.)

The furniture factory was established in 1935 and produces a full line of office furniture, field tables, chairs, bookcases, beds, and military lockers. One of its most defining moments was when the factory produced the prototype for the rocking chairs used by Pres. John F. Kennedy. The reproduction above was made from the original blueprints and displayed during the institutions 100th anniversary in 1997. (Author's collection.)

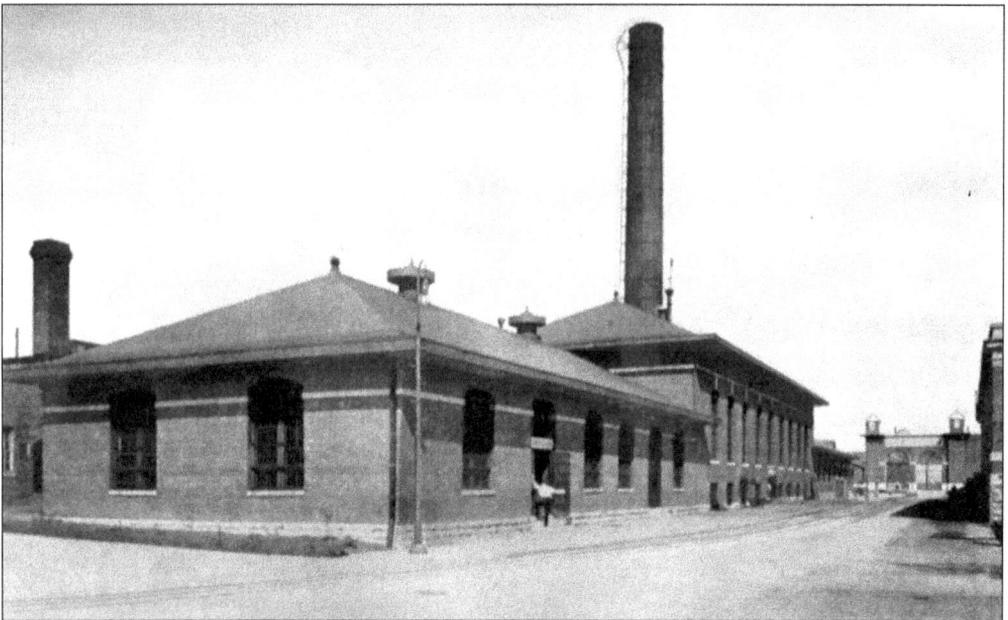

The first powerhouse was located in the center of the institution in what became known as two-gang alley. Inmate work groups gathered here during the workday after each meal, waiting for the work whistle to blow. Two-gang alley is named because it took two gangs of inmates shoveling coal to keep the massive boilers burning. A new, more energy-efficient powerhouse was built, and this building was torn down in 1962. (Courtesy Benedictine College.)

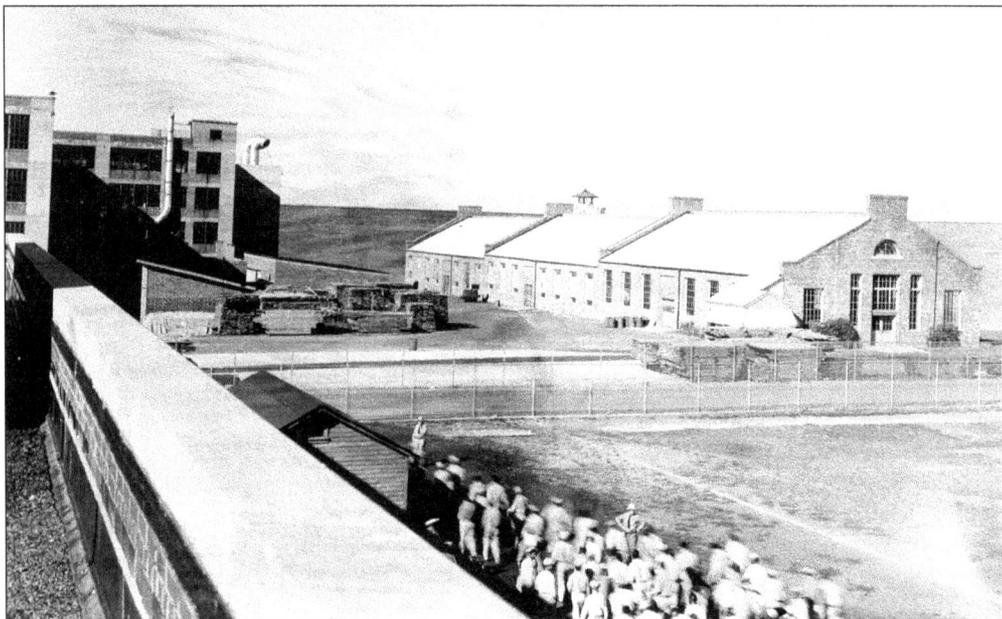

The facilities department oversees the daily plant operation of the institution. Inmates work in plumbing, carpenter, electric, and paint shops. From general, everyday maintenance of the facility to renovation projects, inmates are taught the fundamentals of the building trade. Vocational training classes have provided inmates with the necessary training to become journeyman laborers once released. (Courtesy Chuck Zarter.)

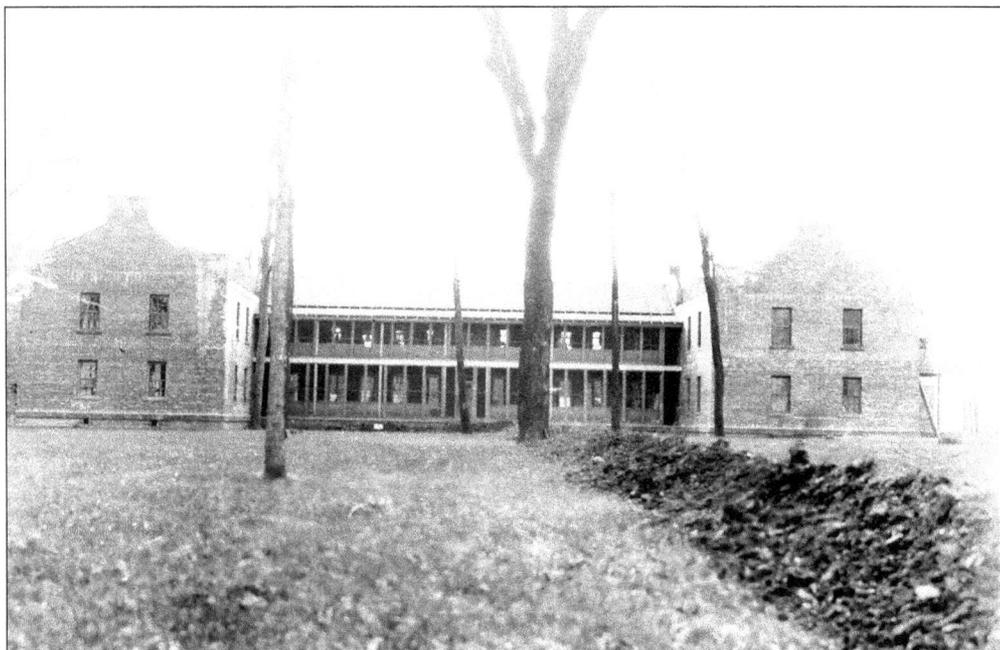

In 1924 at the request of warden W. I. Biddle, Congress approved the purchase of 942 acres of land located east of the institution in Missouri. Expanding the farm operation not only provided more jobs, but it also helped the institution become more self sustaining. Farm two also provided all the meat, poultry, and eggs for the institution. (Author's collection.)

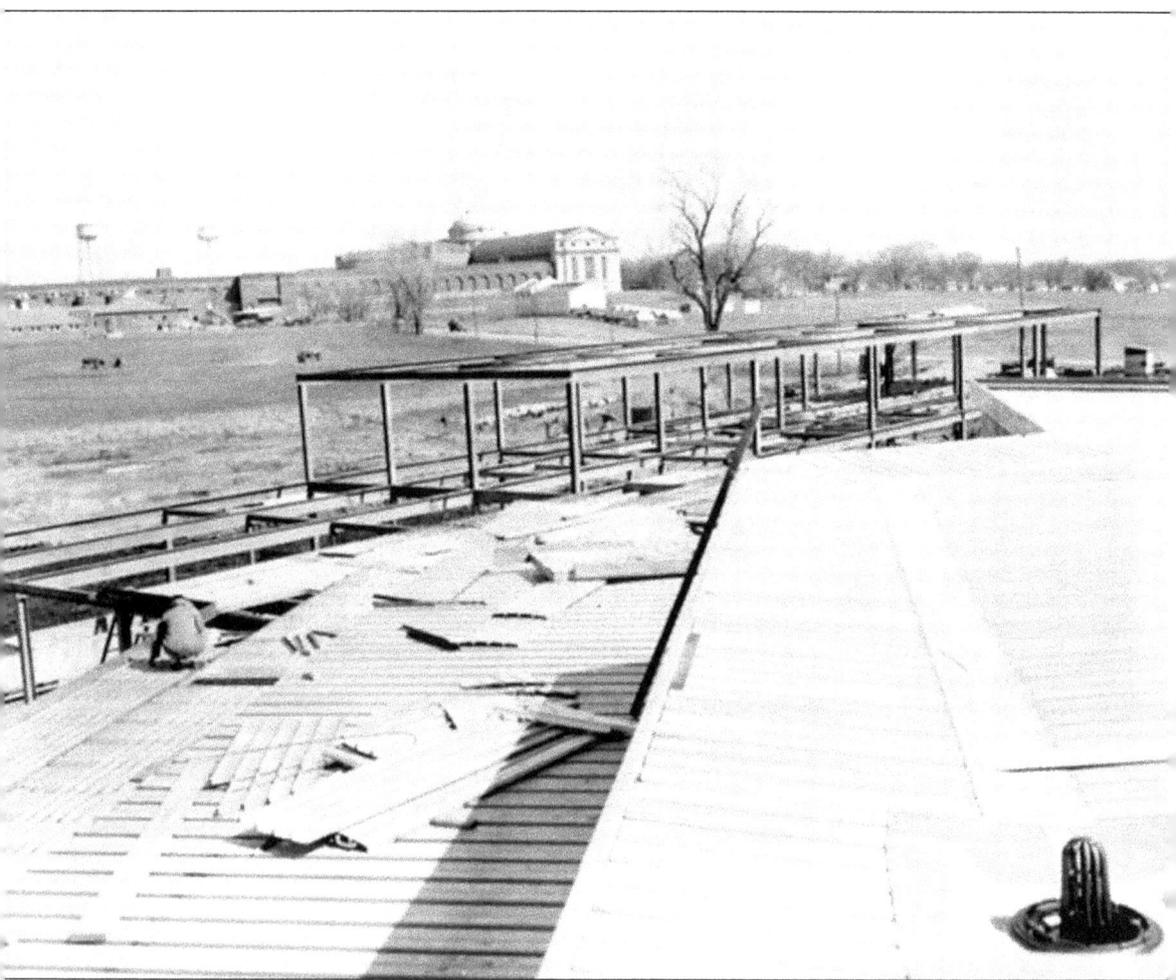

In July 1957, construction began on the new farm dormitory. Located directly west of the institution, this facility housed first-time federal offenders who were serving sentences less than three years. Inmates living in this area provided the labor force for all outside operations. Currently this facility houses inmates that are nonviolent offenders with sentences less than 10 years and has been renamed the federal prison camp. (Author's collection.)

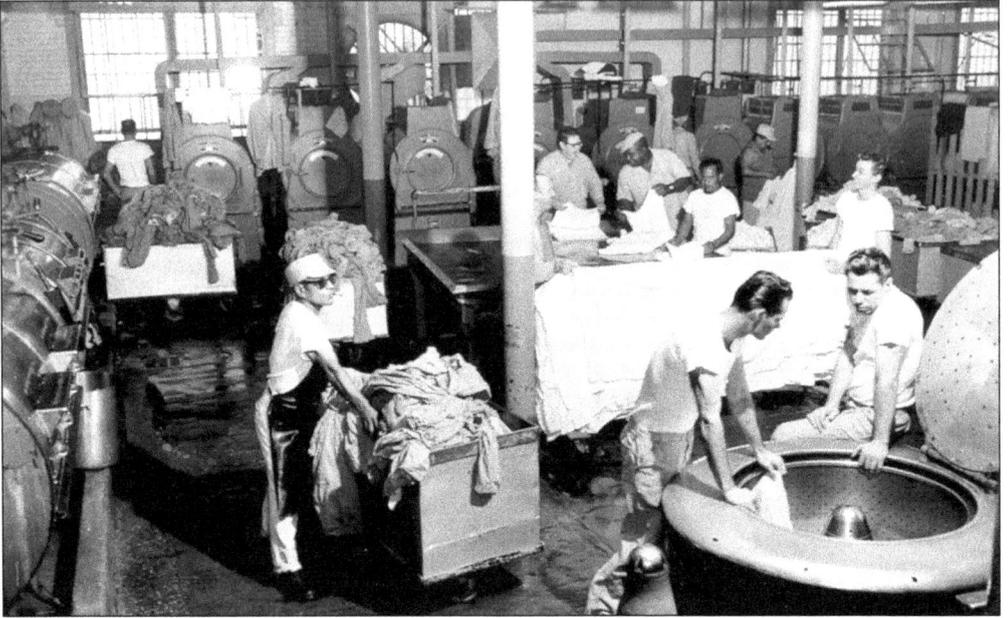

In the early days, the laundry was responsible for sorting, washing, drying, and pressing all the institution's dirty clothes, linens, and guards' uniforms. A tailor shop was on hand to insure a perfect fit for the inmates as well as the guards. Since the vast remodeling of the institution, washers and dryers have been made available in each living unit for inmates who want to wash their own clothes. (Courtesy Chuck Zarter.)

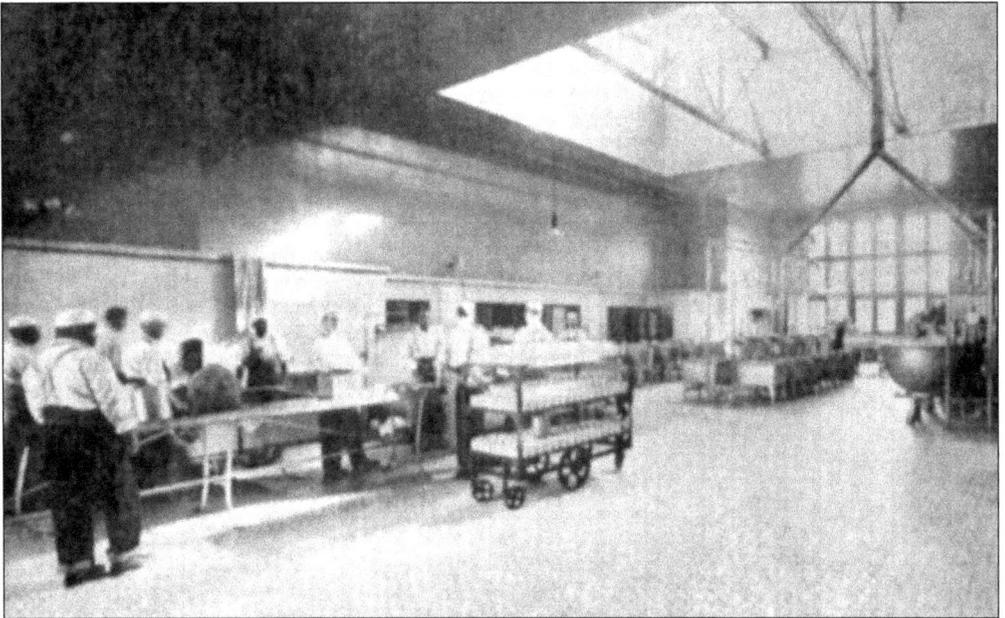

At one time, working the kitchen was a means of punishment for breaking institution rules. It was considered one of the less-desirable jobs, and meals were hardly edible. In many instances, if two inmates had fought, they were placed on kitchen detail together and the battle continued. Today inmates are supervised by highly skilled cook supervisors that are professionally trained in meal preparation. (Author's collection.)

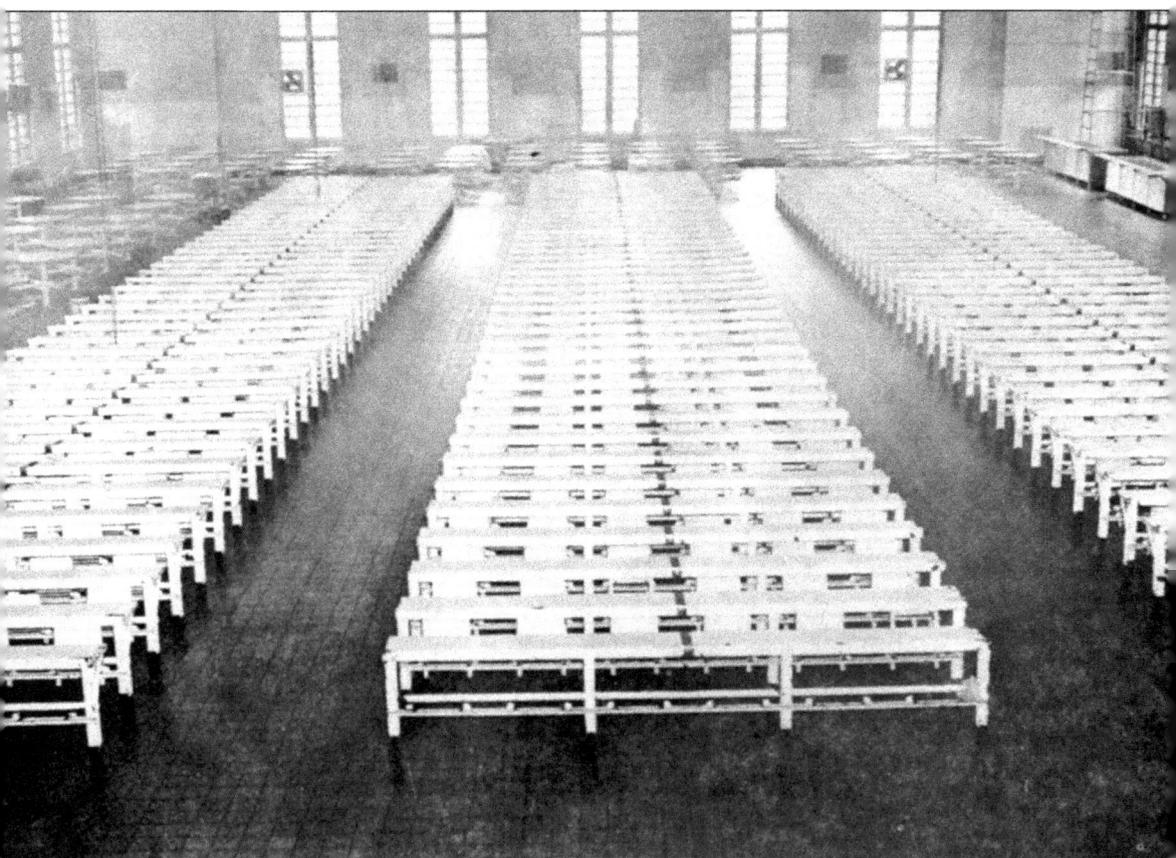

The dining room for any institution is one of the most dangerous places. Three times a day, the majority of the institution's population sits down together to eat. In the early days, inmates marched into the dining room, picked up a plate, were served, and filled the dining hall from front to back facing one direction. Inmates sat in total silence and had to clean their plates. Prohibited acts included eating before or after the bell, using vinegar in one's drinking water, or putting meat on the table. Inmate waiters stood at the ready, prepared to service the inmates as if they were at a local cafe. If an inmate wanted more bread, he held up his right hand; for water, he held up his cup; for meat, he held up his fork; for soup, he held up his spoon; for vegetables, held up his knife. If an inmate wished to speak to a staff member he raised his left hand. In the early days, the inmate orchestra played during the meals. (Author's collection.)

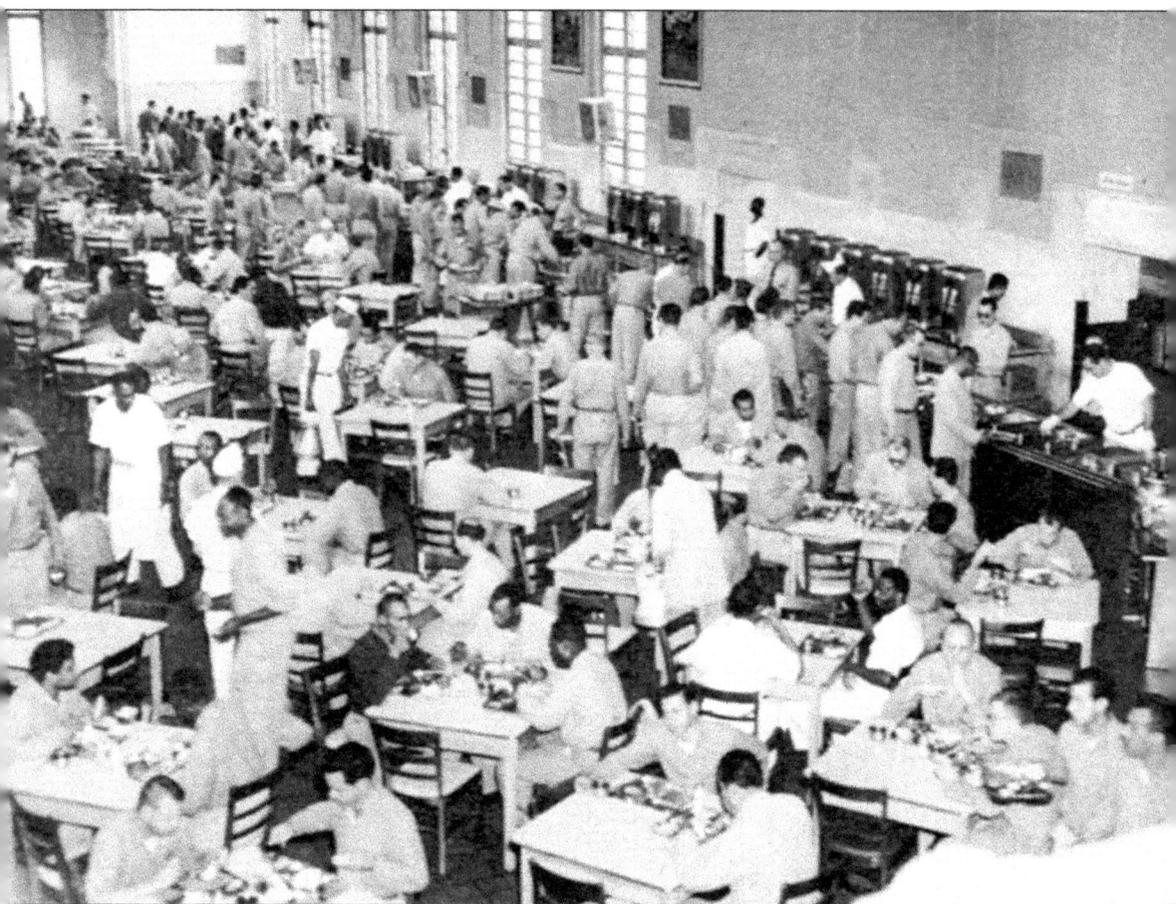

In 1960, under the direction of Warden J. C. Taylor, the old dining room was converted to a more modern eating facility. On the first day of cafeteria-style feeding, additional staff members were placed on standby in case of an inmate uprising. For the first time, inmates walked through the line choosing what they wanted to eat. They were allowed to sit and talk to one another and leave when they got through. As gangs became more prevalent, inmates segregated themselves as to their affiliation. (Author's collection.)

Eight

SCENES

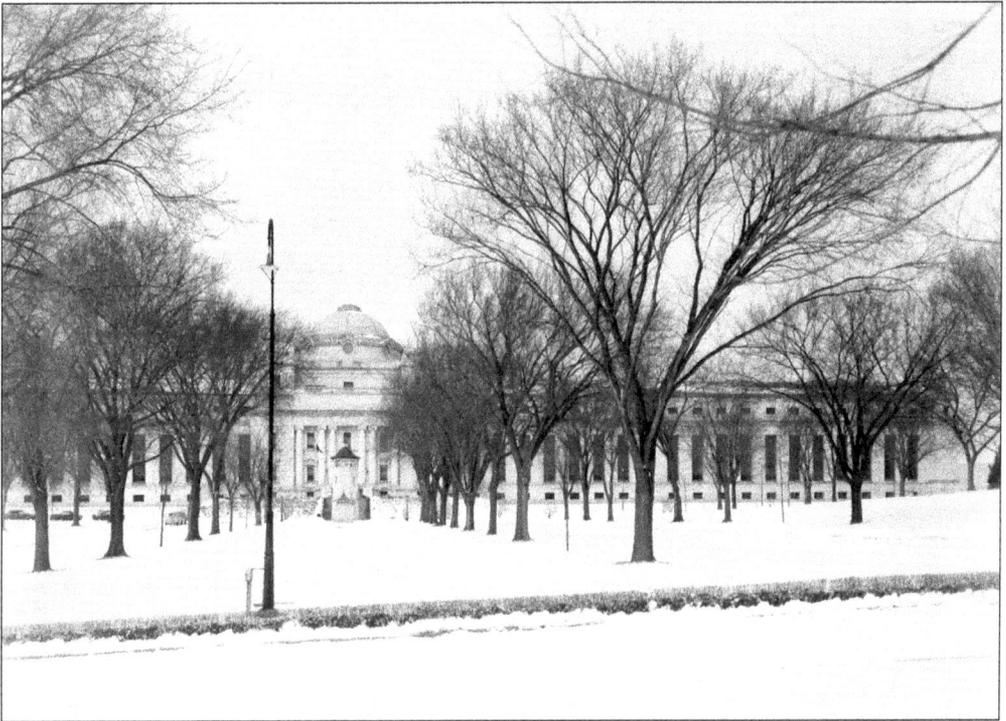

Looking from across Metropolitan Avenue on a cold, dreary morning after snow has fallen, the U.S. Penitentiary Leavenworth looks stoic and peaceful. However, the weather reminds those on the outside of the cold, harsh realities that lay beyond the front gate. For 110 years, tourists have stood in this very spot wondering what it is like behind the massive stone walls with barred windows. Forty-three stairs lead up to the front door. To many, they are the last steps of freedom; to a few, it is a job. (Author's collection.)

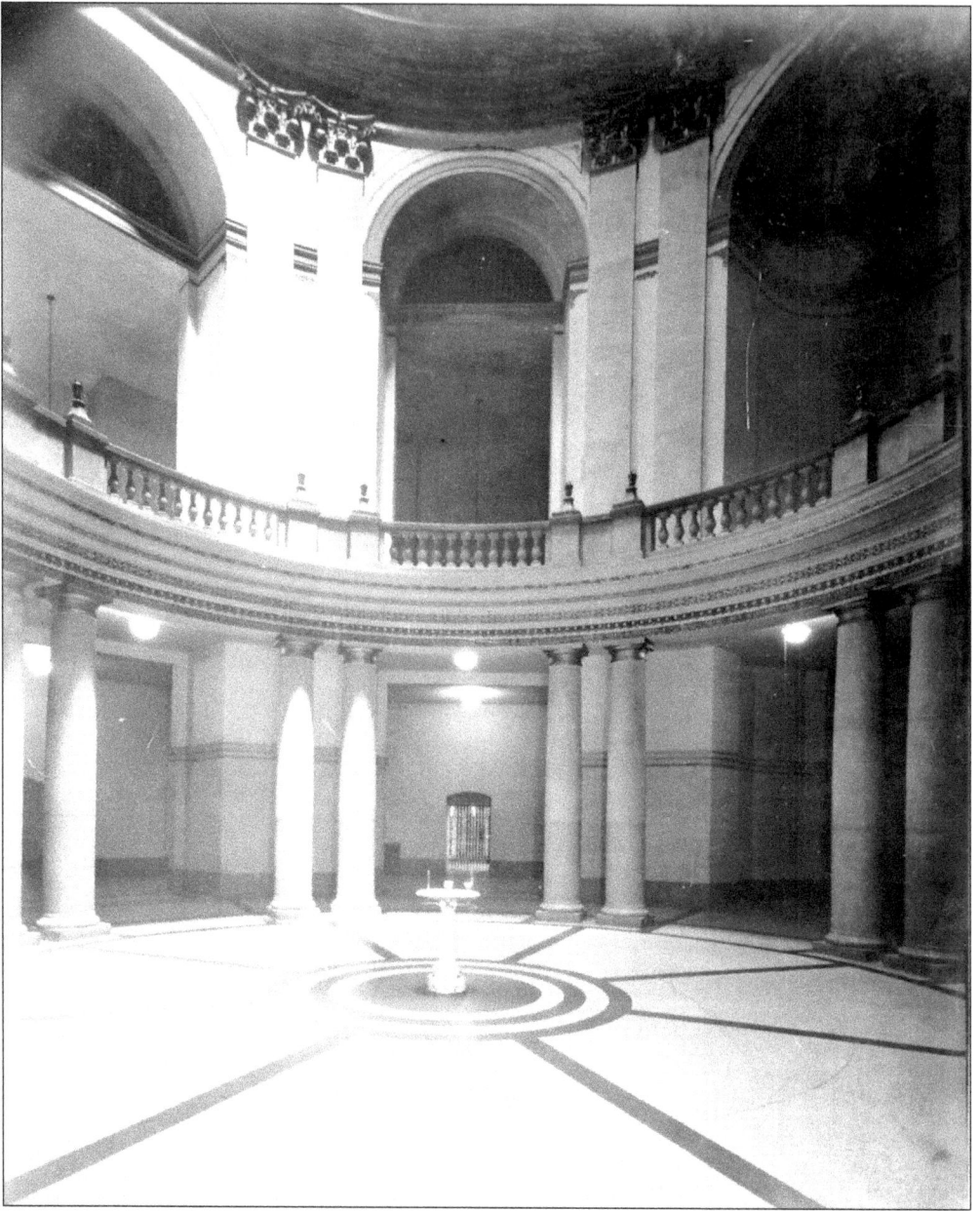

The rotunda lies 132 feet below the dome. Designed after the Capital building in Washington, D.C., each of the four main cell houses radiate from this great hall. Early inmates were forbidden to walk this area unless they were escorted by a guard. Inmates were not allowed within the inner circle without being invited by staff. Years after this photograph was taken, the water fountain was removed, and a desk was placed in the center. It operates much like a precinct desk at any major police department. (Author's collection.)

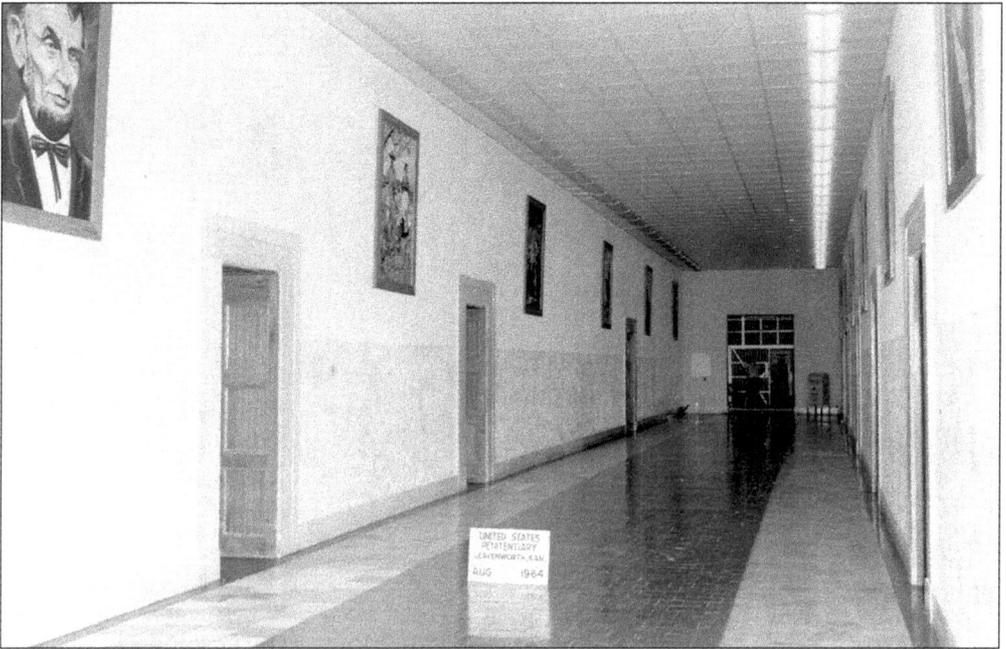

Inmates are not permitted to walk down the center of the main corridor. They must walk down on the right side and back on the left. This helps staff respond to institution emergencies. Over the years, many different offices have served the inmates from this area. The inmate commissary was once located in this hallway. Artwork, motivational posters, and terrazzo have adorned the main corridor over the years. (Courtesy Chuck Zarter.)

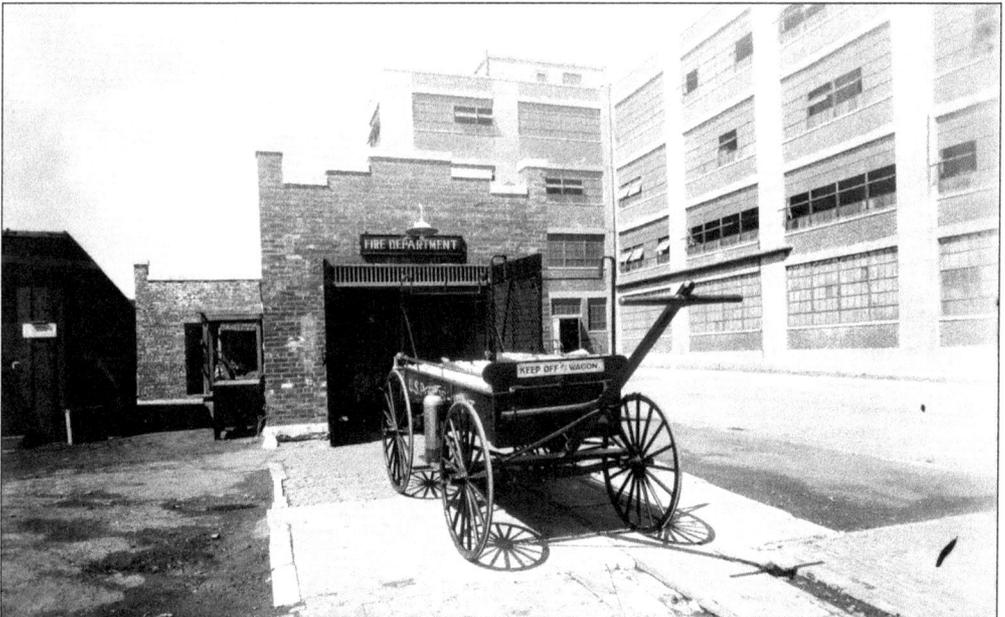

Warden Thomas W. Morgan established the first institution fire department. Inmates were trained in firefighting techniques and competed in local competitions, winning several. For many years, the institution boasted about having the best volunteer fire department in the area. The practice of using inmates to fight fires was abolished in the early 1990s. (Author's collection.)

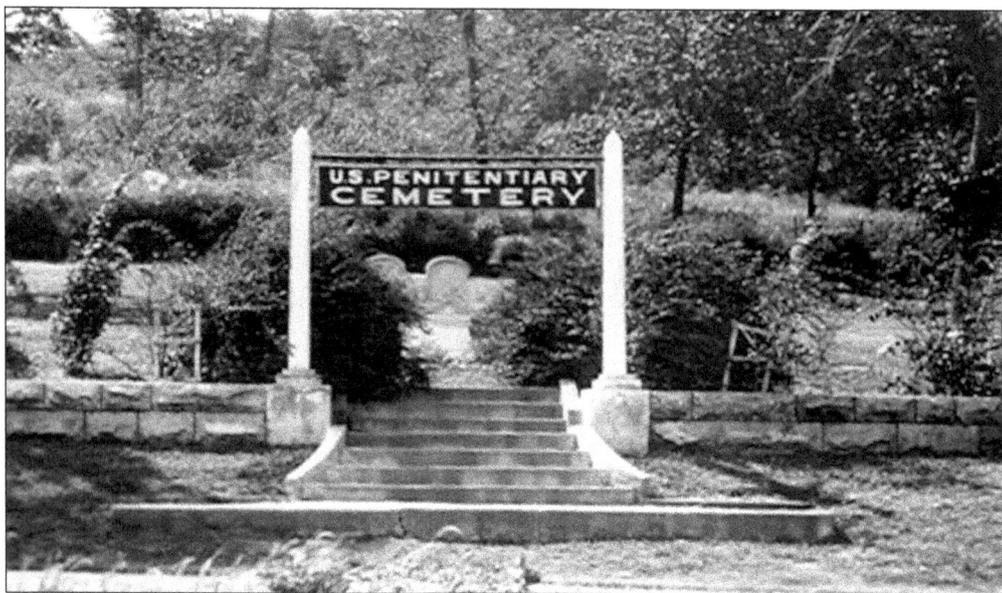

The penitentiary cemetery, affectionately known as Peckerwood Hill, was established for those inmates who died while in custody. Many of the inmates buried in the cemetery died of illnesses contracted before incarceration. Dr. A. F. Yohe reported that many inmates died from influenza, tuberculosis, syphilis, and morphine addiction. Of all the inmates buried there, the most famous is none other than George "Buggs" Moran, the notorious Chicago gangster who died of lung cancer in 1957. (Author's collection.)

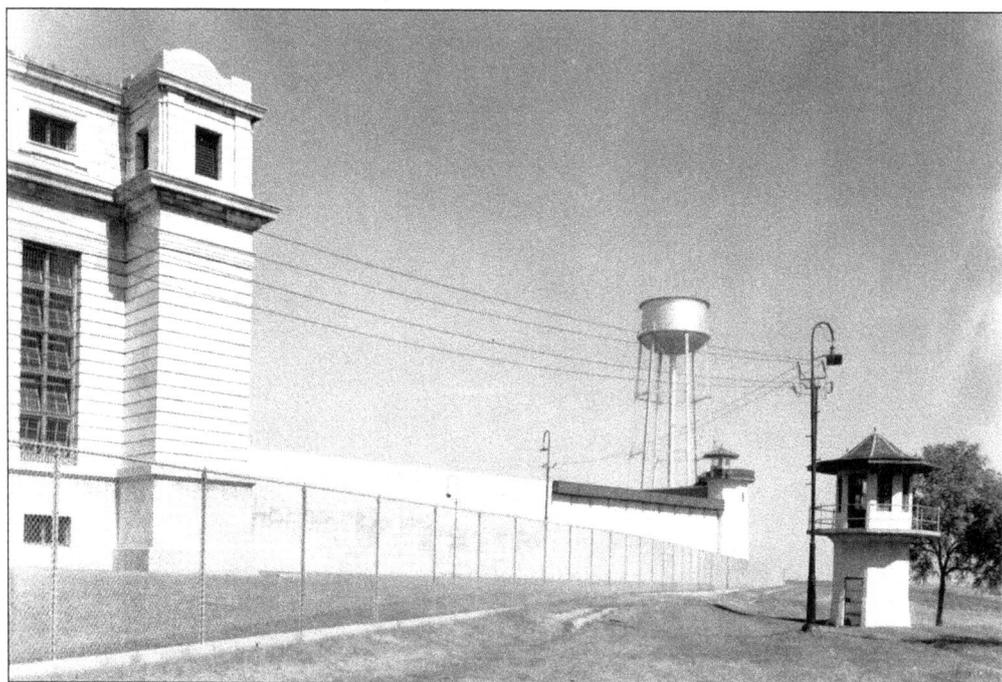

Long before modern security devices, small towers dotted the landscape beyond the perimeter fencing. Cat walks allowed tower officers the ability to get closer to would-be escapees or rioting inmates. (Author's collection.)

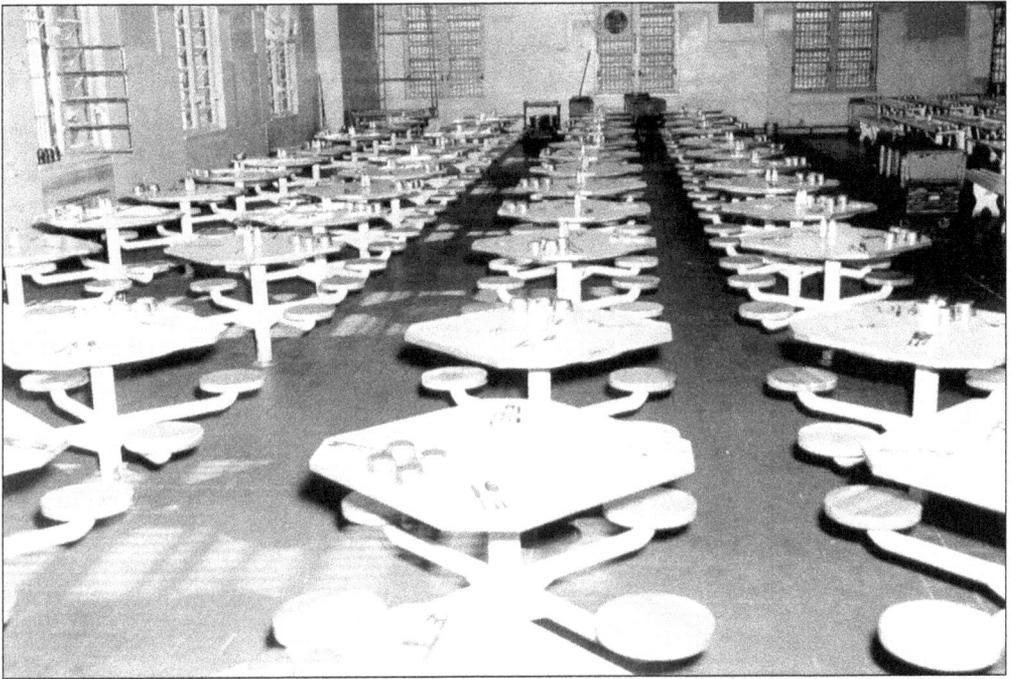

This photograph shows a dining room remodeling project during the 1960s. (Courtesy Gail Leavitt.)

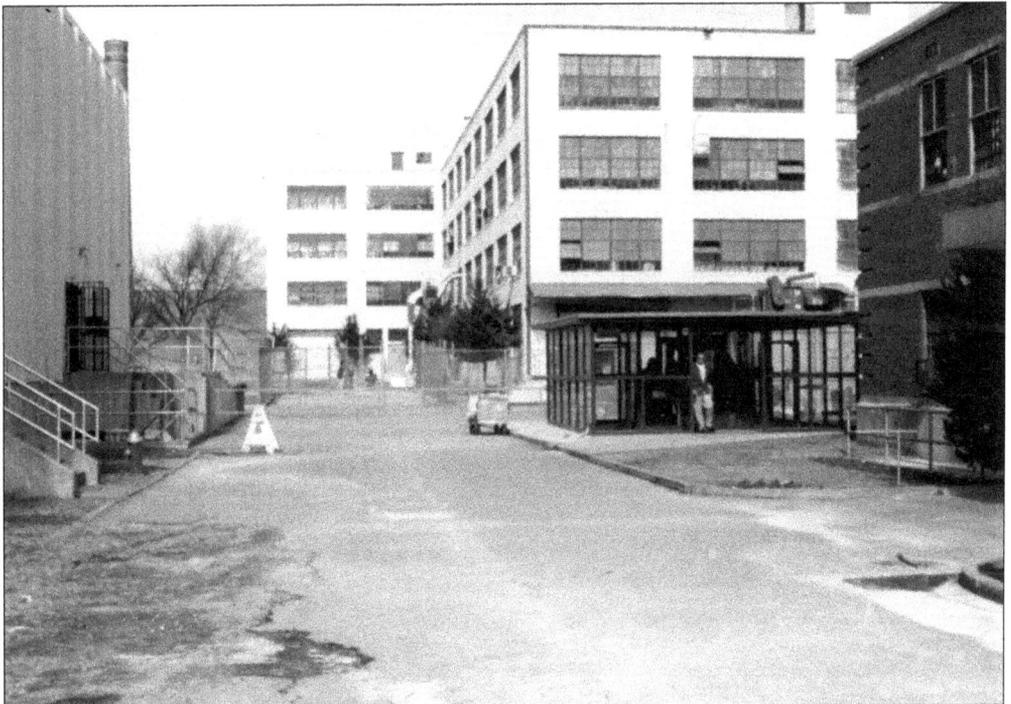

Here is a view of the east yard officer's station from the 1980s. (Author's collection.)

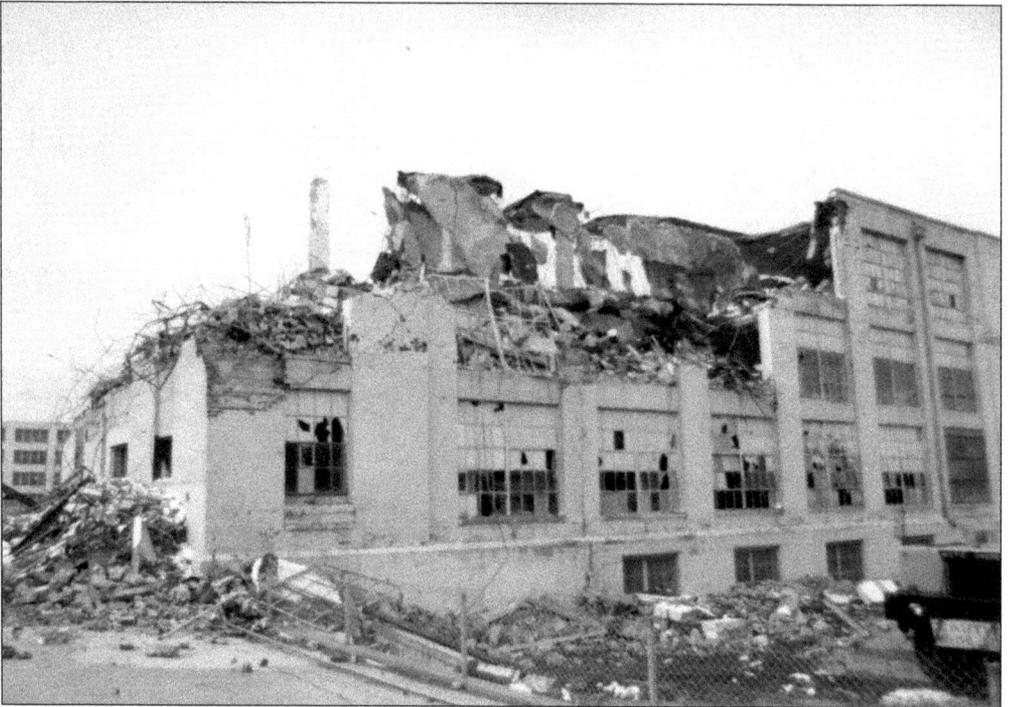

Originally built as the institution's main storeroom, this building housed the vocational training department and recreation department. Some retiree's claim that this building was torn down because it became an inmate battleground and a death trap for officers. (Author's collection.)

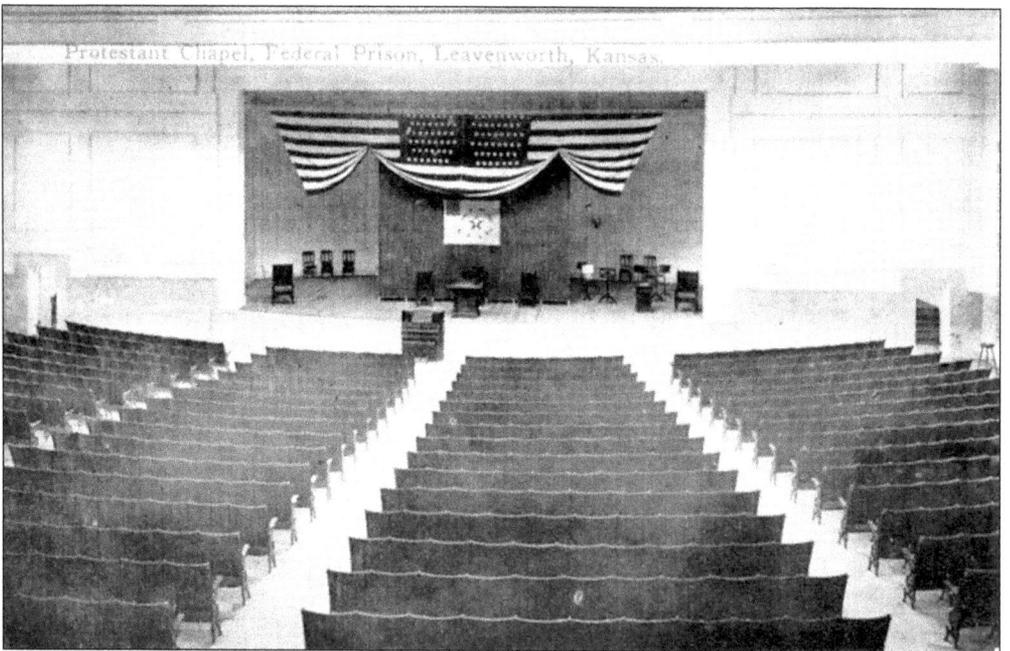

This early-1900s postcard shows the institution auditorium and Protestant chapel. (Author's collection.)

"They are not here for singing too loud in church!" Taken the morning after a 1931 disturbance, this photograph shows the destructive nature of inmates. Though Leavenworth has held the reputation of being the toughest federal prison in the country, there have been four riots in the institution's history, in November 1901, in August 1929, in June 1973, and in July 1992. In each instance, staff members were able to bring the institution back under control in less than eight hours. Inmates manufactured weapons from metal, wood, plastic, glass, toothbrushes, combs, and even trash bags. Once, while strip-searching an inmate, an officer found a rubber phallus that contained a .22-caliber zip gun. After receiving the Cuban rioters from Atlanta and Oakdale, Louisiana, officers were introduced to the Cuban cocktail, which was a mixture of urine, feces, and sour milk. As the officers walked the galleries, the inmates got their attention and attempted to throw it in the officers' faces. (Author's collection.)

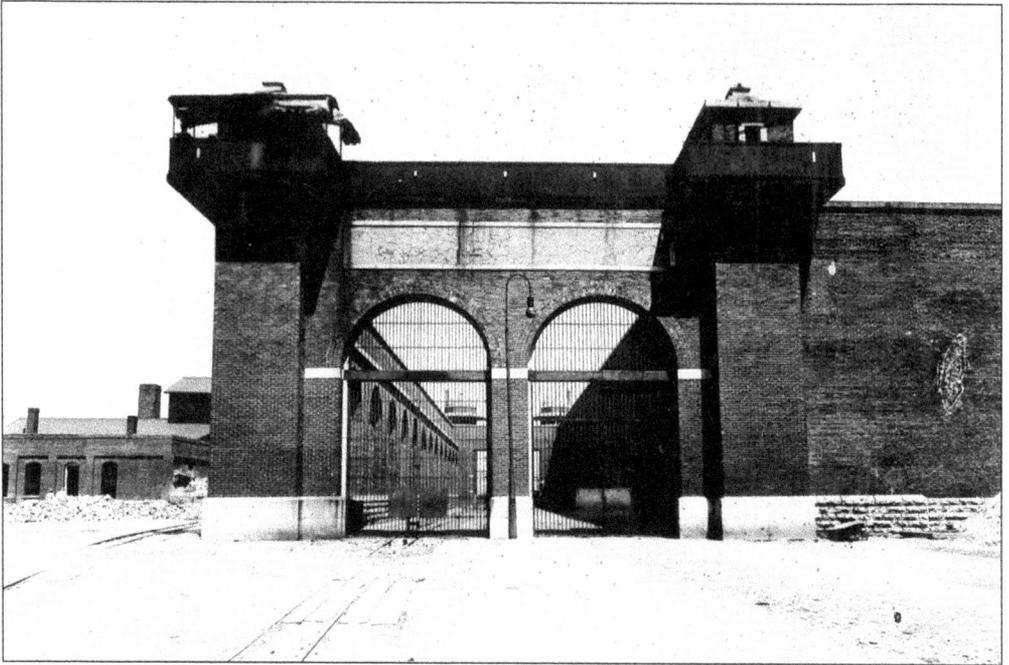

Trains entered the institution daily, carrying supplies and new inmates. As the trains entered the chute, the outer gate was closed and the inner gate was opened. To the left is the brick factory. (Author's collection.)

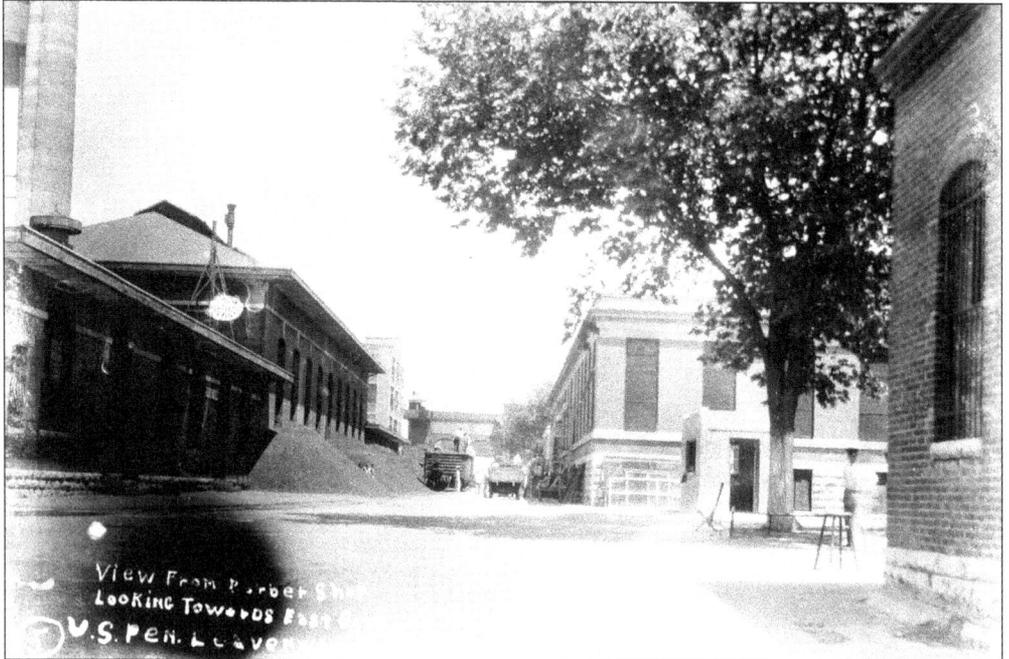

View From Barber Sh
Looking Towards
U.S. PEN. Leav

Early inmates congregated after each meal in two-gang alley awaiting the work whistle. Inmates exited the dining room on the right and reported to work in the shop areas on the left. In this area were the tin, sheet metal, carpenter, plumbing, electric, and tailor shops, along with the north wall warehouse, main storeroom, and the barbershop. (Author's collection.)

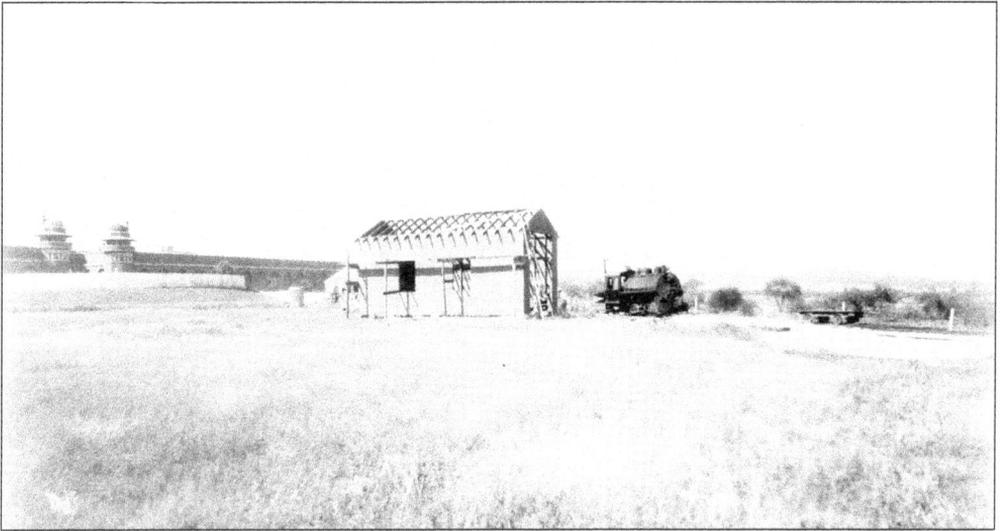

With the derby hat towers in the background, the prison train sits. After an April 1910 escape, a smaller steam engine was purchased. In October 1910, lunch was being delivered to the rock quarry. As an inmate stepped down to throw a rail switch, guard J. N. Crabtree attempted to mount the small engine and caught his coat on the firebox handle. The engine dragged Crabtree for about 60 feet, and he succumbed to his injuries a few days later. (Author's collection.)

As the inmate population grew and jobs became scarce, warden Thomas B. White began an institution beautification project. Inmates were allowed to purchase seeds and build flower gardens throughout the institution. Cell houses competed against each other for the right to be the first to meals or to view movies. Work details competed against each other for the right to be the first to shower or go to the barbershop. (Author's collection.)

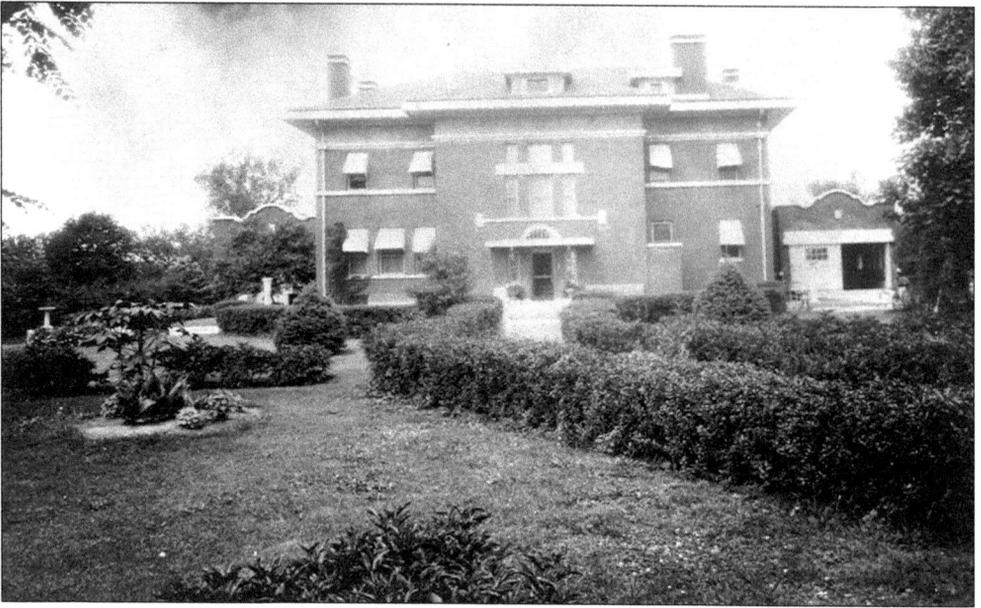

The original warden's residence, built in 1896, contained four bedrooms, a bathroom, a living room, a kitchen, and a grand dining room. Early wardens often entertained and were considered part of the upper social class of Leavenworth County. There were separate quarters for the inmates who worked for the warden's wives. Wardens resided here until the early 1960s when a new residence was built. Since then, this has been an officers' bachelor's quarters and is currently used as the staff fitness center. (Author's collection.)

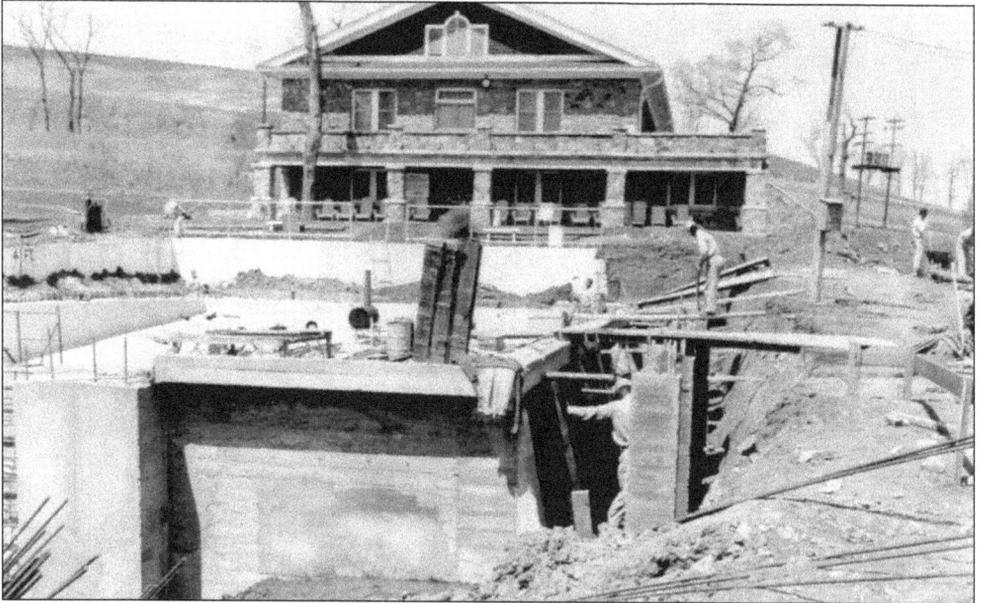

Opened on New Years Eve 1931, the guards club was dedicated to warden Thomas B. White who was recovering from his injuries sustained a few weeks earlier during an escape. The guards club features a kitchen, a serving area, a dining area, a swimming pool, a ball field, indoor and outdoor firing ranges, a bowling alley, and a sun porch. A small apartment housed the club's caretaker. (Courtesy Gail Leavitt.)

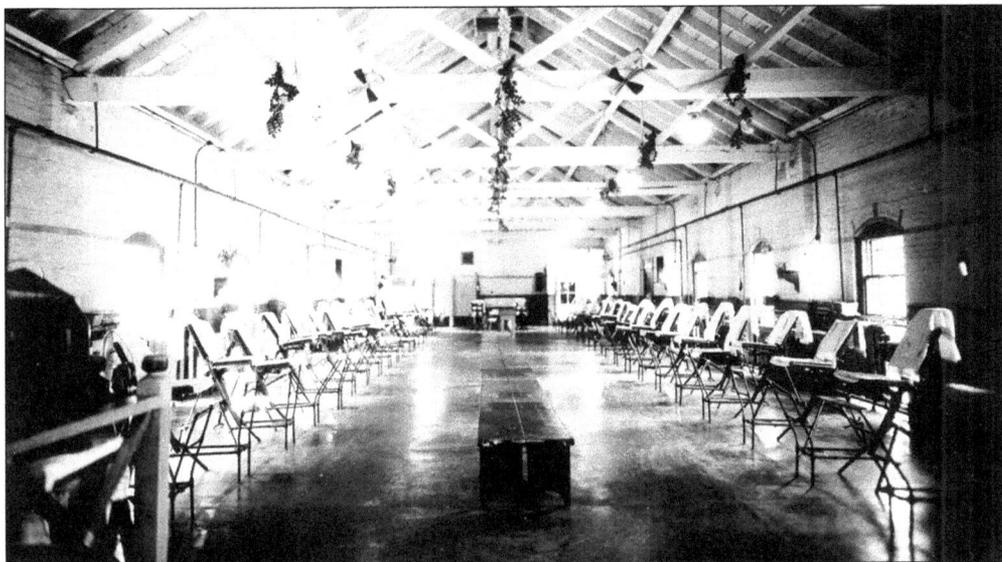

One of the first buildings built was the inmate barbershop. This was an inmate's first stop on his journey inside Leavenworth. Inmates had their faces and heads shaved and were issued their first clothes. They were also issued a bible, cup, mirror, cuspidor, towel, one piece of hard soap, comb, brush, mattress, bed sheet, blanket, pillowcase, nightshirt, camp stool, water jar with cover, and a book of rules. In their cells, they were permitted one electric light, one small library shelf, a library catalog, and such school books, library books, and family photographs as their conduct or grade privileges permitted. (Author's collection.)

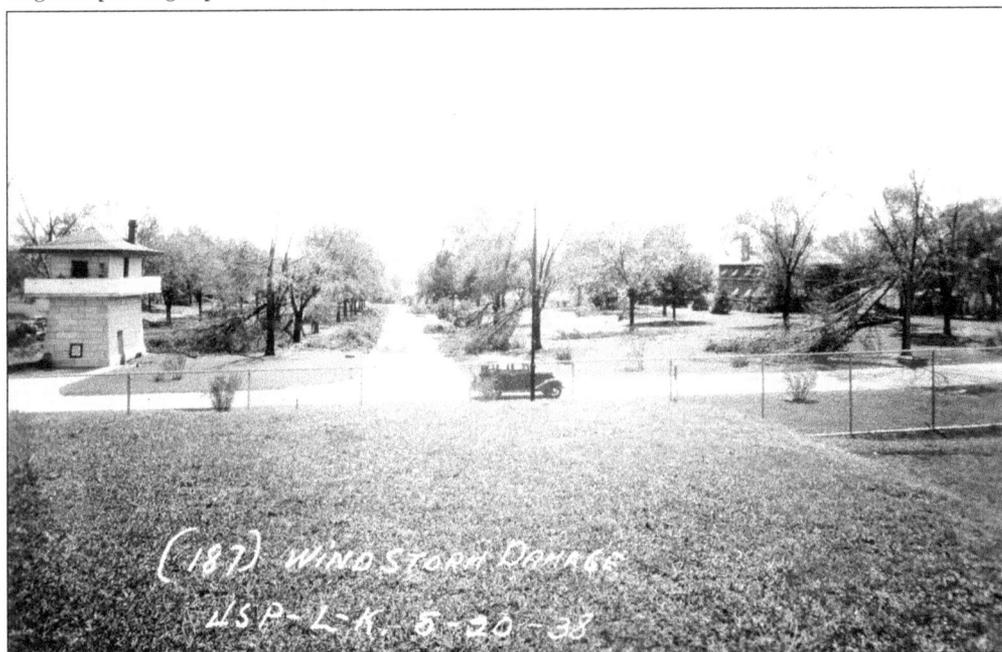

August 19, 1938, a windstorm caused severe damage to buildings throughout the institution. Trees were uprooted or damaged, the farm sustained heavy flooding, and two mules died when struck by lightening. The broom factory and ice plant were total losses. Damage estimates totaled more that $100,000. (Author's collection.)

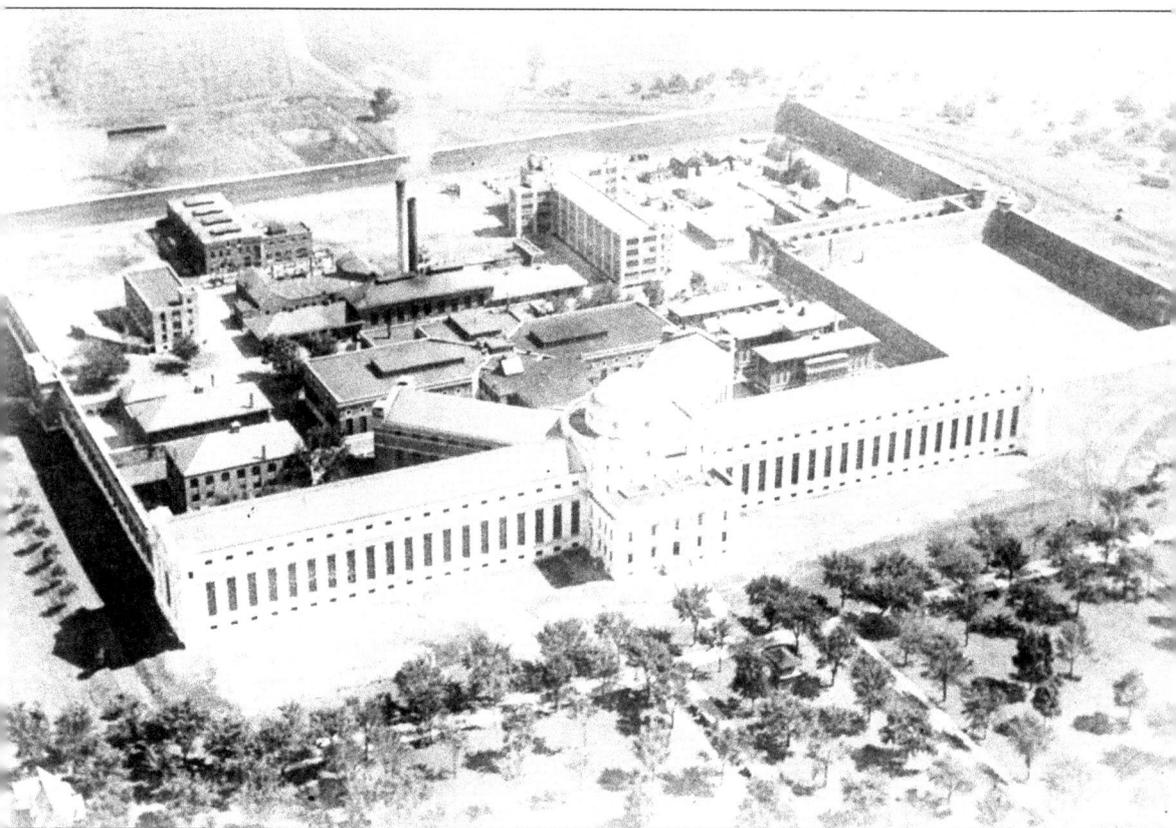

This is Leavenworth in the 1930s. Known as the flagship of the Federal Bureau of Prisons, Leavenworth has served not only as a penitentiary but also as a training ground from which other institutions have grown. It was home to the National Bureau of Identification and was the first training facility for fingerprinting in the United States. It was a regional training facility of custodial officers from Tucson, Arizona; La Tuna, Texas; Terre Haute, Indiana; and Springfield, Missouri. Training schools for storekeepers and junior farmers were also conducted at Leavenworth. (Author's collection.)

Nine

HACKS

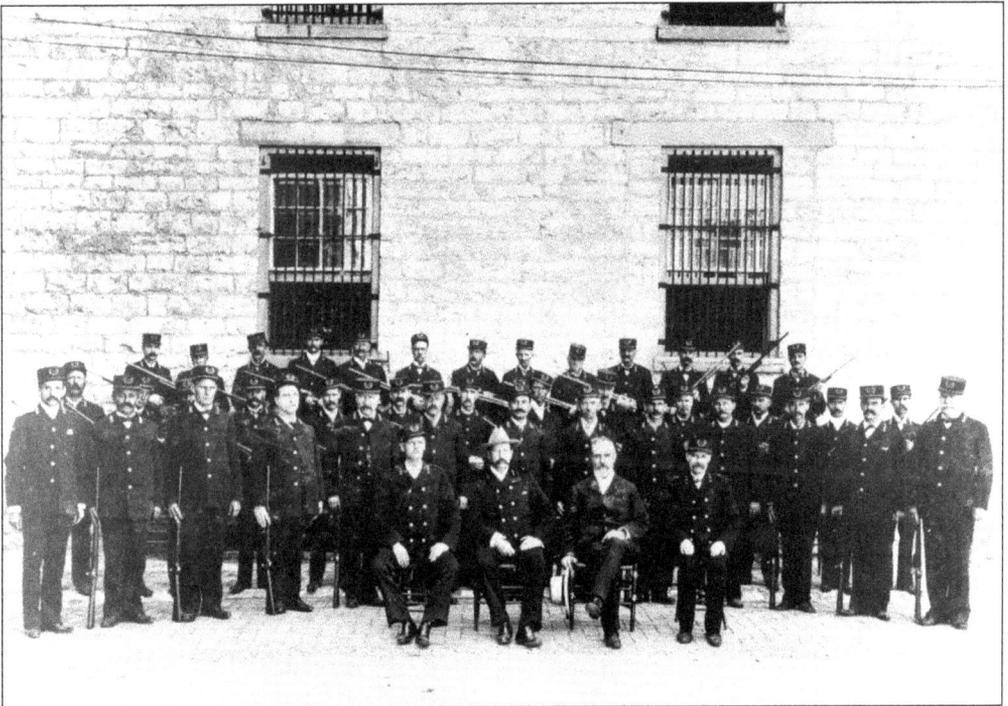

Robert W. McClaughry begins a tradition by posing with guards just inside the south gate area of the old military prison. Leavenworth's first guards were pioneers that laid the ground work for generations of guards and eventually correctional officers. Many were former military men who had fought for their country. If Leavenworth was to house the most notorious offenders, the guards had to be up to the task. Inmates began calling them hacks—an inmate acronym for "hard a— — carrying keys!"—a name that has endured for 110 years. (Author's collection.)

Here is an early photograph showing the first uniform ever worn by guards at Leavenworth. The first guards worked 12-hour days, seven days a week. If they wanted a day off, they had to find their own replacement and only the warden granted permission. Guards were paid $70 a month and had to provide their own uniforms. While on duty, guards were prohibited from whistling, immoderate laughing, and discussions of politics and religion. They were not to hold conversations with foreman or inmates unless directly connected with their duties. Guards on duty were not permitted to read or call any convict by any nickname or slang title that may indicate his nationality or any peculiarity. While off duty, guards were prohibited from entering saloons, gambling houses, and other disreputable places. Guards also were not to allow any familiarity on the part of convicts toward themselves. Any violation of these rules meant dismissal. (Author's collection.)

Greenback, Tennessee, native Joseph B. Waldrupe came to Leavenworth and was appointed to the position of guard in October 1900. At approximately 3:40 p.m. on the afternoon of November 7, 1901, 26 inmates took up weapons that had been hidden about the construction site by recently released inmates. Taking several hostages and using them as a human shield the inmates made their way to the south entrance. They opened fire on the guard's position. Waldrupe was struck in the thigh by a bullet, but the young guard stood up and returned fire. A shotgun blast ripped through the back of the head of inmate Quinn Fort, No. 140, killing him instantly. At the same instant, Waldrupe was struck between the eyes. Waldrupe fell to the floor but continued to fight back inmates, denying them access to the guard box. Shortly before 7:00 a.m. on Saturday November 10, 1901, with his wife, Lena, by his side, Waldrupe succumbed to his injuries and became the first Leavenworth guard to die in the line of duty. (Courtesy Agnes T. Kramer.)

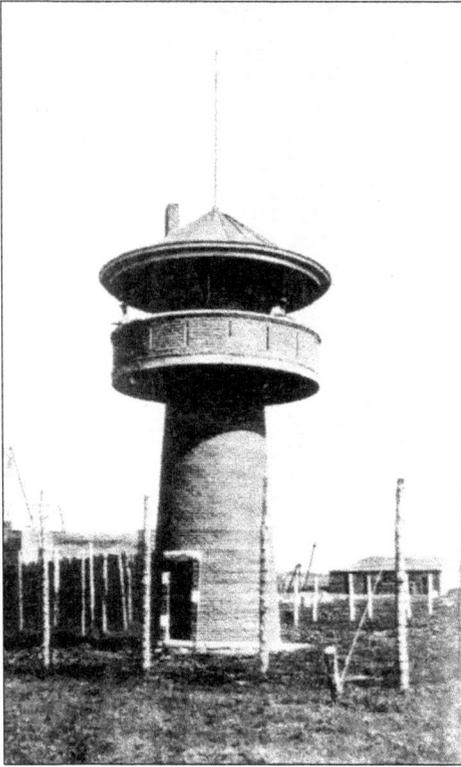

Shortly after the death of Joseph B. Waldrupe, the wooden guard boxes were replaced with brick towers. The towers were positioned outside the construction site and featured port holes from which an officer could fire a weapon and be protected. (Author's collection.)

John J. Edgell Sr. started to work as a mule skinner at the age of 18, driving teams of mules from the quarry to the construction site in 1898. By the 1940s, John Edgell Jr. began work as a guard and eventually worked his way up to be supervisor of the facilities department. Rick Edgell began his career as a correctional officer in the 1970s and is still working. Since the beginning, there has been a member of the Edgell family working at Leavenworth. (Courtesy Rick Edgell.)

Andrew F. Turner began his career as a guard at the federal prison in Atlanta, Georgia, on January 16, 1914, and transferred to Leavenworth on May 26, 1915. During the evening meal on March 25, 1916, Turner observed inmate Robert F. Stroud talking and approached the inmate to ask for his number. During the noon meal the next day, Stroud raised his hand asking permission to use the restroom and Turner granted it. Once in the isle, Stroud approached Turner and asked, "Did you shoot me?" Stroud produced a sharpened knife and stabbed Turner in the chest, killing him instantly. During two trials, Stroud claimed insanity but was discredited by Dr. Karl A. Menninger each time. During a third trial, Stroud claimed self defense and that Turner had assaulted him during a previous altercation. Stroud was sentenced to death but the sentence was commuted to life in prison by Pres. Woodrow Wilson. (Author's collection.)

Andrew H. Leonard began his career as a guard in 1900. A Spanish-American War veteran, Leonard became well liked and respected by staff and inmates. During the 1901 riot and mass escape, Leonard was working atop scaffolding. In an attempt to warn other guards, he jumped from the scaffolding and severely injured his knee. As he lay on a pile of bricks, one of the armed inmates pointed a gun at the young guard's head. Another inmate passing by exclaimed, "You can't shoot an unarmed man!" The would-be murderer laughed and walked off. On the morning of November 14, 1922, Leonard began his morning as usual, making breakfast in bed for his wife. In an unusual turn of events, he walked from room to room kissing each of his three children and telling them, "I love you." Two hours later, Leonard was dead. Inmate Joe Martinez had gone on a rampage, stabbing six guards before being shot. Below is a poem written by an inmate that appeared in the *Leavenworth Times* on the day of Captain Leonard's funeral.. (Courtesy Mercedes Leonard Dougherty.)

In Memory of
Captain Andrew Leonard

In the silence of sorrowful hours,
When the music of prison has ceased,
He sleeps in a mansion in heaven,
Sleeping the sleep of peace.

A straighter man shall never live,
To give a convict the benefit of doubt,
Captain Leonard was liked by many,
Within the walls and out.

There are many who valued his presence,
In the mess hall and within the wall,
Now, we miss him, and long for his smiles,
He gave us, as we passed him in the hall.

He has gone from us forever,
To that wonderful land of peace,
Now we'll miss, and long for his presence,
And wish that it never had ceased.

He is gone, BUT not forgotten,
By the boys who liked him so much,
We wished that our phone reached to heaven,
So with him, we could keep in touch.

Our hearts are filled with sorrow,
For the family he has left behind,
No better a husband and father,
Will they, in this world find.

There a few in our world today,
Like the man that fate took away,
We'll miss Captain Leonard always,
As time goes by, day to day.

He governed us with fatherly kindness,
Like few of the prison guards do,
He could talk to a man without blindness,
He was a man TRUE BLUE.

Our hearts are filled with sorrow,
Which we really cannot express,
He governed us with fatherly kindness,
And him, may our God Bless,

Thru many years of service,
In this, "City of Silent Men"
He was kind to all the inmates,
And we wish he was with us again.

Now my bit of poem is ending,
Tho praise will never cease,
To Captain Leonard, I am sending this wish,
Of rest in heavenly peace.

Composed and written by:
Don W. Urie Reg No. 18297
November 16th, 1922

With the formation of the Federal Bureau of Prisons in 1930, officers were trained in the theoretical and practical methods of prison work. Classes were four months long and included physical training, training in the use of firearms, and communication skills. Prior to being hired, officers had to pass civil-service medical examinations. (Author's collection.)

J. C. Taylor began his career as a correctional officer and was one of the first officers trained and assigned to Leavenworth. Taylor later reflected, "When I arrived at Leavenworth we were not accepted by the older officers who considered us school boys." If one asked an older officer a question, he replied, "Go find out like I did!" (Author's collection.)

An unidentified officer is seen working the lock box in C cell house. The new officers uniforms were dark gray wool jackets and trousers, a light gray long sleeve shirt, and a burgundy tie. Jackets, ties, and long sleeves were worn year round. (Courtesy National Archives and Records Administration.)

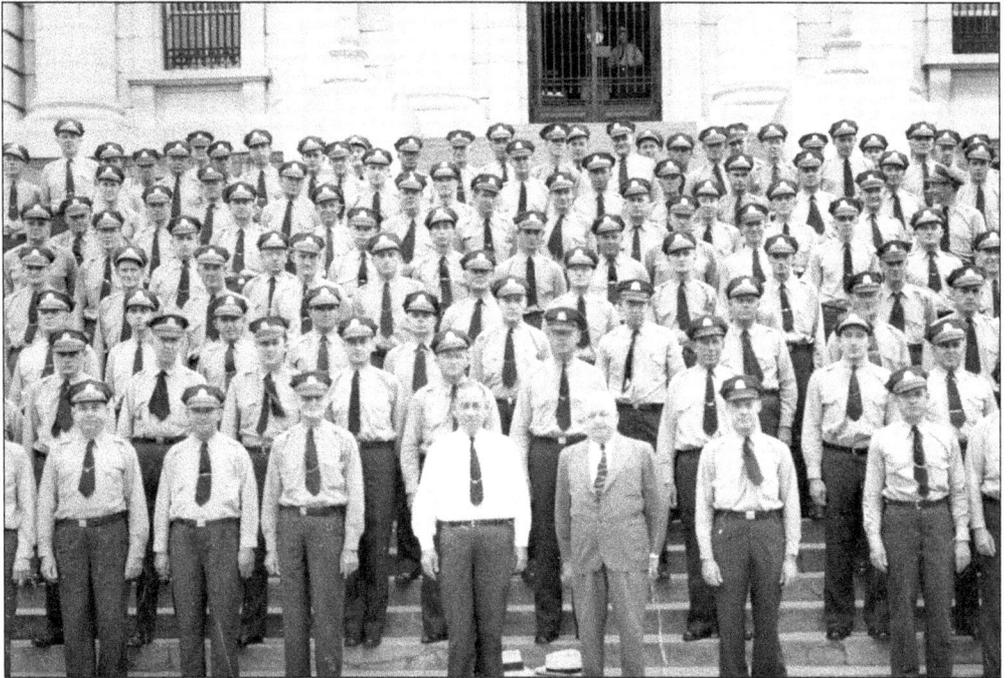

Pictured here is Warden Robert Hudspeth (first row, fifth from left) with other officers on the front steps. By the 1940s, officers could shed their jackets while on duty. A 1948 directive removed the black stripes on the jacket as well as all patches. (Author's collection.)

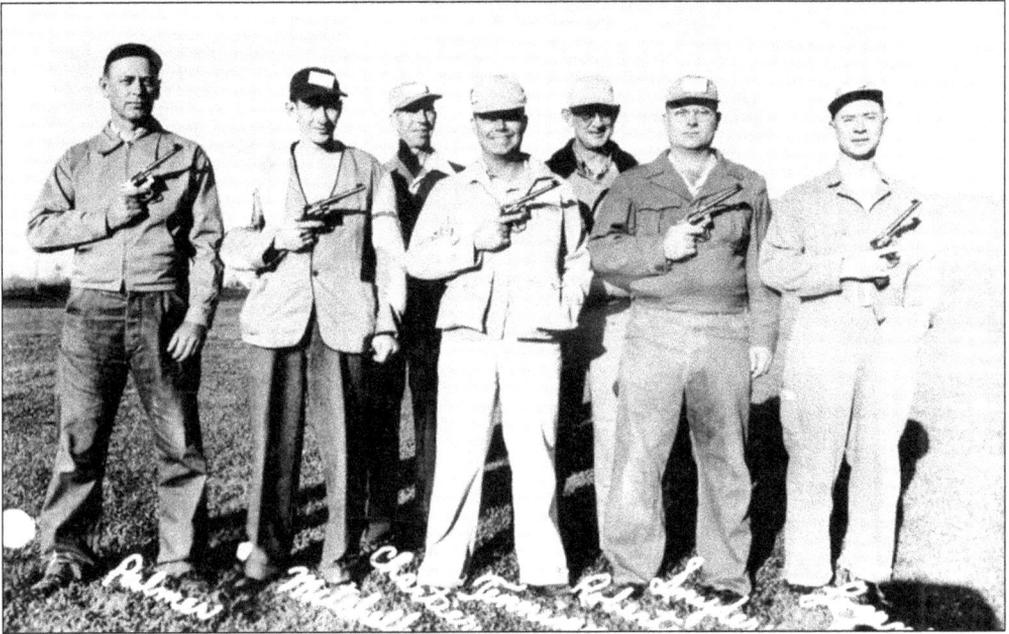

Correctional officers competed yearly in a national shooting competition held in Ohio. Members of the championship team included officer Joseph Palmer, Johnny Mitchell, Arthur Chartier, officer Earl Tennimon, training officer Frank Roberts, Ira Snyder, and Charles Logan. (Author's collection.)

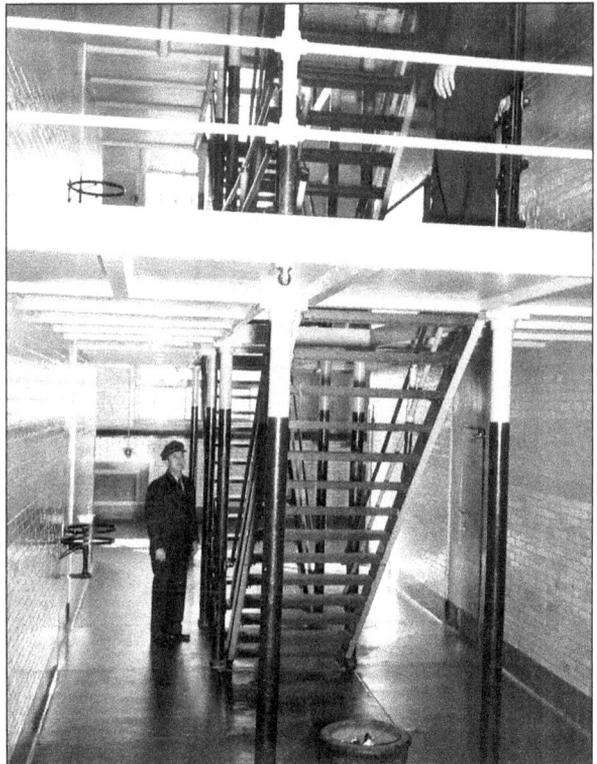

Here is an unidentified officer standing at the middle stairwell of the original A cell house. (Courtesy Chuck Zarter.)

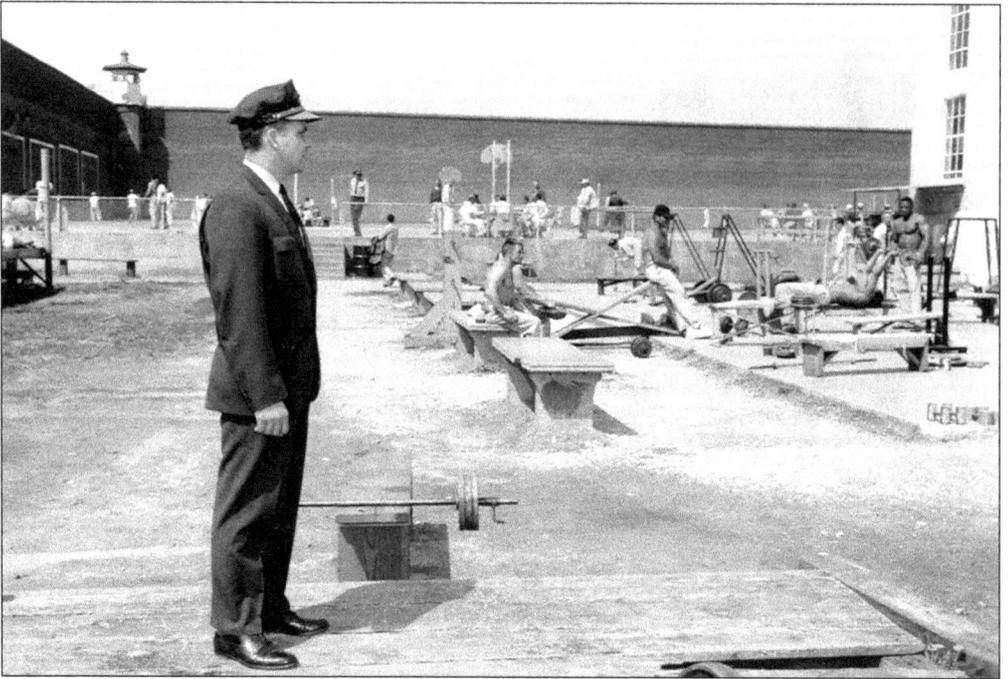

This photograph shows an officer observing inmates on the weight pile. Weights were removed from the institution in the early 1990s when inmates began using them as weapons. (Courtesy Chuck Zarter.)

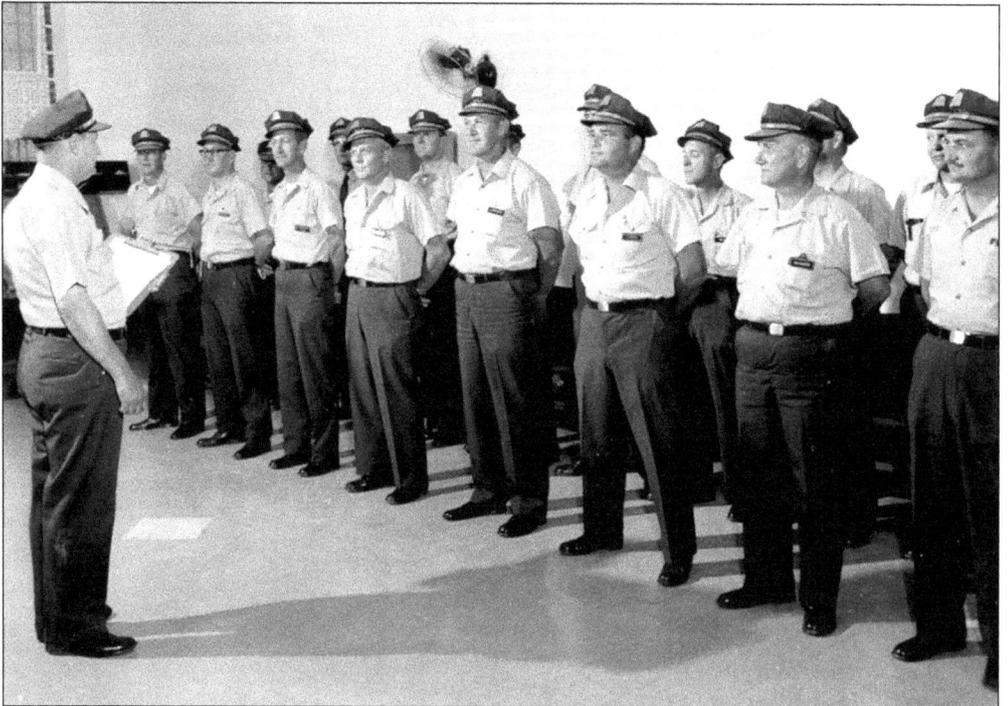

By the 1960s, officers were allowed to wear short-sleeve shirts without neckties during the summer. Lt. Walter Watson conducts roll prior to the officers going on duty. (Courtesy Bob Logan.)

Ray Godfrey used to tell rookie officers, "You gotta be tough to work Leavenworth!" As Godfrey explained how tough one had to be, he shot staples into his leg. "You think that's tough!" he said as he started pulling the staples out. Godfrey later mentioned that he had a prosthetic leg. (Courtesy Sharon Blankenship.)

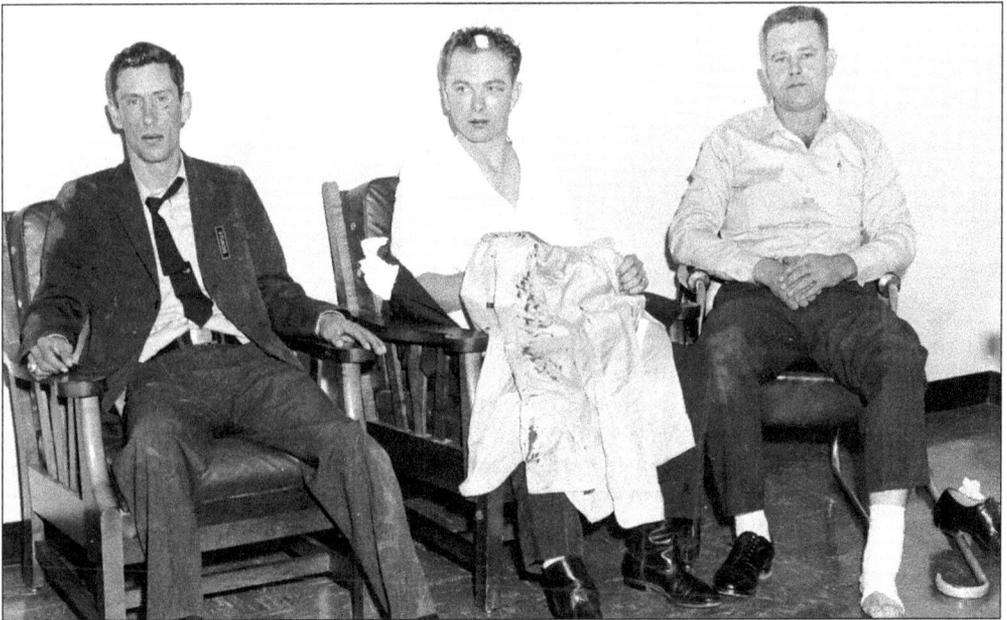

From left to right, Charles Sturgis, Gary Fox, and Roland Logan display the wounds they received during the November 12, 1963, escape. Sturgis suffered a slight fracture of the left cheek when he was overpowered by the escaping inmates. Fox suffered a concussion when he was struck with a pipe. Logan sustained a sprained ankle as he scuffled with inmates. Logan was held at knifepoint and bound. (Courtesy Steven Fox.)

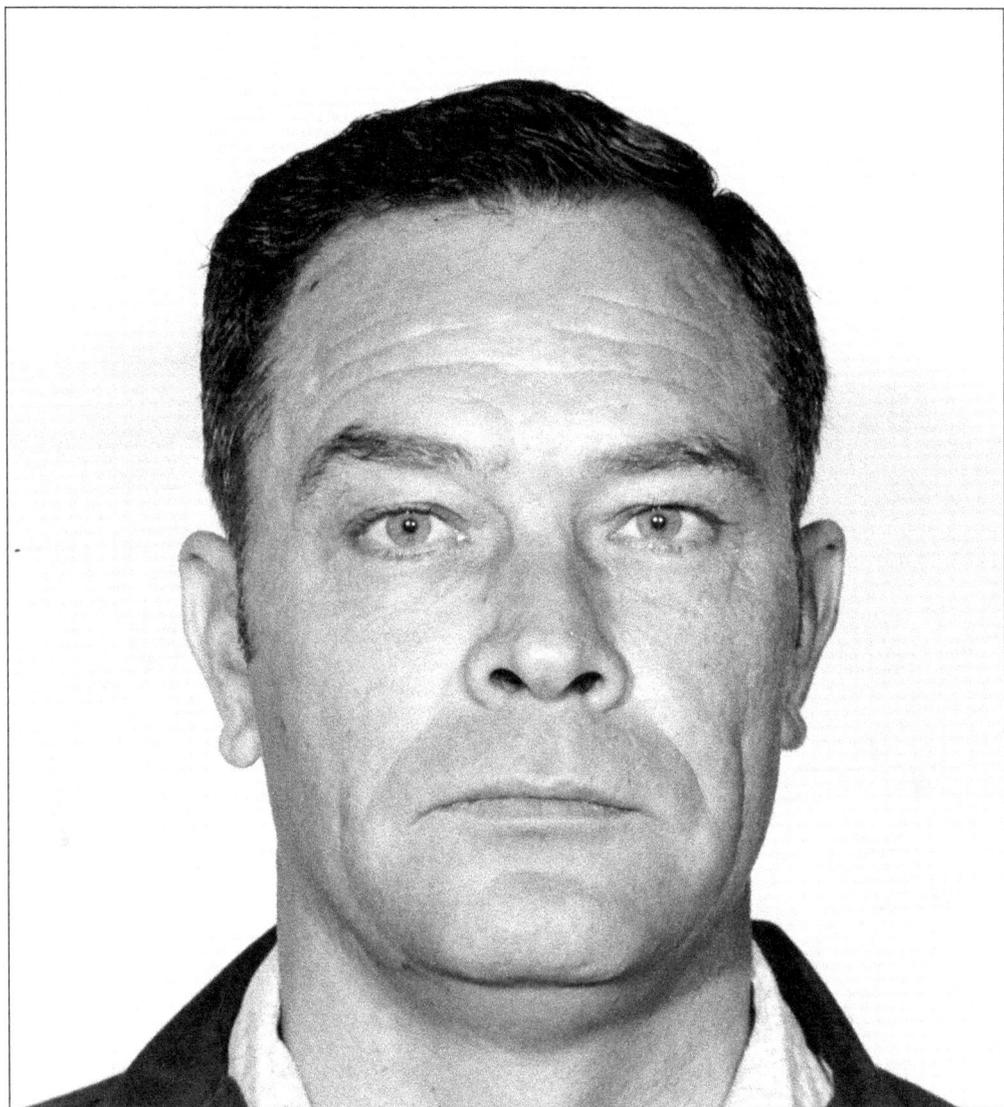

Wayne L. Selle was appointed to the position of correctional officer in 1972 after a long and distinguished career in the air force. On July 31, 1973, Selle was called in on his day off because informants had advised officials there would be a disturbance that day. At approximately 11:00 a.m. as lunch was being served, a disturbance broke out in the dining room. At the same time, inmates took four staff members hostage and locked themselves in the laundry. Militant inmates armed with weapons began chasing Selle and cornered him in a stairwell. His body was discovered later in the day as officers entered the cell house and inmates returned to their cells. (Courtesy Pauline Brown.)

John W. Johnson was a combat veteran and Purple Heart recipient of the Vietnam War. Johnson began his career at Leavenworth in January 1974 as a correctional officer. On the afternoon of September 29, 1974, Johnson had attended the birthday party of his daughter and reported for duty a little late. As the evening progressed, officers had observed a card game and saw what they believed was paper money being exchanged. Officers, including Johnson, broke up the card game and searched the inmates. Inmate "Gypsy" Adams became angered and argued with officers. At approximately 9:00 p.m., officer Johnson was working the gallery in B cell house when inmate Adams attacked him with a 14-inch piece of strap steel sharpened into a knife. After several minutes, another officer investigating a noise discovered the assault taking place. The second officer called for assistance and, while wrestling with the inmate, he also was stabbed. Staff members responding to the emergency were met by the chants of other inmates screaming, "Kill them all!" Johnson had been stabbed 117 times. (Author's collection; inset courtesy Toni McLeod.)

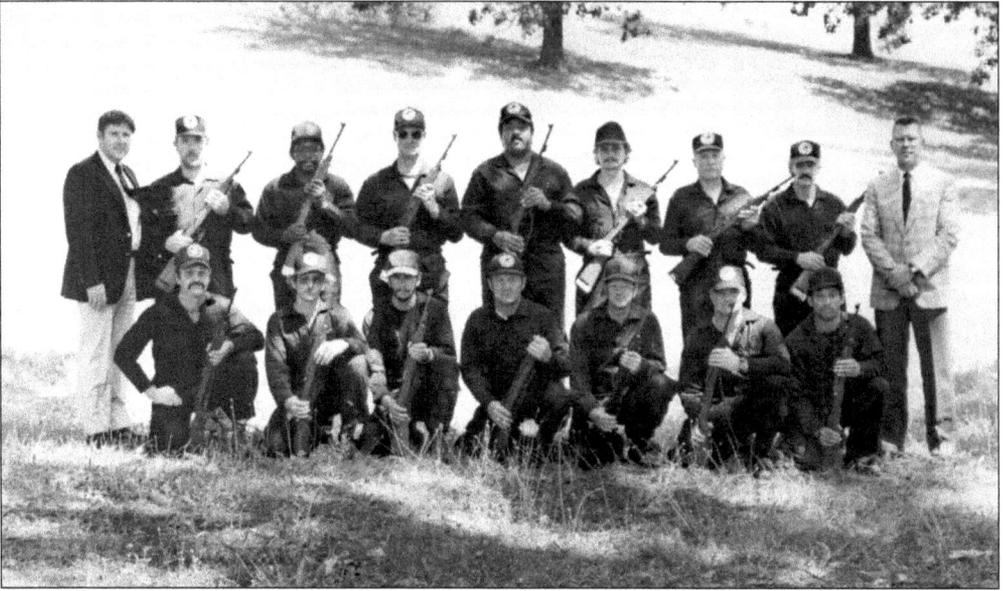

Under the direction of warden J. A. O'Brien and associate warden Patrick Keohane, the first-ever special operations response team was formed in 1982. Throughout the years, Leavenworth officers have been called on to assist in not only institutional disturbances but also civil disturbances. On October 2, 1962, 12 Leavenworth officers fought rioters on the campus of the University of Mississippi when James Meredith enrolled as the first black student. Special operations response team members were also dispatched to Los Angeles and assisted Los Angeles police department officers during the April 1992 riots. (Courtesy Charles Terrell.)

On May 5, 2006, the names of fallen officers from U.S. Penitentiary Leavenworth were added to the Kansas Law Enforcement Memorial in Topeka. (Author's collection.)

Ten

PEOPLE, PLACES

Carl Zarter began his career at the institution in 1931 as the records clerk, and when he retired 39 years later in 1970, he was responsible for receiving over 70,000 inmates. During his career, Zarter was allowed to carry a camera and many of his photographs appear in this book through the kindness his family. After his retirement, Zarter worked writing Federal Bureau of Prison standards in habeas corpus cases. (Courtesy Chuck Zarter.)

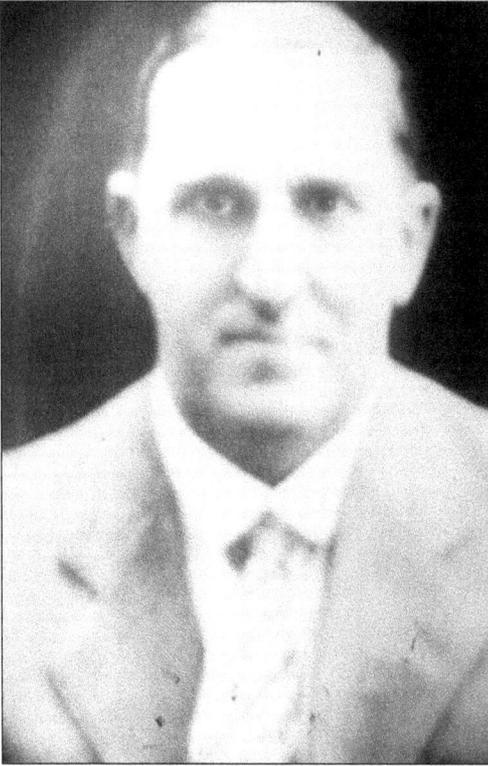

Robert G. Warnke was a Spanish-American War veteran and served with Theodore Roosevelt's Rough Riders. Warnke was appointed to the position of laundry foreman in 1921. On the morning of June 20, 1929, shortly after arriving at work, the foreman was busy inspecting clothes when inmate Carl Panzram took up an iron bar. As Warnke was bent over, Panzram struck him in the head. Once on the ground, Panzram stood over him and continued the assault. Panzram was convicted of murder and was executed. (Courtesy Warnke family.)

Slaughterhouse foreman Elmer Bauder reported for duty on October 14, 1960, and instructed his crew about the day's work. Bauder turned and walked into his office, and as he turned on the light, the building exploded. Witnesses said the explosion lifted the roof straight up and blew out the walls. Bauder and two inmates were killed, and five others were injured. It was Bauder's 46th birthday. (Courtesy Joe Bauder.)

William Berry began his career at Leavenworth after a long and distinguished military career. Berry was working as cook supervisor on the afternoon of August 19, 1972. As he supervised the cooking of the evening meal, an inmate approached and advised Berry that the pilot light had gone out on the oven. As he was attempting to relight the oven, an explosion occurred. Berry succumbed to his injuries, leaving behind a wife and daughter. (Courtesy Cheryl Mellavan.)

John F. (Jack) Cogan began his career as a correctional officer and had also worked as a correctional counselor. In December 1978, Cogan received a promotion to farm supervisor. On January 31, 1979, Cogan and his crew were working on a truck in the garage. An inmate who was under the truck sparked a blowtorch, and an explosion ripped through the building. Cogan and two inmates were killed instantly. (Courtesy the Cogan family.)

Over the years, photographs have been used in all types of training. This photograph was used to demonstrate what not to do while on duty in a tower. (Author's collection.)

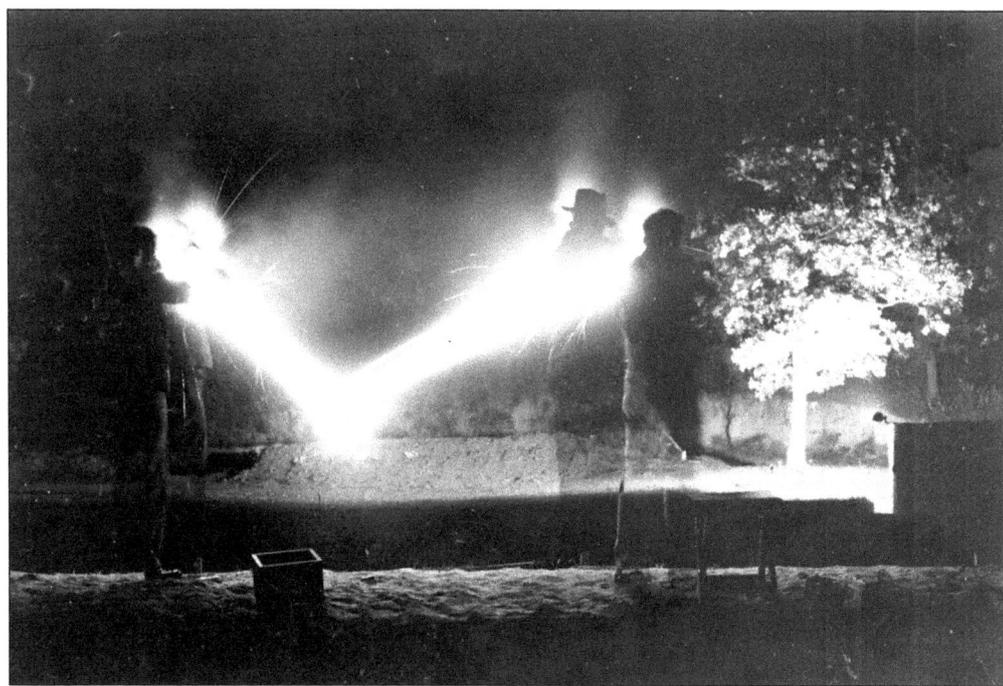

During the Central Division Firearms Competition, held at Leavenworth on October 13, 1949, staff witnessed a demonstration of the Thompson .45 caliber machine gun with tracers. (Courtesy National Archives and Records Administration.)

Prior to the opening of the farm dormitory in 1961, staff members from other institutions were sent to Leavenworth for formal locksmith training. As a portion of their training, these men installed all of the locks in the new facility. (Author's collection.)

The new farm dormitory became known as a federal prison camp in the 1970s. By the mid-1980s the circle driveway was removed and a new visiting room was built with a courtyard. (Author's collection.)

This is the outdoor visiting area at the prison camp early 1980s. Inmates are allowed 24 hours of visiting a month with approved visitors. Inmates that have families living outside the immediate area can apply for extended visiting privileges. (Author's collection.)

Staff members' children are seen here aboard the institution fire truck in the 1960s. (Courtesy Jim Will.)

Built in the 1930s, reservation housing has been available for staff that transfer from other institutions. (Author's collection.)

On the day of his 28th wedding anniversary, Bill Arnold (left) was working in the furniture factory when an inmate assaulted him. Arnold received injuries that resulted in the loss of his right hand. During the assault, another staff member came to his aid, and the inmate attempted to also stab him. A six-inch steel pocket ruler kept the staff member from getting hurt. (Courtesy Dorothy Arnold.)

In December 1982, a buffalo was being received from the military reservation at Fort Riley. The buffalo bolted from the trailer as she was being unloaded. For the next 24 hours, staff searched for the buffalo in cars, planes, and even on horseback. Shown are three officers attempting to lasso the escapee. (Author's collection.)

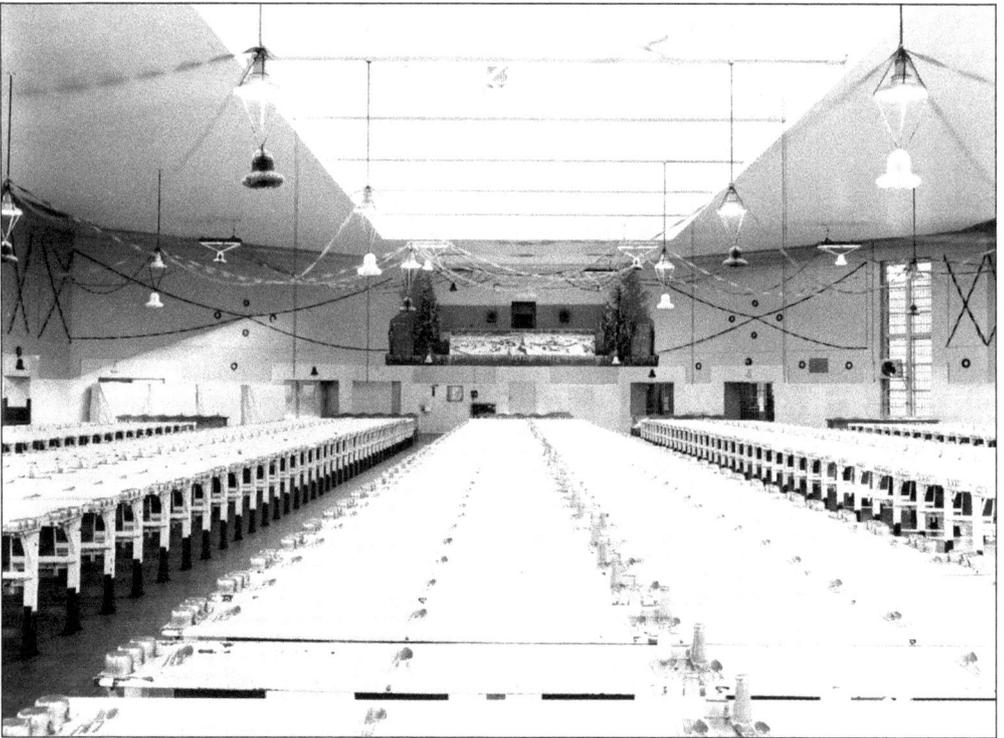

Shown here is the dining room at Christmas during the 1950s. (Courtesy Chuck Zarter.)

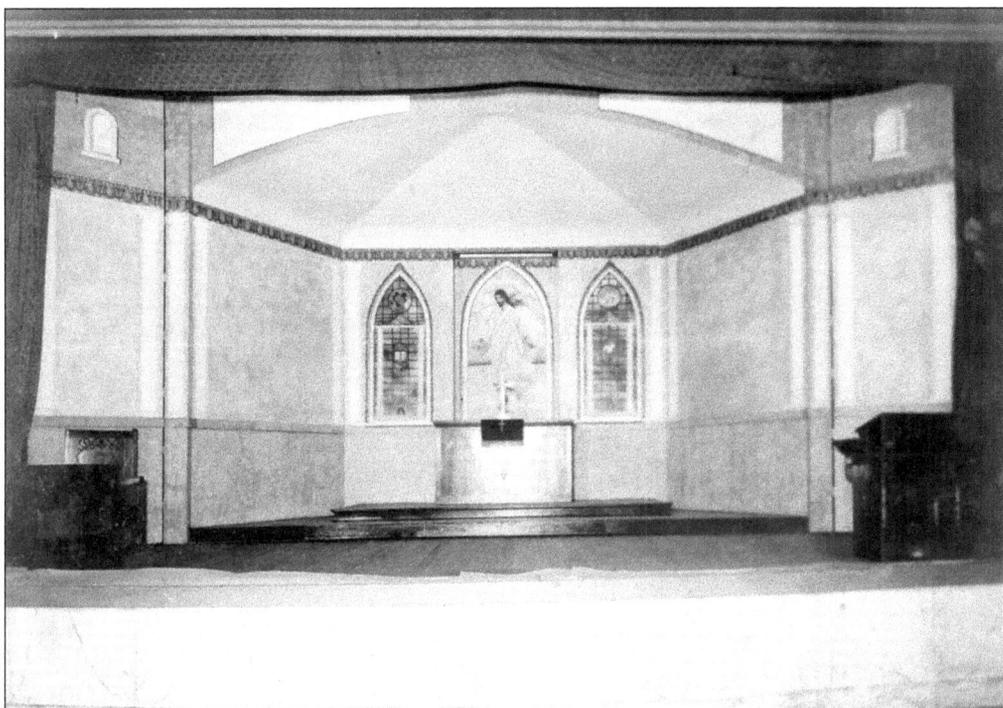

This photograph shows the Protestant chapel on the stage of the auditorium during the 1930s. (Author's collection.)

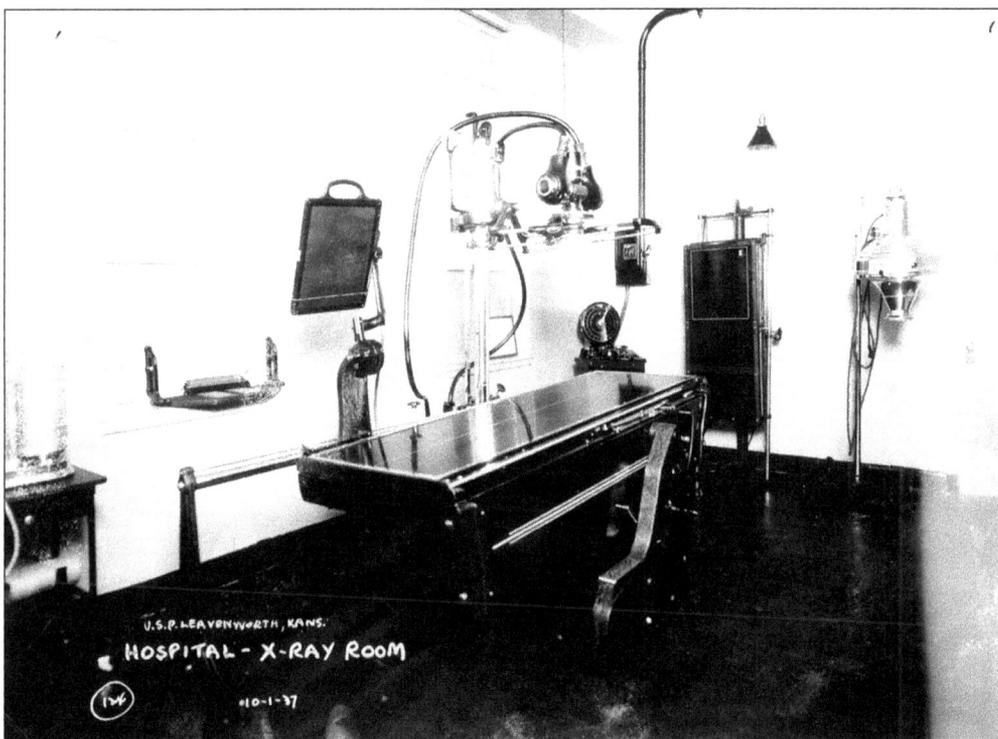

The institution's first x-ray machine was installed during the 1930s. (Author's collection.)

A typical street view from B cell house shows the new institution hospital being built in the early 1930s. (Author's collection.)

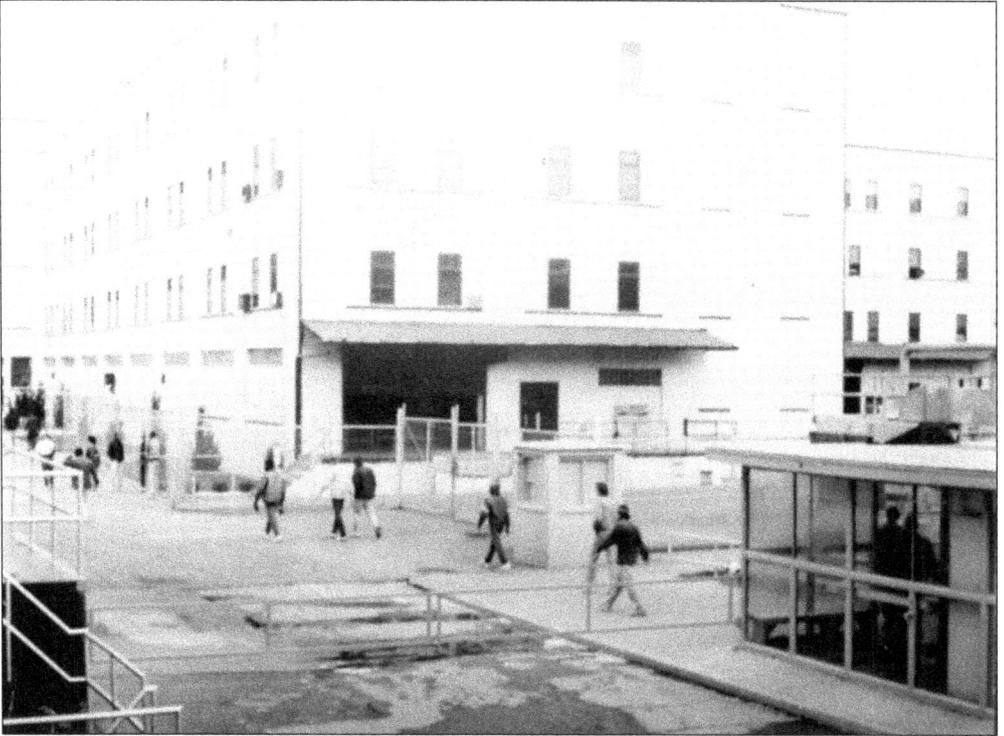

Inmates head for work in the factory during the 1980s. (Author's collection.)

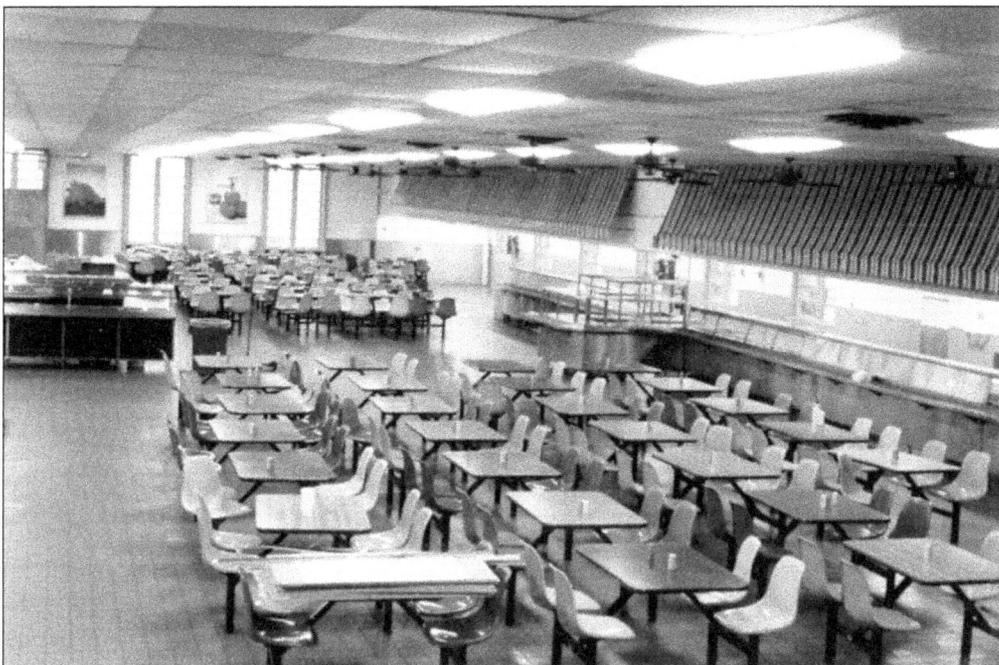

This photograph shows the inmate dining room in the 1990s. Gone are the days when inmates sat in total silence and all in one direction. (Author's collection.)

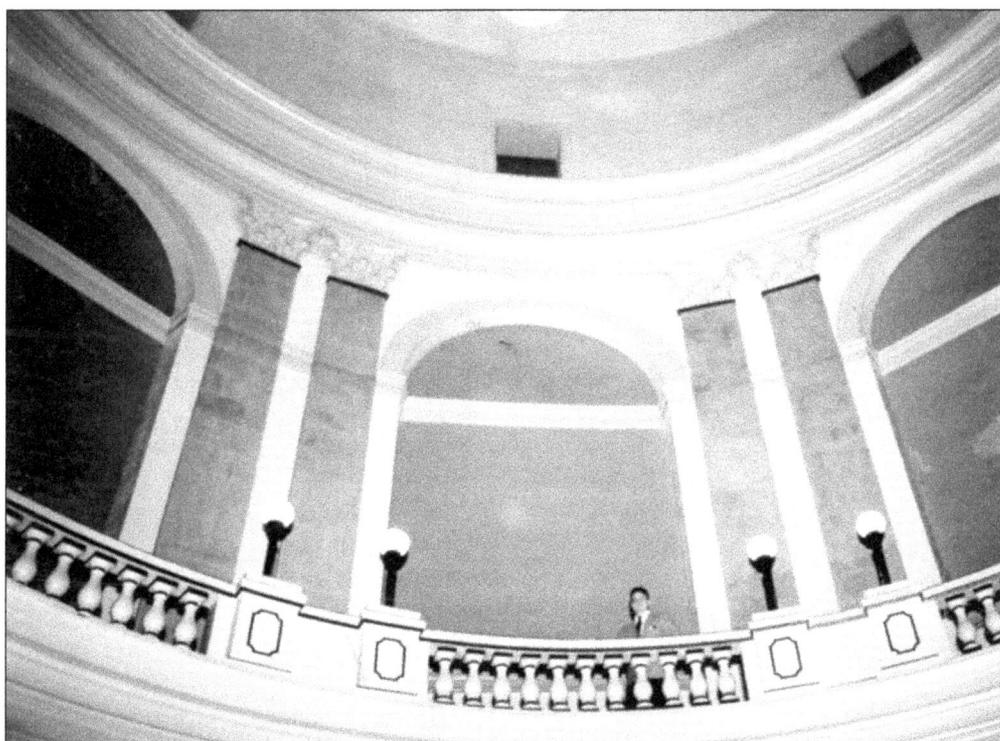

Here is a view of the upper rotunda during the 1990s. (Author's collection.)

Cars are lined up for the institution car show in the early 1960s. (Courtesy Chuck Zarter.)

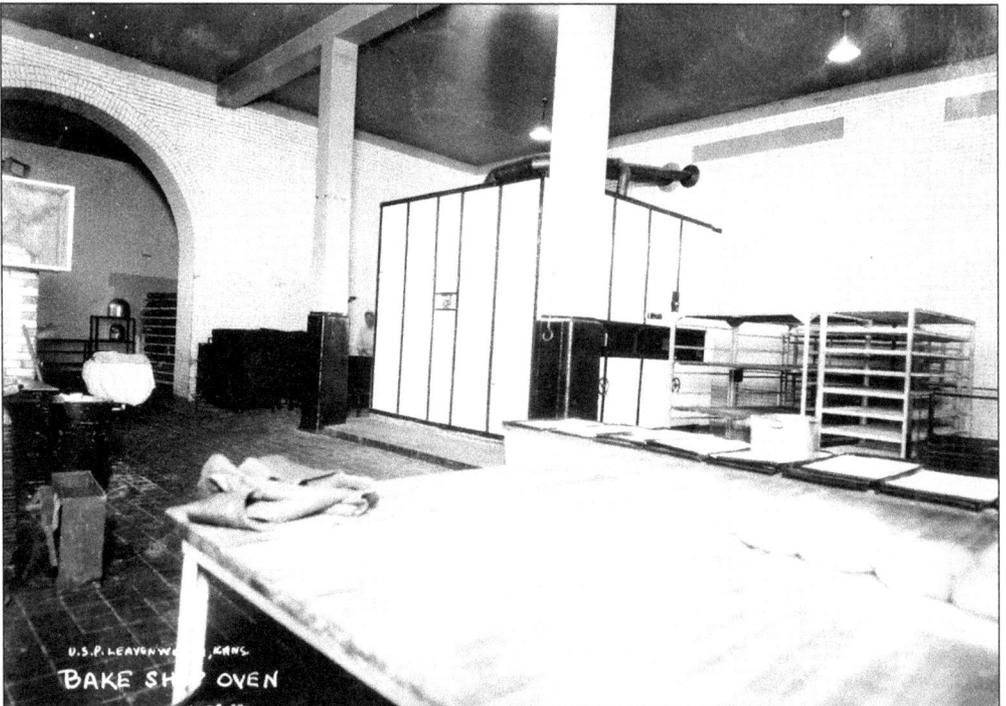

This 1937 photograph shows the institution bakery. From this oven came many baked goods such as bread, dinner rolls, pies, and cakes. (Author's collection.)

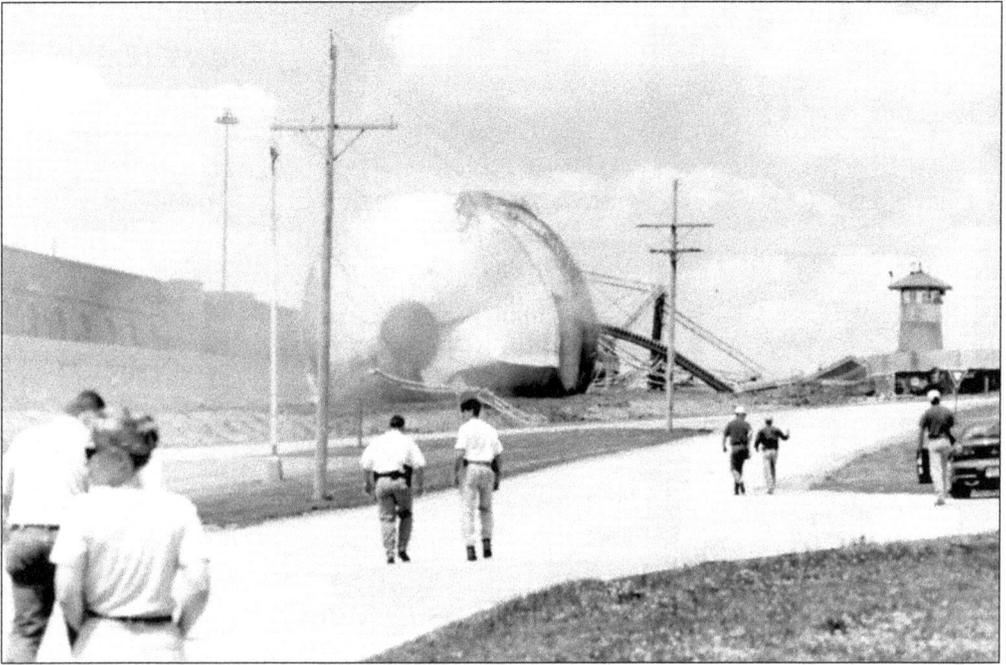

After years of service, the water tower was reduced to rubble in seconds. By 1997, the institution water towers had "holes you could drive a car thru!" (Author's collection.)

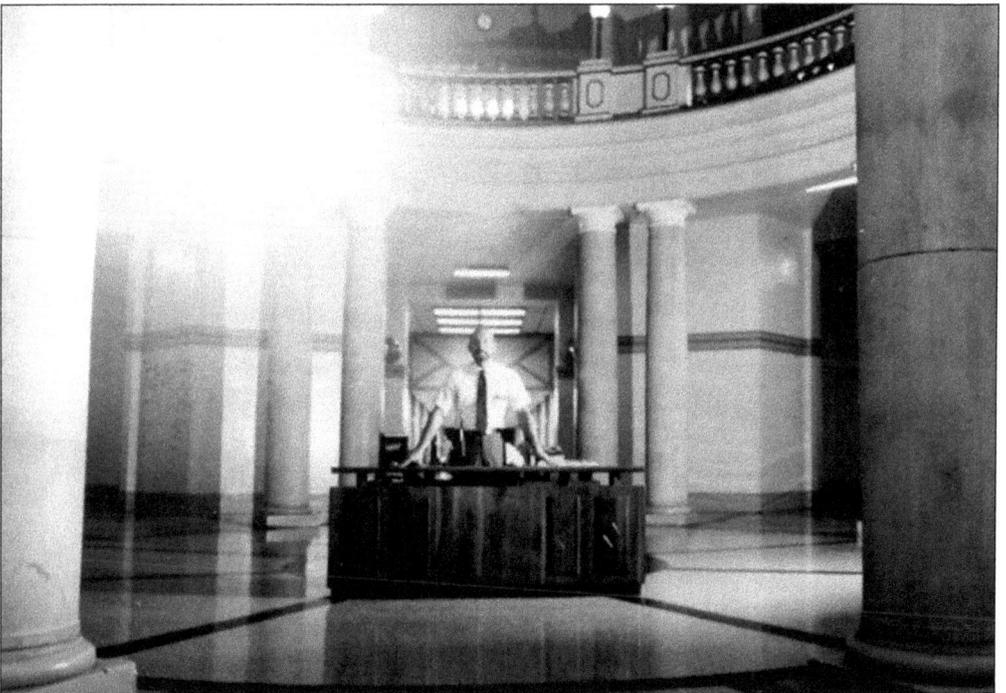

Senior officer specialist Roy Moore stands at the center hall desk during 1990s. (Courtesy Roy Moore.)

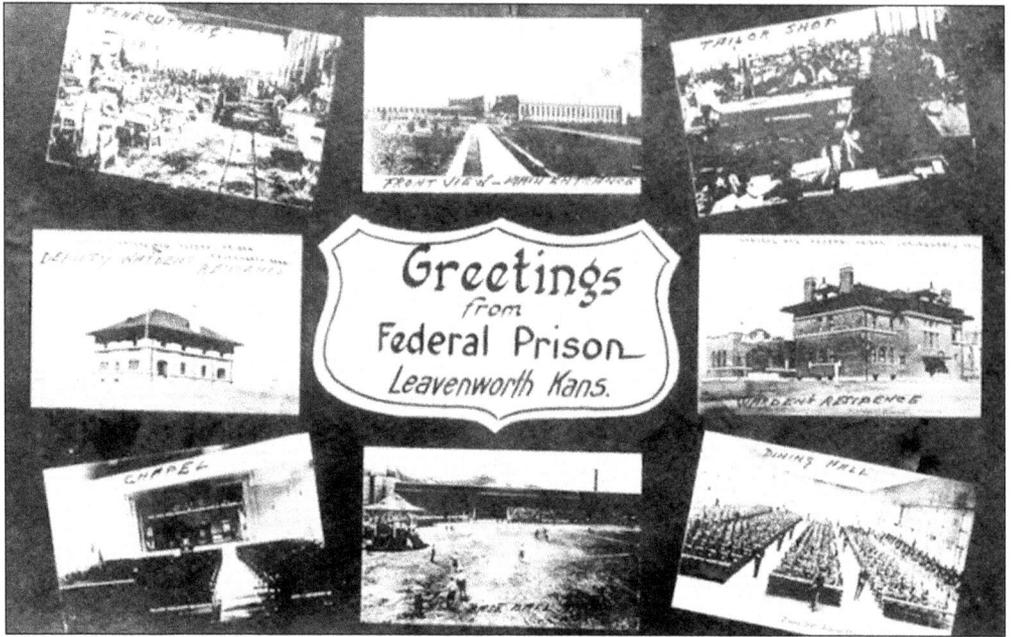

Greetings from the federal prison in Leavenworth. This early-1900s postcard says it all. (Author's collection.)

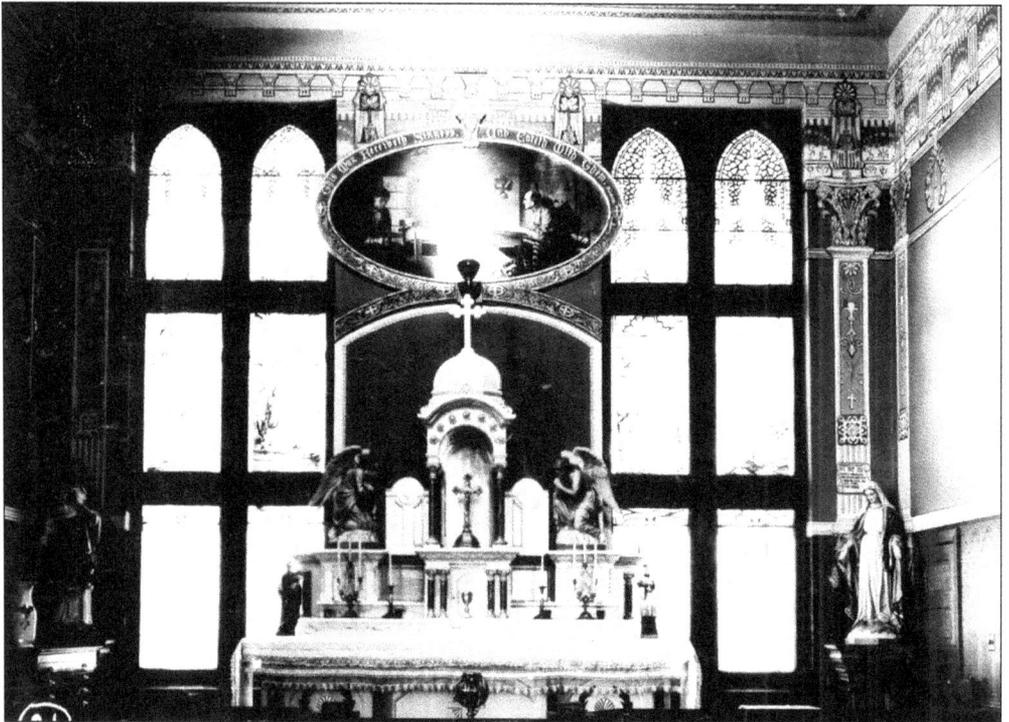

Here is the Catholic chapel in the 1930s. Shortly after this photograph was taken, the chapel was destroyed by fire. Painted and decorated in 1913 under the direction of a Benedictine priest, the stained-glass windows remained intact until they were destroyed during an institution riot on July 5, 1992. (Author's collection.)

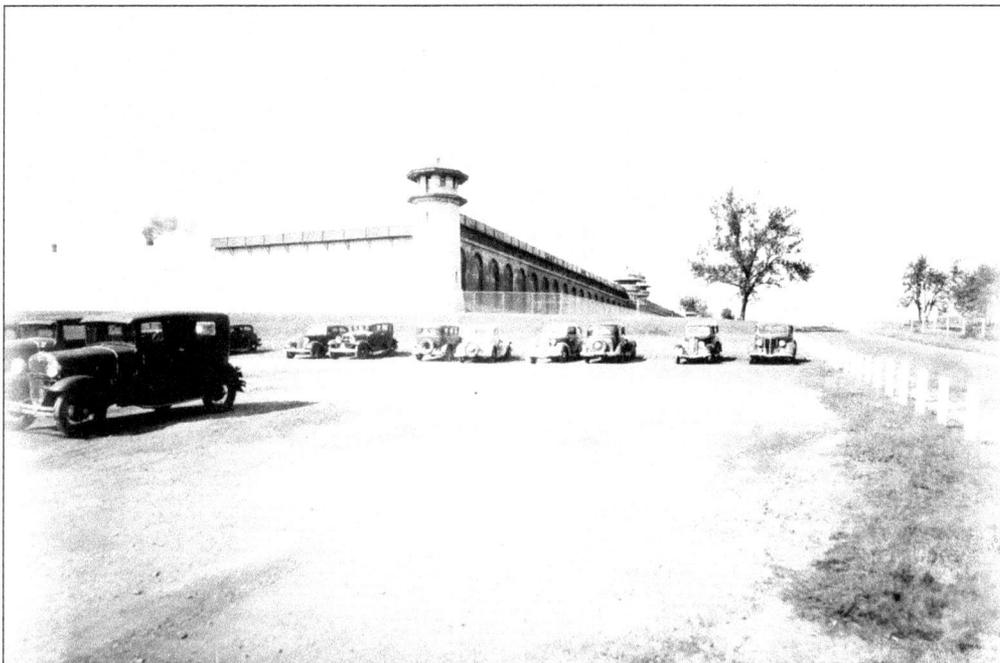

This is officer's general order number 38. It says that all officers reporting to the institution by motorcar must park in the southeast parking lot, and all those riding horses, mules, or wagons must park in the field east of the institution. (Author's collection.)

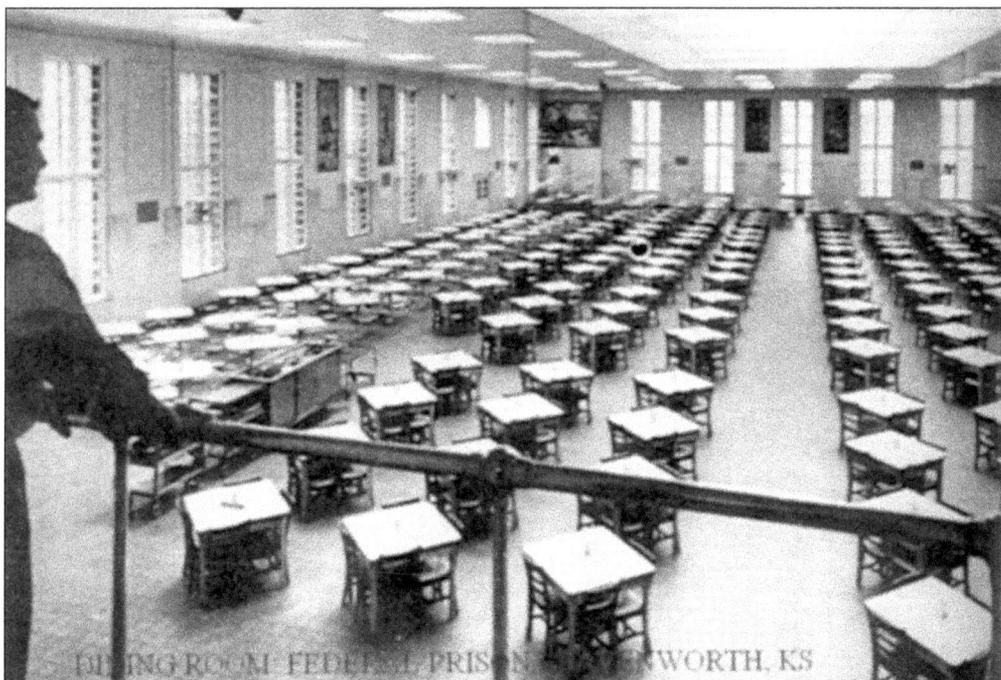

Overlooking the inmate dining room, this is a view from the gun gallery in the 1960s. (Courtesy Chuck Zarter.)

This photograph, taken during Christmastime in the 1950s, shows the rear corridor, which was the busiest intersection inside Leavenworth. (Courtesy Jim Will.)

On November 3, 1983, the renovation of B cell house was well underway. A decision had been made to cut bars from a window to aid workers with the removal of debris and the remodeling process. As a staff welder was cutting the bars, Joseph J. Haas, an institution construction supervisor, was working on a scaffolding below. Suddenly the welder fell from the window and Haas attempted to break the staff member's fall. Haas was pulled from the scaffolding and would succumb to his injuries on November 8, 1983. Haas was married and had three children. (Courtesy the Haas family.)

Made by the New Metal Arts Company in Rochester, New York, this hat badge was actually called a hat ornament. It is one of the most sought-after pieces of bureau of prisons memorabilia. Officers wore silver badges and supervisors wore gold or bronze ones. (Author's collection.)

This wallet badge was used on inmate transports and escorts during the 1970s. Many staff members did not like this badge and refused to carry it. (Author's collection.)

Correctional officers wore two different styles of uniform buttons. The button on the left was worn on coats from 1897 until 1920. The button on the right was worn from the 1920s through the 1940s. Legend claims that when military units, police departments, and fire departments interlocked the symbols of their departments or units, it meant unity, strength, and perseverance. (Author's collection.)

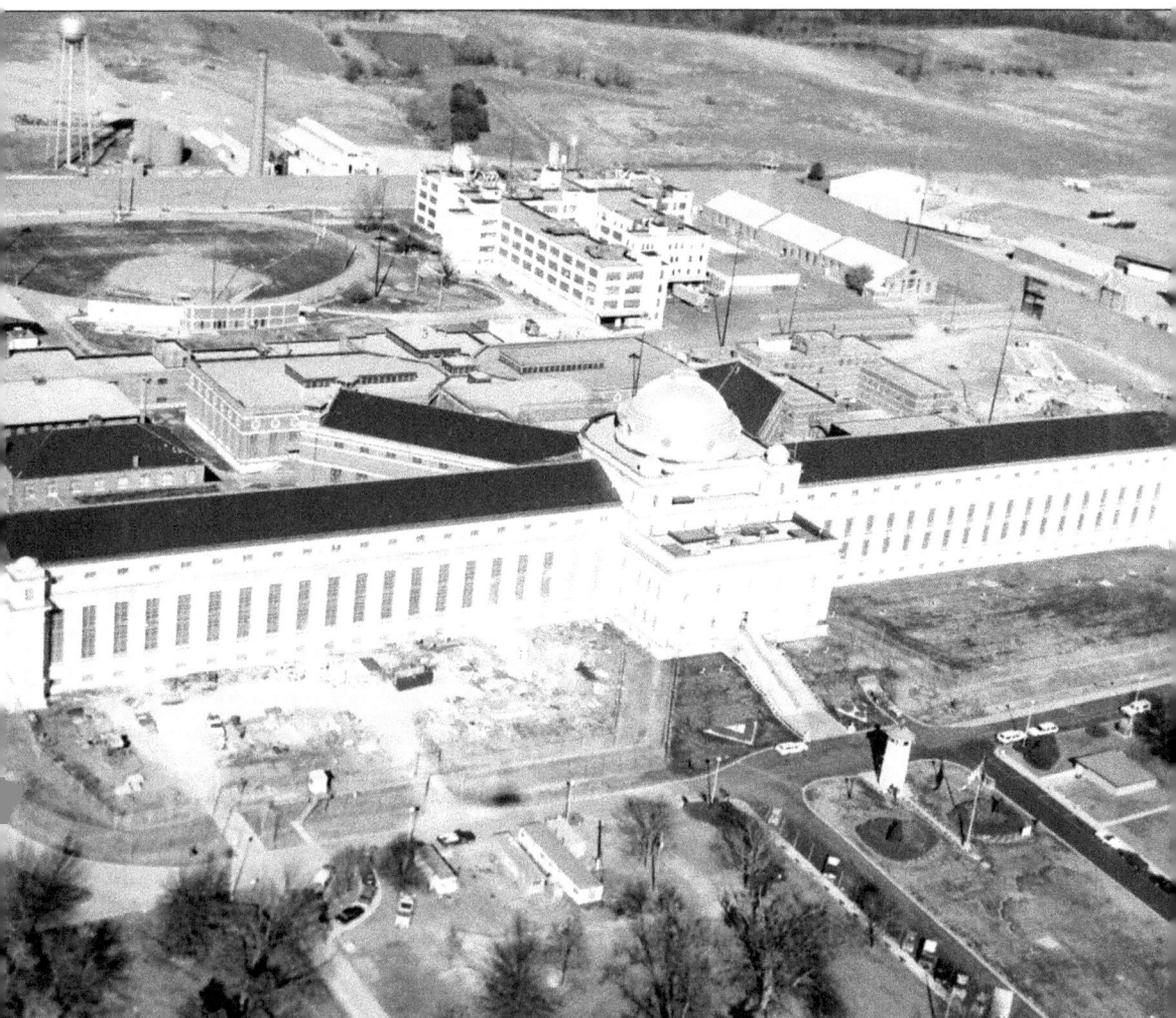

Here is an aerial view of the institution in the 1980s. (Author's collection.)

Visit us at
arcadiapublishing.com

...